MASS SOCIETY AND ITS CULTURE

———

THREE ESSAYS CONCERNING ÉTIENNE GILSON ON BERGSON, CHRISTIAN PHILOSOPHY, AND ART

Mass Society and Its Culture

BY

Étienne Gilson

AND

Three Essays concerning Étienne Gilson on Bergson, Christian Philosophy, and Art

BY

Henri Gouhier

TRANSLATED BY *James G. Colbert*

CASCADE *Books* • Eugene, Oregon

MASS SOCIETY AND ITS CULTURE;
AND THREE ESSAYS CONCERNING ÉTIENNE GILSON ON BERGSON, CHRISTIAN PHILOSOPHY, AND ART

Cascade Books
An Imprint of Wipf and Stock Publishers
199 W. 8th Ave., Suite 3
Eugene, OR 97401

www.wipfandstock.com

PAPERBACK ISBN: 978–1-6667–1792-1
HARDCOVER ISBN: 978–1-6667–1793-8
EBOOK ISBN: 978–1-6667–1794-5

Cataloguing-in-Publication data:

Names: Gilson, Étienne, author. | Gouhier, Henri Gaston, author. | Colbert, James G., translator.

Title: Mass society and its culture ; and three essays concerning Étienne Gilson on Bergson, Christian philosophy, and art / Étienne Gilson and Henri Gouhier ; translated by James G. Colbert.

Description: Eugene, OR: Cascade Books, 2023. | Includes bibliographical references and index.

Identifiers: 978–1-6667–1792-1 (paperback). | ISBN 978–1-6667–1793-8 (hardcover). | ISBN 978–1-6667–1794-5 (ebook).

Subjects: LSCH: Christianity and culture. | Christianity—Philosophy. | Gilson, Étienne, 1884–1978. | Bergson, Henri, 1859–1941.

Classification: BR2430 G474 G785 2023 (print). | BR2430 (ebook).

Étienne Gilson, *La Société de Masse et Sa Culture*. Paris: Librairie Philosophique J. Vrin, 1967.
Henri Gouhier, *Étienne Gilson—Trois Essais: Bergson, La Philosophie Chrétienne, l'Art*. Paris: Librairie Philosophique J. Vrin, 1993.

Contents

Translator's Preface

As HENRI GOUHIER POINTS out in the second part of the present translation, Étienne Gilson had a lifelong interest in philosophy of art, although he is better known as a medievalist and for his work on the concept and nature of Christian philosophy.

Some of his work on the arts was originally done in English, but then rewritten and not just translated. He used the French version in composing his work on mass art, thus creating a need to find the parallel (or as close to parallel as possible) passage in English. The discussion of mass art is important in itself. Our hope is the reader may also be impelled to dip into the broader aesthetic works.

As Gilson's admirers should know, Henri Gouhier was Gilson's first doctoral student. A major part, some would say the major part of Gilson's work, was to show modern (that is, early modern) philosophy's medieval roots; Gouhier, by contrast, continued to center his work on early modern philosophy.

Gilson and Gouhier remained lifelong friends. A selection from their correspondence was published as *The Malebranche Moment*. Gouhier succeeded Gilson as the occupant of chair number 23 of the French Academy.

In the little book on his mentor and friend, Gouhier's essays have a rather colloquial tone. At times for instance, the remarks are unnecessarily repetitive. This has a certain endearing quality, if one pictures Gouhier reconstructing his mentor's thinking. However, it can also be off-putting and somewhat confusing, We have tried to simplify a bit in order to clarify.

The third essay, on Gilson's philosophical explorations of art appears to me to have remained unfinished. In particular, it does not indicate exact sources for many brief quotations. (Gouhier's book was published in

1993, and he died in 1994. It is easy to imagine that bad health kept him from a thorough revision of his manuscript.) I have identified sources in the English versions of Gilson's work to the best of my ability but with incomplete success. I have kept Gouhier's numeration of footnotes and placed my additions in brackets. This is the reason for the odd mix of references to English and French versions of Gilson's works in the third essay, as well as references given as footnotes but also within the text.

To Senator Count Vittorio Cini
and to the Spirit of Venice,
in grateful homage

Étienne Gilson,
Preface to *Mass Society and Its Culture*

THE ORIGIN OF THIS work was an invitation from my colleague and friend Professor Vittore Branca to give three lectures at the International Course of High Culture for the Giorgio Cini Foundation on the island of San Giorgio Maggiore at Venice. The three lectures were delivered on September 7, 8, and 9 of 1964.

The issue of the Quaderni San Giorgio in which these lectures were published by the efforts of Piero Nari is titled as a whole *Arte e cultura nella civiltà contemporanea*. The lectures as a group bear the title "L'industrialisation des arts du beau." The individual titles are: 1. "Industrialization of the Plastic Arts"; 2. "Industrialization of Letters"; 3. "Industrialization of Music." The three lectures were delivered as they are printed in the *Quaderni di San Giorgio* except for footnotes and the short general introduction.

The present text differs in two ways from that of the *Quarderni di San Giorgio*. We have restored the original order of the lectures here: Plastic Arts, Music, Letters. We had modified it in deference to the desire expressed by the organizers of the International Course of High Culture. Perhaps they judged that music is more interesting to the general public and preferred to end with it, but there was a reason for the original order, a philosophical reason. The industrialization of the plastic arts and music have in common that in place of the real work of art they substitute an artificial imitation that, as we will see, differs specifically from the model. By contrast, we will insist on the fact that no specific difference distinguishes the manuscript from the printed version. To see a "reproduction" of a picture, however excellent it is, is not to see a picture, but the image of a picture, whereas to read a manuscript of the *Aeneid*, or a modern edition of the *Aeneid*, is to read the same literary work, or nearly so, with

textual differences. Therefore it seems preferable to group the plastic arts with music and to treat literature separately.

The second difference is in the title. At Venice, we did not read the introduction published in the *Cahiers*, 77–81. It was omitted because there was not enough time to give the necessary clarifications about concepts that were still obscure and alien to many minds, like those of "mass society," "mass culture," "means of mass information," and other similar ones that are well known in the United States, where "mass civilization" is in its native habitat, but are less familiar in Europe, except among sociologists. Indeed, industrialization of cultural products is only the means of creating a mass culture, for which it is both the cause and effect. The notion of mass culture is broader than that of industrialization, even if the use of mass means is always required at a certain point in the operation. It did not seem arbitrary to us to join to other cases of mass culture (which are innumerable, to tell the truth) that of the post-conciliar Catholic Church in its effort to integrate each of its members as intimately as possible, while increasing their number as much as possible. However, in this case, the effort of "massification" clearly controls the recourse to the resources of industry, planning, and social organization supported by a strong discipline taking over the movement's direction. When the pope speaks on the radio to address the whole world, religious culture controls, and industry follows and allows itself to be used. The new title allows us to include under a common concept defined by pages 77–81 of the *Quaderni di San Giorgio* the industrialization of works of art and the effort to make the Church itself a mass society by using when necessary modern techniques of massification.

Altogether, these essays are open to ungraceful sociological jargon, whose use, however, is often unavoidable. I know no better definition of mass society than that of Edward Shils.[1] I accept it unreservedly and even gratefully, so rare is it, since Socrates, to see a philosopher careful of defining his concepts and the words that signify them.

Several other lectures also included in volume 29 express similar concerns, notably Ezio Raimondi, "L'industrializzazione della critica letteraria," 141–72; and Umberto Eco, "Valori estetici e cultura di massa," 195–212.

1. See below xiv2.

Introduction

By AESTHETIC EXPERIENCE I understand experience of objects of art, particularly arts of the beautiful, which are the arts whose peculiar function is to produce objects desired for their beauty itself.[1] Artists are the natural producers of objects of this kind, but in our time they have the competition of the manufacturer or at least of certain branches of industry whose peculiar goal is to produce imitations of works of art and in

1. On this concept, see Gilson, *Introduction aux arts du Beau*, 30–53 (*Arts of the Beautiful*, probably 17–34). On the concept of mass culture and by-products, many subjects for reflection are found in the *Daedalus* journal issue titled *Mass Culture and Mass Media*. The problem takes on particular urgency in the United States, because the whole process of industrialization has been taken to an extreme there. This excellent issue of an actual journal remits to the work of a pioneer on the subject, Paul F. Lazarsfeld; see Schram *Communications in Modern Society*. At the heart of these reflections is the question of knowing whether the advent of a mass culture in a mass society, where it is spread by mass media, is good or bad. *Grosso modo*, the answers are divided between these of pessimists, meliorists, and optimists. This is not our issue. We ask whether the mass means employed to spread mass culture do not replace the cultural objects transmitted with others that are specifically different from them. The intrinsic value of this type of culture is not the issue. It may serve its own functions. The issue is simply to find out whether what it spreads is what it claims to spread. Whether we are dealing with jazz or a classical quartet, the work's nature changes according to whether it is played or reproduced on a phonograph. At least this is the question posed in these three studies. For example, it has been said, "When cultural objects, books, or pictures in reproduction, are thrown on the market cheaply and attain huge sales, this does not affect the nature of the goods in question" (Arendt, "Society and Culture," 283). This is partly true, although the size of the edition does not improve a print, a record, or a book. But the transformation of a painting into a reproduction does change its nature. The same author correctly says the same thing about books: "By contrast, the nature of these goods is affected when the objects themselves are changed (re-written, condensed, digested, reduced to *Kitsch*, in the course of their reproduction or adaptation to movies) in order to put them in a form that permits a massive sale that they would not otherwise achieve." The German category of *Kitch* or that of adulteration, may be useful, but a novel adapted to cinema is not a adulterated product; it is a *denatured* product.

selling to make not beauty but money. The object of our reflections will be first the influence that industrial production and the spread of imitations of works of art has exerted upon aesthetic experience. The case of books presents particular characteristics that will be specified in its place. The important point is that the industrialization of aesthetic experiences tends to substitute everywhere the experience of mechanical reproductions and imitations of the work of art for experience of the work of art. This is an old problem, but now the phenomenon reaches such proportions that we feel the need to reflect upon it.

Like all the problems that concern art, this problem involves what we call culture today. Furthermore, since this form of culture consists in multiplying to infinity the objects constituting it, it falls under what nowadays is called *mass culture* in the United States. It clearly relates to *mass production*, or production in bulk of standardized objects manufactured by mechanical procedures that are themselves standardized. Understood in this way, *mass culture* would be a massive culture, or culture in mass, that is to say a production and diffusion of cultural objects that is both massive and directed to a mass society, massively and for the masses.[2] The "culture" goes beyond the field of art but includes it. Our problem is to find out what happens to aesthetic experience when it bears upon objects of massive culture thus defined.

In discussing this problem, we will have to formulate some criticisms about the value of the results achieved, but only when mass culture seems such as to mislead the public on the nature of the object that it multiplies and disseminates. Even when mass culture does not do what it thinks it does or claims to do, it may be that it does something else legitimate and beneficial in its orders. A collection of photographs is not a collection of paintings, but it can be a collection of documents on certain paintings. In this role, it is an irreplaceable means of information about a certain moment of art history. Therefore we will discuss objects of this kind only in the measure in which experience of them is presented as experience of works directly created by artists. Unhappily, it is difficult to denounce certain illusions without seeming to attack or belittle the realities, often excellent in their own orders, upon which they are parasitical. That can only be lamented.

2. Shils, "Mass Society and Its Culture," 288, has proposed a precise definition of mass society: "The new society is a mass society precisely in the sense that the mass of the population has been incorporated *into* the society." Cf. Arendt, "Society and Culture," 278.

The advent of mass culture stems from two principal causes without direct relation to the arts of the beautiful or aesthetic experience. On the one hand, there is the advent of mass society, which imposes mass communications with the corresponding mechanization of means of production and distribution. On the other hand, there is the development of schooling and the expansion of intellectual culture. Schooling presupposes the mechanization of cultural means, and in turn it facilitates that mechanization. The combination of these two factors has the effect that is called cultural explosion. First observable in the Western world of Greco-Latin culture, the phenomenon has progressively reached the whole world. UNESCO's campaign against illiteracy foreshadows an unimaginable growth of the consumption of cultural goods and thereby increase of these goods themselves. From low culture (*lowcult*) to middle and high culture (*midcult* and *highcult*), all the intermediary degrees are possible, but the concept of high culture is connected to that of an élite, without which no culture is possible.[3] From the beginnings of human history there have been creators whose level, whatever it was then, was superior to that of others. The same is true today. Rigorous science, great art, and the humanities are created by a small number of geniuses or talents whose works are understood and appreciated by a variable proportion of felicitously endowed minds. Two centuries ago, this proportion was quite meager. It has continually grown since then, and there is no doubt that it will continue to do so in the measure that the cultural explosion extends its effects. Even if we admit, as the growing difficulty of techniques allows us to fear, that the difference in level of the two groups will be still more pronounced in the future, the participation in culture will become more and more massive. Accordingly massive means are needed to serve the interests of the masses, and for now, they must serve the mass just as it is.

In its highest form, culture is spiritual, but it requires all kinds of material objects to be established, developed, and spread. Paintings and

3. Perhaps it is impossible to apply the concept of *altitude* (or *height*) to different types of culture. All the American attempts to find satisfactory nomenclature collide with the fact, which the authors acknowledge, that they apply aesthetic judgments whose foundation is uncertain by nature, or, in any case, that it is difficult to generalize. Among other terminologies, let us note: high culture, middle culture, low culture; refined culture, mediocre culture, brutal culture; highbrow, middlebrow, lowbrow cultures, etc. Cf. Shils, "Mass Society and its Culture," 291n. Note his observation: "I have reservations about the use of the term 'mass culture,' because it refers simultaneously to the substantive and qualitative properties of the culture, to the social status of its consumers, and to the media by which it is transmitted."

statues, books, musical scores and instruments are so many realities or, as they say, *things*.[4] Insofar as they are means for culture or they express culture, nowadays they receive the name "cultural things." The expression is barbaric but we may have to accept it. Its most serious flaw, however, seems to be unavoidable. It is that these material means or instruments of spiritual culture are not strictly speaking *things* but rather works; they are not products of *nature* but productions of human beings.

We cannot attempt to make this point clear without immediately going to the heart of the matter, because if it is true that human productions are works rather than things, products of machines that human beings have invented to manufacture them become things again. They are produced by machine instead of being produced by nature, but they are things, cultural objects rather than works of art. The mechanical procedures of multiplication, reproduction, and distribution of industrial imitations of works of arts, therefore, have the effect of substituting, in place of works of art made by human beings, objects "of art" or "cultural objects" whose ontological status is analogous to that of natural things. Depending on art in its origin, which is the artist, the object of art differs specifically from art by its efficient cause, which is the machine, and by its end, which is money. The object of art is inconceivable without art. It is inseparably linked to it by its origin, but the aim of these studies is to prevent their confusion. We will underline the traits by which "cultural things" *are not* genuine works of art; their goal is to denounce the degradation with which aesthetic experience is threatened by techniques apparently entirely devoted to serving it.

4. Concerning this concept, which is new in anthropology, see Professor Marvin Harris of Columbia University, *Nature of Cultural Things*. The object of the book is to confer upon "cultural things" an epistemological status "logically equivalent to the status of the entities that constitute the object of research in the physical sciences" (Harris, *Nature of Cultural Things*, 3). We immediately see that what will be the principal source of difficulties. Works of art are the effects of a human behavior (*behavioral actor type*). The point for us is to find out whether the experience of objects whose cause is a *who*, is of the same kind, even insofar as experience, as that of objects whose cause is a *what*. Every attempt to include the two species of experiences in the same genus, that is to say to treat human behaviors as things, is both required to constitute a physics of the human being and exposed to the initial danger of dealing with the purely physical and the human by the same methods. The need to be prudent, however, does not authorizes us to reject in its totality a problematic capable of opening new vistas upon the very complex reality that is aesthetic experience. There is certainly something physical in human behavior.

1

Mass Visual Arts

St. Augustine called one of his early works *De Pulchro et Apto*, which is almost to say *On the Beautiful and the Convenient*. Since the treatise has been lost, we do not know precisely how to translate *aptum*, but the word must have meant something like "the good that is useful with a view to action."

The same problem is posed for us in a different form today and on a much vaster scale. Modern industry permits the practically indefinite multiplication and dissemination at accessible prices of objects which, if made by hand, could be produced only in a small number and consequently have to be sold at higher prices. Nowadays, everyone is familiar with these two types of products: what is made by hand, which in principle is more solid and better finished, scarcer and more expensive; and the product made in series by machine, more widespread, of lower quality but cheaper. Mechanization is linked to industrialization. The latter presupposes that work by machine has replaced work by hand.

The pursuit of the useful and the convenient is at the origin of the invention of machines and mechanization. The desire to provide more easily for practical needs has brought about the birth of industry and guaranteed its development. From it, two consequences related to the beautiful have resulted. The interested pursuit of the useful has turned away from the search for the beautiful a fairly large number of persons who, absent the facilities that the machine offers, would perhaps have cultivated that search. Formerly, they would have brought an album for sketches like Goethe; today, they are content to make photographs. Instead of going to the piano to play Bach, Beethoven, or Schumann more or less well, the modern music-lovers put a record on their phonograph

or CD player and content themselves with hearing some virtuoso play. Moreover, the possibility of mechanically imitating works of arts has led to taking industrial reproductions for works of art, or at least to embellishing and decorating industrial products in the hope of making them kinds of works of art.

Today, we know that there is an error in that. Industrialists do not need philosophers to become convinced that the beauty of a machine does not increase by being loaded with ornamentation. The year when American industrialists loaded their automobiles with statuettes and ornaments in the hope of increasing sales was not a good year for them. An industrial project can be beautiful, but having industrial beauty is peculiar to the products of industry, as natural beauty is to the products of nature. Furthermore, the search for beauty specific to products manufactured by machine is called "industrial aesthetics."[1] This beauty is therefore what corresponds to the machine itself, because its product resembles it. It has been very well said: in industrial aesthetics, "art must never be applied to the machine: on the contrary, it must be involved in its functioning."[2]

Nowadays, there is a tendency to agree that there is a beauty of the useful and the mechanical as such. This beauty is immediately perceived by the eye as the visible sign of a certain conformity of the form to the function, of the means to the end. The kind of beauty that is expected today from machines and their product is therefore naturally allied with a certain soberness and an extreme simplicity. It receives the name of "functional beauty" because the object is all the more beautiful insofar as its form and color are more closely motivated by the function that they fulfill. To take the title of André Hermant's work *Formes utiles*, it is generally admitted today that the more useful a form is, the more beautiful it is. Still, let us add the nuance that a form of this kind can only express the function of the object without really participating in it. In any case, airplanes, cars, ships, locomotives, typewriters, sewing machines, food or coffee grinders—all participate in the American category of the *streamlined*. By that, we understand the elimination of everything that is not required to carry out the function and therefore is an obstacle to it or simply prevents one's perceiving it.

1. In French, the word *industrial* goes back to 1770 (Albert Dauzat in Huisman and Patrix, *Esthétique industrielle*, 10.)

2. Huisman and Patrix, *Esthétique industrielle*, 5.

The boundary between these two kinds of beauty passes through this point. Useful beauty belongs to that whose form stems from its function and expresses it, whatever this function may be. Artistic beauty also arises from the adaptation of the form to its function, but the function is none other than beauty. A work of art does nothing other than be beautiful. If it renders other services incidentally, such as to decorate a wall or cover a hole, that is not *qua* work of art. Certain works, indeed, seek beauty in austerity and simplicity, but nothing forbids them to seek it in exuberance and fantasy. Doric style has its beauty, as Baroque style has its. The incongruous decorations with which a machine is burdened harm its beauty, but there is no incongruous ornamentation—a statue or a painting—in a building, if it is required for the work's beauty. If industrial beauty is composed above all of "useful forms," all practically useless forms are permitted for the beauty of art, provided only that they serve its beauty. The machine lives off utility; art lives off freedom.

These remarks allow us to clarify a confusion that nowadays tends to overrun the visual arts, especially architecture. Under the pretext that industrial architecture, architecture in series, must be first and foremost functional, it is inferred that even as art of the beautiful, architecture must be nothing else. Le Corbusier affirms that "the comfort of a house constitutes its authentic beauty."[3] The expression is understandable in an architect. It is true in the order of utility. An uncomfortable house is a failed house, and many such houses are built, but an uncomfortable house can be beautiful to see because of the visual perfection of its spaces and its lines. It even comes to pass that the architect may have ill-advisedly sacrificed the building's comfort to the search for the kind of visual beauty proper to art. Le Corbusier also says that a house is "a machine to live in" or, we could even say, "a machine to be inhabited." In the cases where this

3. Huisman and Patrix, *Esthétique industrielle*, 18. Le Corbusier's definition conveys what a house is for him, that is to say, the kind of houses he finds it interesting to build. Their beauty is functional by definition. Therefore this concept is completely legitimate within its own limits, but it is specifically distinct from that of the beautiful envisaged by artists when they construct not with a view to the useful or the useful alone but totally or partially with a view to the beautiful. Huisman cites the remarkable phrase of Fénelon: "It is not necessary to admit into a building any part destined to ornamentation alone, but all of the necessary parts must be fashioned to maintain a building, while aiming at beautiful proportions" (Huisman, in Huisman and Patrix, *Esthétique industrielle*, 19). This remarkable anticipation of Le Corbusier is both legitimate in itself and perfectly arbitrary. Someone has a perfect right to admit nothing else but no right to oblige us to it, nor the duty to oblige himself to it. Because we are dealing with the art belonging to arts of the beautiful, the art is free.

holds, the rule of beauty naturally becomes that of industrial beauty, the most complete and the most visible adaptation possible of the means to the end envisaged. But the builder and the architect can have in view ends other than that of simple habitation. Venice and its surrounding region, of all the places in the world, are where this truth most visibly shines before our eyes. In all this land, probably not a single palace or a single villa would be found that their architect essentially conceived as a "machine to live in." These immense edifices are certainly inhabitable; they are even conceived with a view to a princely life like Stra or a pleasant one like Villa di Maser or adapted to the exercise of certain public functions like the Doge's Palace. But in what is essential, their beauty does not stem from the adaptation of their forms to the functions for which they serve. That holds for these residences as for so many churches, which would also be completely usable and often much more usable if they were reduced to just an enclosed place covered by a roof and sheltering an altar. We can conceive of functioning churches and even build them in series with the help of prefabricated elements. There are cases where it is wise to proceed in this fashion. Such churches would be "machines to say mass" or "machines to pray," but they fall under the industry of building more than under the art of architecture. The controversies that trouble our schools of fine arts are understandable; they set in conflict those who principally want beauty and those who principally want utility. All of them are right, but only the first are at home in a school of arts of the beautiful or fine arts. Architecture as an art of the beautiful is visible in Villa di Maser, for example, which essentially does not care only or primarily for the commodities that the house offers. What is beautiful in so many residences is that which, in choice of materials and choice of forms, serves for nothing other than their beauty.

These remarks let us clarify concepts that are continually obscured by being mixed up. Is there industrial art? Certainly, because industry is interested in its products being pleasant to sight rather than ugly or simply indifferent. All beauty is desirable, that of products of industry just as that of works of nature. The history of the typewriter is divided into two main periods: before a certain machine of Italian manufacture, which I refrain from naming in order not to be accused of mixing publicity and aesthetics, and after the appearance of this machine. It is completely certain that there is a visual beauty peculiar to mechanically manufactured products and that this element's importance in industrial production grows unceasingly, but the beauty of a machine or any object manufactured in

series is never its peculiar end. This end has been defined in different ways. Its most famous definition was given by an American industrialist, "to make the cash register ring." It is a bit crude but frank and true. Less crudely, the specialist in industrial beauty Raymond Loewy said basically the same thing by titling his book, well known in France and in America, *La laideur se vend mal.*[4] It is a perfect title, precisely because its object is to sell the book.

Moreover, the example makes us put our finger on the limits of the thesis. An industrial product sells better if it is beautiful. So does a statue, but the statue has nothing else to do but be beautiful, while it is is necessary first for a machine to be good, a house to be solid, and a tool to last a long time. A beautiful automobile sells well, but if it goes back to the garage for repairs too often, that will be known rather quickly, and sales immediately will drop. The cash register rings less and less frequently. Furthermore, and perhaps above all, one would like to be sure that ugliness sells badly. That is certainly not true in the order of the fine arts. In the visual arts of statuary and imagery, for example, the ugly proliferates, and who would dare to maintain that it sells badly? Certain painters amuse themselves by painting or engraving imaginary machines, and they are there only for their beauty, but they do not work and do not manufacture anything. It is a little like Piranesi's *Prisons*, where we see everything but the prisoners. The ends of these two orders of visual production are not opposed, provided that one avoids mixing them.[5] If we mix them up, we

4. In this book, Loewy demonstrates by personal experience that industrial beauty sells better than ugliness. By a curious paradox, the conclusion does not hold so evidently for the beauty of the fine arts. Often, the bad painting sells better than the good one. Ordinary religious art is an illustration of this observation. The industrial production of Madonnas and Sacred Hearts, intolerable in an artist's view, is a remarkable case of financially profitable exploitation of ugliness. It is obvious that in cases of this kind, the art of the beautiful is no longer the issue. Only the subject counts, and the religious feelings it awakens obliterate any other consideration; see ch. 4 below.

5. There is a sophism that taints almost everything that we read on the subject. Nothing can be said about industrial beauty compared to beauty of the fine arts without what one says being understood as an attack. Its defenders then undertake to demonstrate that industrially manufactured objects can be good. They rightly insist on the fact that certain machines are good. From there, they conclude that industrial beauty exists. Louis Longchambon honors Paul Souriau "for having started the struggle against Kant, Durkheim, and so many other philosophers who dogmatically defend the concept of incompatibility between beauty and utility" (Longchambon, "Nécessité d'une esthétique industrielle"). That is not the issue. Nobody denies that the useful has its beauty. It can even be maintained, as it is, that the beauty of the useful consists precisely in the coincidence of the form with the requirements of its function.

will commit the error of believing that it is possible to produce visual beauty industrially. The beauty of the fine arts then becomes a particular case of industrial beauty, so that in the last analysis industrial art comes to include the whole production of the beautiful in all orders.

Every phenomenon of this kind takes place at the point of convergence of distinct and even, in principle, heterogeneous forces. An example will convey this better. The invention of the airplane, which permits displacements whose slowness until then had rendered unfeasible, has favored the multiplication of travel agencies, and in their turn the travel agencies have provoked an astonishing number of religious pilgrimages, which are only a particular species of the genus "organized trip." The only goal that characterizes these agencies is to make money; nonetheless, they propose to the faithful programs for tours next summer of famous sanctuaries, replete with apparitions of the Holy Virgin: Lourdes, Fatima, La Salette, Beaurain, without forgetting Paris and its Chapel of [Our Lady of] the Miraculous Medal. The same mix of financial interest and scientific discoveries with the machines that make them possible and with completely selfless higher feelings is found at the origin of the industrialization of visual arts. To remain in the same order, let us remember objects produced by the invention of electroplating, and by photolithography, photoengraving, halftone, or some other photomechanical procedure. The modern physics of optics and electricity is at work in productions of this kind. There is no relation between all that and religious feeling. However, from it results a proliferation of statuettes that claim to represent Jesus Christ and his Sacred Heart, the Holy Virgins of

The better the useful serves its function, the more beautiful it is. Paul Souriau was right to write: "Beauty is in evident perfection. Everything is perfect in its kind when it is true to its end. Therefore every object true to its end is beautiful" (Souriau, *Beauté rationnelle*, quoted in Longchambon, "Nécessité d'une esthétique industrielle"). Yes, the locomotive whose lines serve well its end, namely speed, is beautiful by that very thing, but its end is not to be beautiful. It is a beautiful machine because it is made for speed, but it is not made for beauty. Accordingly, there is no incompatibility between utility and beauty, but there is incompatibility between wanting a form principally in view of its utility and wanting this same form principally in view of its beauty. Its last end must be one or the other; but that does not signify that an object made to be beautiful could not be useful in addition, nor that an object made to be used could not be beautiful in addition. It can even be so essentially, if its beauty merges with its utility. In this way we return to the fundamental distinction between the beauty of the arts of the useful and the beauty that the arts of the beautiful produce as their peculiar goal.—All that must have been explained, and better explained, in St. Augustine's lost treatise, *De Pulchro et Apto*.

the famous sanctuaries, St. Joseph carrying a lily or, in a more virile way, a carpenter's square. To make these industrial products of uncertain beauty into likenesses of works of art, their manufacturers are often content with "reproducing," as we say, famous statues, paintings, or engravings, but we know where attempts of this kind lead. The industrial reproductions of visual works are to the original like the colored postcard or museum photograph are to works whose souvenir they permit tourists to purchase.

In all cases of this sort, a noble, disinterested motive is necessary to cover the operation. To serve religion is this kind of motive. To serve one's country is another. All that is inoffensive, but we should be skeptical when the industrialization of visual arts claims to be inspired by disinterested motives. It is not industry's nature to be disinterested. The most frequently invoked motive in our times is the duty to democratize the joys of art by providing the means of aesthetic experience for everyone. The intention is good, if this is possible. Unhappily, being unique is of the essence of genuine art. One does not find even two runs of the same engraved plate that are strictly identical. Therefore the lover of prints searches for "the beautiful proof." Experience allows us to fear that, under the pretext of democratically placing works of art within the reach of all, the industrial multiplication substitutes more or less perfect mechanical imitations for works of art, imitations that, whatever their quality, *are not* works of art. When an engineer undertakes to make possible the enjoyment of the beauty of art to the greatest number, he does not simply run into practical difficulties due to the undertaking's cost price but to an authentic impossibility linked to the very nature of art. To succeed in this democratization of fine arts and aesthetic experience, it would be necessary to multiply objects whose essence is to be unique. There is a contradiction in wanting what can exist only in a single instance to be within reach of everyone.

Irreducible differences distinguish the artist's work from its industrial reproduction. The distinction starts from the level of utilitarian production. Then, it takes the form of the distinction between the artisanal and what is manufactured in series. The artisan's work involves preparing each object separately, individually, and in the last analysis, in producing each particular useful object as if it were a work of art. Artisanal work is distinguished from the other kind by what is individual in its making and in its finished product. Thus the artisan's work bears the mark of the worker. From that come certain irregularities due to the work's very singularity. In order to mechanize the production, by contrast, it is enough

to establish a prototype and to entrust its multiplication to a machine specially constructed for this purpose. In principle, a considerable number of objects is then obtained with an almost perfect regularity of form. Their differences are accidental. They come from mechanical chance and not, as in artisan production, from the intrusion of freedom in the mechanism of production. Also, for as long as we remain in the order of the useful, change is without much importance, its advantages even sometimes balancing the disadvantage, but the problem's nature changes when we pass from industrialization of the useful to that of the beautiful.

Then, we have a change of kind. Thousands of houses or shelters can be prefabricated; a model of knife, fork, or chair can be multiplied by thousands without the product losing its utility. If the model is good, it will never be multiplied too much. It is not certain that the same reasoning holds for beauty. A manufactured object does not change its nature by being multiplied by the thousands; as long as the machine holds up, the product remains good. But while the useful object manufactured in series loses nothing of its utility, the work of art produced by an artist who has chosen its materials, created its form, and provided for the execution in its slightest details, changes nature by becoming the work of a machine that employs different materials and is unconscious of what it makes. Certainly, it has been constructed and arranged to manufacture this statuette or that painting. At least that is what is said, but really only a facsimile is produced, an image or an imitation of the work of art in question.[6] The thousandth fork is a genuine fork, the first "reproduction" of the statue, is already no longer a statue; the first mechanical "reproduction" of the painting is already no longer a painting. There would have been no drawback in multiplying artificial imitations of masterpieces;

6. I find exactly the same sentiments expressed in the expert judgment of James Johnson Sweeney, "Artist and Museum," 355–56. Notably, what both long-playing records and color reproductions basically provide is information about the works of art in question, not an immediate experience of either the music as played or the actual painting. In painting and sculpture, the danger lies in the confusion that can so readily develop between information about a work of art and the experience and immediate sensuous contact that the work of art provides. After having noted the essential difference introduced among the works by the difference of materials used in the work itself and in its reproduction, the author continues: "What seems to be unthinkable is that a time will ever come when a 'reproduction,' made up of materials completely different from those which enter the texture of a painting will affect our eyes in the same way as a painting" (Sweeney, "Artist and Museum," 356). Cf. Gilson, *Painting and Reality* (1957), 72. The word *information* felicitously condenses and fixes the truth of all the reflections in this order.

those who devote themselves to this profitable industry did not often pretend to place at the public's disposition objects of the same nature as the original. The so-called democratization of visual beauty is most often an interested duplicity. The public asks only to let itself be misled. Provided that it recognizes the original in seeing the copy, it thinks it possesses the same work. Besides, this is what industrialists suggest they believe, because their interest is that it should be believed. That belief is possible because of the existence of a scientific invention nowadays pushed to the highest point of industrialization, the printing press.

The combination of photographic reproduction and the book industry, which we find always connected to teaching, dominates the entirety of our problem. Statues and paintings cannot be printed, but images of statues and paintings easily can, as can those of medals, jewels, and generally speaking, all the objects of the visual arts. If we lose sight of the specific difference between a work of art and its image, we can easily make others believe that it is possible to make one or several volumes hold the greater part of the masterpieces of universal art. The book then becomes a museum; all paintings are at hand, all statues are before our eyes, and even cathedrals are there. It goes without saying that this is a swindle. Books of art contain different numbers of photographic illustrations, and they may be excellent, but unless a book of art contains original engravings, it does not contain any work of art. This is what radically distinguishes it from a museum, which, by contrast, contains only works of art. The book of art has its utility, and we can often find pleasure in leafing through it. It lets us see thousands of images of art that we have never seen, that we will probably never see; the image can inspire in us the desire to see the originals. It is an incomparable source of information. Also, it is completely harmless as long as it does not claim to substitute the experience of mere imitations for the experience of works of the visual arts themselves.

It certainly might be thought that nobody could be mistaken in this or seek to mislead others. But the facts are there. We have extensive experience. First, the work of art: museums are full of them, and their number grows unceasingly. A scientific invention gives us photography. A powerful industry seeks a market to move its products: the book industry. To sell printed and therefore unreal museums, it is enough to make people believe that they are real. The industrial exploitation of visual art will maintain to its public that to possess the image is to possess the work, because it is easier to see it in a book than in reality.

Among the numerous examples of this kind of undertaking that could be cited, I pick only one. I choose it because the great authority of the institutions to which it appeals lets us see the ultimate force at work, which is always combined with others in such cases. It is the pride of serving an ideal, which here is the universal dissemination of works of great art or the aesthetic experience of visual arts placed within the reach of all. To achieve this goal, there is a collection titled *Museums without Walls* that promises to make available *the complete library of world art* to its subscribers in 150 volumes adorned with more than nineteen thousand "reproductions." One can only admire the infallible sense of the truth that here permits an effective publicity to be based on the affirmation of its opposite. In other times, we are told, only kings or princes could presume to possess such works, but today, "thanks to photography, to modern techniques of reproduction, and to the learning of art historians, more people than ever have the means of possessing art collections and *to live with art*. They can do so with the help of books. These books, which André Malraux calls 'museums without walls,' make it possible for you, *for you*, to surround yourself with the art of the centuries, and to do so on a more universal scale at the same time and more intimate than the noisy rooms and the galleries of a royal sovereign, yes, and all that for the price of a book."[7]

All this publicity rests on the sophism that the images of works of art are objects of the same species as the works whose image they are. There is no truth in that. The least statuette fashioned by a child is sculpture. The most beautiful photograph or photoengraving of a Greek marble is not. A crude sketch is painting. The photograph of the most beautiful portrait is not. This substitution of object has the consequence of creating an aesthetic pseudo-experience whose easiness is such that it replaces the true experience. Images of more masterpieces can be seen in a short time by leafing through a book than would be seen in the course of a long trip. The images are seen more conveniently and sometimes better than the objects themselves would be seen, as statues perched on the top of a building, practically invisible paintings in a dark chapel, or the ceilings of the Sistine Chapel are visible only at the cost of uncomfortable physical efforts or complicated devices. The nature of the image is the triumph of information, and it is irreplaceable there, but it is not the object about

7. "Museums without Walls," published as a publicity piece. It is an interesting example of the manner in which a literary metaphor can be used for purposes of publicity without its author doing so at all.

which it informs. The printing of the image on a flat sheet of paper reproduces almost none of the perceptible qualities that are the very substance of the visible work. The dimension is not the same. *The Wedding at Cana* is made to fit on a page of a book. The background is not the same because one cuts, clips, and thereby modifies in a hundred ways the perspective of the painting. An accurate idea of it cannot be formed with the help of however many reproductions there may be.[8] Certainly the image of an engraving in black and white is much less unfaithful to the original than that of a painting or a statue,[9] but a successful *trompe l'oeil* is nonetheless a deception. It accustoms the eye to satisfy itself with images instead of realities. It is not unusual that the acquired habit of admiring a reproduction ends by causing disappointment the first time one sees the original.[10] The art book that so often stimulates the desire to see certain

8. "Unhappily, publishers tend to resort to a great deal of trimming and sizing of reproductions in both cheap and expensive volumes. The *Mona Lisa*, owing to trimming (even in Franco Russoli's Viking Compass *Renaissance Painting*) seems to be moving constantly back and forth as one views her in a succession of books. Some of us have not had the opportunity to find out for ourselves exactly where she is in the picture space, even if we probably cannot solve the riddle of her smile" (Crossgrove, "Art for Publishing's Sake," 8).

9. We would be dealing with an extreme but possible case there. In a remarkable article, with whose inspiration I have deep sympathy, the American architect James Marston Fitch affirmed as evident, "The industrial duplicate or facsimile cannot under any circumstances be the qualitative equal of its prototype, no matter how socially useful it may be" (Fitch, "Forms of Plenty," 8). One of the readers protested against the phrase "under any circumstances" and reported the following fact: "More than twenty years ago I worked on a folio of reproductions duplicating crayon and pencil drawings on the same paper as the original, and the original had to be identified on the back because no one, including the artist, could tell it from the copies" (Seldes, *Columbia Forum*, 44.) The story is completely possible. One only asks, if the identity was so perfect, what interest could there still be in marking the original? Ten reproductions indiscernible from the original are ten originals from the point of view of aesthetic experience. The copies have absorbed the original.

10. There will be an opportunity to consider separately the role played by photography on glass and the luminous projections that it permits. The series of slides on films, which have replaced glass, put at the public's disposition countless photographs of monuments, frescoes, paintings, drawings, and all kinds of artistic objects, without which no teacher of art history or of aesthetics would dare to address a class. One asks how Hippolyte Taine could give his courses on philosophy of art without disposing of these aids. None who have heard the lectures of the admirable Henri Focillon imagine them without the luminous projects that he himself hardly saw but upon which he nevertheless commented magisterially. Projection poses a curious aesthetic problem. It substitutes light for pigments as the matter of paintings. The effect is fantastic to such a point that those who know certain masterpieces only by luminous projection are

works cannot dispense us from seeing them, in any case. There is no real aesthetic experience by means of representation of works alone. To believe the contrary is an error that is fatal for this very experience.

We cannot pursue this path without passing from the terrain of aesthetic experience to that of literary experience. All the industrializations are allied and reenforce each other. By means of the book and its colossal diffusion in our time, the trade in images of art reaches the economic level of big business.[11] Art itself will never do that. There are always some artists made wealthy by their art, but their creative activity has never been that of a merchant or an industrialist. Alongside the artist, the art dealer is necessary, who often sells what he does not produce better than the one who produces it. We only note here the curious collaboration that takes place nowadays, thanks to the replacement of the work by the image, between visual arts and the book industry. We have come to speak of art *with a view to edition*, which is almost the limit of its possible industrialization. What becomes of aesthetic experience in all that? It learns to read visual works and forgets how to *look* at them.[12]

I have spoken until now about the industrial multiplication of objects of aesthetic experience. Now I would like to say something about

disillusioned the first time they see the original. I remember having attended a lecture in Canada followed by luminous projections, immediately preceding the visit to an exposition of masterpieces of Dutch paintings. All the canvases seemed dull and gray. One of them that we had particularly admired on the screen was so diminished in tone that we could not recognize it. There clearly had been substitution of object. All that we want to retain from this observation is the specificity of their difference.

11. "Art and big business, traditional archenemies, are becoming friendlier every passing day. Indeed if current trends continue, art will *be* big business. The artist, not so long ago, the lowest paid and the least respected member of society, the creator of things unnecessary, is slowly gaining status. In his role of commercial artist and industrial designer, he helps make a big business possible. In his role of fine artist, as painter, sculptor, printmaker, he creates what an affluent society is willing to invest in" (Crossgrove, "Art for Publishing's Sake," 3). The same author dates in 1962 the entrance of the so-called paperback into the area of interest for big business. It had been published for some twenty years. But it is only from 1962 that industry and finance have taken interest in it as a source of possible large profits. A habitual process can be expected: huge investments at the beginning, ferocious competition, saturation of the market, concentration in the hands of surviving publishers.

12. "Yet all these new inexpensive art books are mixed blessings, for art books in particular are only introductions of one degree or another and we still depend upon meeting the originals before there can be any real communication. Ideas can certainly be circulated without books or libraries, though with great difficulty. Art cannot be seen or felt in reproduction, but reproduction can stimulate the desire to see" (Crossgrove, "Art for Publishing's Sake," 9).

the industrial multiplication of *subjects* of this experience and, along with that, about this experience itself. The experience can happen in two ways, either by bringing the object of art to the spectators or by leading the greatest possible number of spectators, by different means, to the work of art. This time the point is not to replace the work by its image but rather to place the work itself before the spectators' eyes. In the first case, the visual beauty is delivered to someone's home. Since the spectator cannot go to the work, the work will henceforth go to the spectator.

At first sight, there can be nothing objectionable. To be seen by one, a thousand, or a million spectators changes nothing in the nature of the work. On this point, I will limit myself to express some reservations, rather as questions than as assertions. As always, when the issue is aesthetic experience, the experience precedes the judgment. The experience is what conditions the judgment rather than the judgment justifying the experience. The *Mona Lisa* went to New York and Washington. Michelangelo's *Pietà* went to the international exposition in New York. The *Venus de Milo* left its pedestal at the Louvre to present itself in Japan. This is a way of multiplying aesthetic experience. What must one think of it, or rather, what do we think of it?

As for myself, the first reaction that I would mention is that visual works are not made to be seen in this way. Their peculiar function is to beautify. Today, they have been changed into attractions, into objects that by reason of their fame have the power of drawing crowds. The international expositions or "fairs" of all kinds are financial, industrial, and even political undertakings whose peculiar end, under whatever heading they are embellished, is really to augment a nation or city's prestige, and ultimately, since everything ends this way, to make money. The principal quality of an attraction is what it is worth in box office terms. Animal or human monsters, authentic or not, play this role in popular fairs. We also speak of "sacred monsters" to designate the *vedettes* of the theater and movie stars, about whom everyone is aware that they are also industrial products in their fashion. It could also be said by analogy that with the new method of making masterpieces travel, the "cultural monsters" have just been transformed into attractions. The thought of irreparable risks incurred by the *Mona Lisa*, *Venus de Milo*, or *Pietà* of St. Peter's in Rome does not concern philosophical reflection. The question of finding out to whom these works belong likewise escapes the philosopher. But to discover what influence these travels of masterpieces exert upon aesthetic experience is a question that haunts the imagination.

Once again, a considerable quantitative growth is produced, but is what is multiplied still aesthetic experience? On the part of the spectators, works offered thus to the admiration of crowds are less works of art than objects of curiosity. From the opposite perspective, it can be doubted that the object is the same in a pavilion of an international exposition, a commercial fair whose authentic god is money, as it is in St. Peter's in Rome, where the *Pietà* is truly at home, carrying out its specifically religious function as an object of sacred art in a place of cult. But the organizers of the event have not counted on that kind of feeling to attract the public: "This will be the first time Michelangelo's *Pietà* has left St. Peter's since the sculptor placed it there himself. It will also be the first time that a Michelangelo marble will have been seen in the United States." In other words, this is *a world premiere*.[13]

Such remarks naturally leave the organizers of these exhibitions indifferent. Moreover, it must be acknowledged that if one of the exhibitions decides a single vocation of sculptor or painter, which is possible, it is very difficult to condemn the organizers. But it is impossible to approve those responsible for deplorable presentations where the setting, the proportions, the lights, and the colors are all false. The superiority as publicity of the artificial over the real is affirmed here without false shame. We are simply assured that the *Pietà* is viewed better in the New York exposition than at St. Peter's in Rome: "The chapel [at St. Peter's] provides a simple setting for the *Pietà*. The light is just bright enough to suggest that the creamy marble is neither flesh nor stone. The setting at the World's Fair will be more dramatic. An immense cross will tower

13. See the picturesque article in a 1964 *Saturday Evening Post* on this event. [Gilson appears to have placed in quotation marks his summary from the article. The actual quote is: "The masterpiece will be making its first trip outside the walls of St. Peter's Basilica since it was completed seven years after the discovery of America. It will arrive in New York almost exactly 400 years after the death of Michelangelo, and it probably will be seen by almost as many people as lived in the whole of Europe in his lifetime" (McCarry, "*Pietà*," 25).] The photograph in colors that adorns the cover of this issue presents the face of the Virgin in a pleasant green jade on a light blue background. The same article notes that the decision to move the masterpiece has provoked criticism. The risk of losing the work is the dominant note, but those responsible note that an insurance policy of five million dollars has been taken out: "Should the priceless work be lost, a sum would be available to carry on the work of the church that made possible the art of men like Michelangelo" (McCarry, "*Pietà*," 28). This abundance of sophisms defies analysis.—Incidentally, the Mar. 27, 1964, *Toronto Globe and Mail* published the image of the *Venus de Milo* safely arrived at Tokyo. A note informed the reader, "The statue was slightly damaged on the long trip." One would like to think that she will be none the worse for it, once repaired.

behind the *Pietà*, which will be illuminated by a circle of lights above and lamps at either side. . . . Fairgoers will see the *Pietà* better than they could have seen it at St. Peter's, for in New York it will be displayed as Michelangelo intended—mounted on an inclined plane on a low pedestal. The *Pietà*'s pedestal in St. Peter's, though recently lowered, is still 12 feet tall, and the face of the Christ is only partly visible. Fairgoers will, however, be obliged to view the *Pietà* through a sheet of bulletproof glass."[14]

This astonishing presentation that has succeeded in the apparently impossible undertaking of shrinking the masterpiece, let us call it "this staging," is the work of a well-known theatrical director. It has allowed good viewing, although no one was authorized to stand less than sixteen feet away. It would naturally be necessary to keep moving at times when there were large crowds, but "a special area is provided for those who wish to stand for a time and gaze at the sculpture instead of passing by."[15] Those whom the sadness of these details leaves indifferent will never be convinced of how lamentable certain changes are that have arisen in the modern table of aesthetic values.

I will comment briefly about the second method of multiplying aesthetic experience, which consists of mobilizing possible spectators massively. There exists a colossal industry of artistic cities, festivals, and different artistic manifestations to arouse the imaginations of millions of possible visitors. Picking them up at home, transporting them, giving them lodging, and making them enter museums is a formidable mass undertaking. The museums themselves, which one would believe were protected against this sort of temptation because, in principle, they spend more money for art than they gain from it, begin to present troubling symptoms. When the Metropolitan Museum of New York bought *Aristotle Contemplating a Bust of Homer*, it naturally was aware that the work had cost $2,300,000. Was it too expensive? Beauty is not translated into dollars, but we will never know how many visitors will go to the museum to see a Rembrandt and how many to see a painting worth $2,300,000. It is possible that the museum directors' calculation is justified entirely by the outcome, because their peculiar role in this regard is to attract the greatest possible number of visitors. After the acquisition of this masterpiece,

14. McCarry, "*Pietà*," 27–28.
15. McCarry, "*Pietà*," 28.

the attendance at the New York Museum grew by 40.7 percent, we are assured. The simple mention of the problem here causes vertigo.[16]

I have not seen this painting worth more than $2,000,000, but I am haunted by a photograph that represents it, hung alone on an empty wall, among green plants and flowers, like an idol or a catafalque.[17] Before it, there are several rows of visitors contemplating the backs of those who are closer to the cultural monster, to this masterpiece of art of painting changed into attraction at a fair, but everyone—men, women, and little children carried by their mothers—is kept at a distance by a barrier that puts the phenomenon outside their reach. What is scandalous in that? Nothing. The New York Metropolitan is one of the most beautiful and best museums in the world. It has fulfilled its peculiar role by offering a refuge to a masterpiece of such monetary value that no private owner is rich enough to have it. It is not its fault that the conditions constructed for aesthetic experience in the modern world inevitably have the effect of falsifying the data. Protests and regrets are equally vain. The philosopher can only observe the fact and try to interpret it.

16. In New York, the number of visitors to the Metropolitan Museum increased by 200 percent from 1950 to 1962 (around five million visitors per year). For the country as a whole, the number is some sixty million. The public contributes the greater part of the three hundred million dollars needed to maintain these institutions. Cf. Stanton, *Mass Media*, first given as a lecture by the president of CBS at Dartmouth College, Nov. 26, 1962, n17–20. At the other end of the scale, let us mention the "artmobiles," traveling museums of art transported by trucks, pitching their tents in public places and carrying art books, reproductions, postcards, negatives, and so forth. The speculative reservations that a philosopher believes ought to be formulated about the nature of these experiences does not authorize their total rejection as sterile. Above all, those reservations do not blind him to the sincere love for art that inspires them. As Stanton rightly says, "I don't think that looking at reproduction in the pages of a book or magazine can ever equal looking at an original painting. There are too many matters of texture and scale involved. But it can open up new awareness." Who would dare to deny it? But it is necessary to add that what the reproduction conveys about the painting is that it is necessarily imagery. A "new awareness" can be that of a "misunderstanding."

17. A photograph of this staging is found in Stanton, *Mass Media*. Further on, I will recur to this valuable document several times.

2

Mass Music

I WOULD LIKE TO recall first that the elliptical expression "industrialization of music" simply means "industrialization of musical experience." During the last half century in Europe, the number of societies of symphonic concerts has considerably increased. In the United States, where the size of social phenomena makes them easily observable, the growth of traditional musical production and consumption, as well as that of opera houses and of concerts, is quite remarkable. Musical life has not suffered from its industrialization. Some even judge that it has gained. The same can be said of the number of amateurs who learn to play an instrument and play it for pleasure. The statistics are not detailed enough for us to know how many of these musicians go to music for the love of jazz or the joy of playing Bach and other great masters, but the growth of the production and diffusion of musical instruments in America at least proves that the mechanization of music has not hurt it. Quite the contrary, music has never shown such vitality.

The problem of aesthetic experience of musical works, that is to say of the conditions in which music is perceived today, is posed in different terms. Two events have perceptibly modified the conditions of this experience in the course of the last hundred years. The first was the unexpected development of a device invented in 1877 by Thomas Edison (1847–1931), the phonograph. The second is the invention and generalization of the wireless telegraph, work of the physicist Édouard Branly (1844–1940) and the engineer Guglielmo Marconi (1874–1937). I do not count separately the pairing of these two inventions, because their

meeting was inevitable, but it directly concerns our problem. Perhaps it is even the most important datum.

Neither of these two occurrences was originally related to music. Edison simply wanted to find out if it was possible to register sounds and then to reproduce them. He naturally started with the human voice and began with his own voice. The first time that he heard two very simple words come out of his machine, he was frightened. Indeed, the power of recording and conserving human speech is a very important event in the history of human civilization. We have hardly begun to reckon with it and to gather for the future the soundtrack of certain voices that ought to be saved from oblivion. However that may be, the possibilities of the soundtrack go beyond the realm of music in all directions. Whether we are dealing with a conversation, a speech, a lecture, a letter, a defeat in battle, the failure of a nuclear explosion, the rumbling of an earthquake, or the noises made by certain natural phenomena and certain political or social phenomena, the phonograph does excellently what it is made for. The device invented by Edison and perfected by his successors has the primary function of recording, conserving, and communicating all kinds of audible information. The information is dependent on the order of knowledge, and there is no knowledge that cannot be communicated by speech or by some apparatus capable of recording and reproducing speech. Unless the point is precisely to conserve the pitch of a voice, it matters rather little that the quality of the sound may be altered, provided that the sense of the message is not. In itself, phonographic recording has no essential relation to aesthetic problems of the beautiful. The objective knowledge of the true is the only thing at issue.

Let it be understood that in what follows, there is no reservation intended about the capacity of talking machines to preserve, communicate, and spread information. The issue is only that music is included in that realm insofar as it can also be recorded, preserved, and spread by this means. The field of possible musical information is quite vast, as we see now in the pedagogical, historical, and instructional turn that radio broadcasts take in some countries. The announcer does not fail to say by what orchestra, by what singers, and under the direction of which conductor the work has been recorded. He recalls the composer's name, the work's title, date, and approximate place in the artist's opus, or even in the general history of music. Speaking about the recorded music is something easy, and many do it very well, but this is information about information.

The nature of this information, however, poses problems. Today, it has become possible to give the music its turn and make the work about which we are speaking be heard. In a lecture on history of music, words mark the beat. When listening to preserved music, music dominates. The very substance of the musical work is at issue then. The information is no longer simply about music but is musical. We are not, however, getting away from information, but this information creates a new situation, as if instead of preserving and producing the text of a speech by Demosthenes or Cicero by printing press, we could make their voices and their very speeches be heard. Professors of the history of music or of musical aesthetics know this. They are no longer reduced to talking to students about the beginnings of polyphonic music. They can make a Pérotin mass be heard. The remarkable German collection of musical recordings made by Archiv is very well named. The disks of which they consist give in a condensed form the principal historical information on each work, in addition to not the musical work itself but the lasting trace of what remains of it, after the real music has provisionally ceased to exist.

Since aesthetic experience has as its object sensorial qualities, it is important to know whether the experience of a musical recording is equivalent to the direct experience of the work itself, and not just to know whether it is also perfect but whether, perfect or not, it is of the same nature. That can be doubted. The only known means of producing music are the human voice and the musical instruments that the person, whom we label musician, plays. The phonograph and the radio microphone are neither singers nor instrumentalists nor musical instruments. Someone who controls the execution of recorded music plays the disk and the microphone; he does not play music. Despite the complaisance with which we are informed of their names, these subordinate agents are not musicians. Under reserve of some specifications that will be offered on the subject of emission by radio, the history of these devices that have so profoundly modified the conditions of aesthetic experience do not concern either a little or a great deal the history of the musical art. We can still write a complete history of music without mentioning the phonograph. This apparatus only concerns music already made. It does not make it.

To reproduce music has the effect of transforming it. The phonograph is essentially composed of a disk in motion, of a needle and a diaphragm connected to a loudspeaker. The tones of the music recorded on the disk are conserved there with a fidelity that, save exceptions, makes them recognizable without possible errors, but all these tones are

rendered through that of a vibrating membrane that modifies all of them. Moreover, it modifies them in different ways according to its individuating particularities. The matter and form of the needles themselves play a considerable role and perceptibly alter the quality of sounds. The always perceptible difference between the voice of a human being and its phonographic reproduction can symbolize the phenomenon. What comes out of the machines is the image of music; it is not the reality. Nobody despises these images; it would be contrary to evidence to deny that they can be objects of aesthetic experience. Nowadays, even a well-informed, experienced, and long-time music fanatic knows many works and still more interpretations of those works only by a recording. The pleasure these recordings give can be great, but it is to music what the pleasure of seeing a photograph of a painting is to seeing the painting. It is not simply a weakened image; it is another object.

The advances the phonograph has made since its invention are indisputable, and it will make more yet. The invention of the microgroove (around 1947) and that of the stereophonic disk (around 1957) are the last stages of this evolution as of this writing. The history of the advances in manufacture of these devices falls under that of applied sciences. It is completely in diagrams, processes, and creations or failures of factories, without relation to musical art. Every study of the record industry, particularly that of its production, insists on what is called the effect of distortion. The causes of distortion are many,[1] and there is an effort to remedy them. There is no possible comparison between what are called "old recordings" and those made today, but the latter are still no more than transpositions of musical sounds by machines that conserve only that which is in their nature to conserve.

That regards the modification that the music itself undergoes at the source. But what happens to it as an object of aesthetic experience because of the fact that it can be mechanically recorded and industrially disseminated?

The most visible consequence is the unforeseen, unbelievable multiplication of objects of this aesthetic experience and of the experience itself. The possibility of recording music has from the first modified the ontological status of musical experience. Until the phonograph and the recent development of the record industry, works of music existed between two performances only in the form of written signs that symbolized them.

1. A simple but precise exposition is found in Gilotaux, *Industrie du disque*, esp. 51–63.

Incidentally, the same holds for poetry, which loses all actual existence between readings. But it is easy to return poetry to life since any person who knows how to read can resuscitate poetry at will, provided only that the book is there. The case of music is different, because its performance is what has to be resurrected. Few music lovers can read a musical score for orchestra or even piano; a still smaller number can hear the sonorous image by reading the score. Someone who reads poetry has the complete experience of the poem, where spirit speaks to spirit. Someone who reads music can imagine it more or less distinctly, but since spirit speaks to spirit only by the sense of hearing, its readers do not hear it really, and the experience they have of it is imperfect.

Thanks to the phonograph, the situation is no longer entirely the same. Anyone at all at present can make the existence actual, if not of music, at least of its sense image. For that, it is enough to place the record on the turntable, turn on the machine, and listen. It is good to listen to a recording of *Pelléas* while having the orchestra's score before one's eyes, but if it is necessary to do without one or the other, the better thing is to keep the record. We are closer to the music with its real acoustic image than with its symbolic musical notation alone. Therefore, the phonograph confers on music a permanent possibility and continues its actual existence, imperfect but real, which it does not have by nature. There exist art galleries for paintings. There do not exist music galleries because, unlike paintings, different pieces of music are not possible together. As Leibniz would say, they mutually go against each other. But there are discotheques for musical recordings as there are libraries for books, precisely because the records are not music. Consequently, music exists at present in a completely new form, in the sense that its recorded image has become a permanent means of possible acoustic experience. Someone goes to look for *Parsifal* on the shelf of the record player as one can take up *The Tempest* at any time on the shelf of a library. We owe this to Thomas Edison.

A second consequence of the invention of the phonograph is a considerable expansion of the possibilities of aesthetic experience. This is a natural consequence since, as we have said, the peculiar realm of phonographic reproduction is information. Nothing can be compared with recording as a means of musical information. After the creation of collections like Archiv's, musical erudition of average music lovers rapidly exceeded what they could acquire in many years just by attending concerts. There are even rarely executed works that they would probably

never hear. It is impossible to know the number of works currently re-corded and of disks—excellent, mediocre, or bad—currently on sale in the world.[2] However, we can foresee a time when the majority of musical works that have been handed down to us will be recorded on disks or tapes and kept in discotheques provided with listening rooms where any-one can listen to them at his or her convenience. There will be complete editions, unexpurgated editions, as they say, of Monteverdi and Vivaldi, Couperin and Debussy, of Bach, Mozart, and Beethoven, as there are complete works of the great writers of every country.

Like the phonograph, radio broadcast was not created with music in mind. Initially, it was a simple laboratory experiment for Édouard Branly. The radio coherer permitted the transmission over distances of waves whose length were adjustable at will. In the mind of its inventers, the radio broadcast was initially exactly what its original name says, a "wire-less telegraph." Henceforth, it was possible to dispense with expensive lines and almost instantaneously spread important news from one point of the globe to another. It was soon understood that music was made for the new discovery and vice versa. The alliance between phonograph and microphone imposed itself. Since all music can be recorded, all music must be capable of being broadcast on the radio. This confluence of two inventions is where we are today, and it is obvious that for bad or for good, the conditions for the exercise of musical experience have been profoundly transformed.

The most obvious consequence of this is an inflation of musical ex-perience that is not only considerable but enormous and, in some coun-tries, almost insane. At the point when these lines are written,[3] in France, a station called France Musique broadcasts musical works from 7 a.m. till midnight.[4] How much can be offered to listeners, when it is necessary to

2. I am not aware of a catalogue of all the records produced in the whole world. In 1960, the number of records produced reached 136 million in the United States, 68 million in England, 56 million in Germany, 30 million in France; hence for these countries alone and in just that year, 290 million records. Of this number, so-called classical or serious music makes up around 40 percent, popular music around 60 per-cent. I take these figures from Gilotaux, *Industrie du disque*, 108–10.

3. The lecture delivered at San Giorgio, Venice, was written in 1964. In Gilson, "Industrialisation des arts," 129n1, there is a summary of the programs of France Mu-sique for Sun., Jan. 19, 1964.—On the problem in the United States, see Cazeneuve, *Sociologie de la radio-télévision*, 63; for Belgium, see p. 89.

4. Here is, with brief commentaries regarding the problems that it poses for its organizers, France-Musique's program for Sat., Sept. 24, 1966: 7 a.m. *Dances and*

occupy microphones 17 hours each day for 365 days a year! That makes more than 6,000 hours of music per year. In the face of such a problem, we no longer think about criticizing what is being done, because it is obviously unsolvable.

This, however, is only a part of the data, because while France Musique does only music, another station named France Culture also does music. Its output is considerable. For just Monday, January 20, 1964, I note twelve musical emissions on this station, *which is not limited to music.*[5] On the same day, France Musique's listing is such an avalanche of symphonies, lyrical music, and chamber music that it is very difficult to group. The most slender thread is enough to hold them together. When

Diversions (Rimsky-Korsakov, Vivaldi, Mozart); 8:15 a.m. *The Yves Nat Cycle* (a pianist is selected and some of his recordings are broadcast, here Franck and Schumann); 9 a.m. *Notes Traveling in France This Summer* (I note the rather odd presence under this heading of Saint-Saëns, *Piano Concerto Number 2*, played by Philippe Entremont and the Philadelphia Orchestra directed by Eugene Ormandy); 10 a.m. *For the Lover of Stereophony* (jumble emission; choice of records); 11:30 a.m. *Stereo to the Four Winds* (same comment); 12 p.m. *Music for Your Images* (Dvorjak, Turina); 1 p.m. *In the Shadow of the Royal Gardens* (Rameau, Couperin, Dandrieu, Montorin); 1:30 p.m. *Overtures and Preludes* (another jumble emission: Berlioz, Mendelssohn, Adam, Weber, A. Thomas, Bizet); 2:30 p.m. *The Guitar and Its Virtuosos* (an indestructible program that has been broadcast for more than a year, imposed on the public by a radio baron, about the guitar but without a guitar player); 3 p.m. *Notes on Travels, in Europe This Summer* (the violinist D. Oistrakh at Stressa, the pianist Géza Anda at Montreux, but simple records replace what could be transmission of these concerts); 4 p.m. *Service aux champs* (recordings requested by listeners); 5 p.m. *Rejoinders* (new jumble broadcast: records of Mozart and Beethoven); 6:30 p.m. Paul Arma, *Polydiaphony*; 7 p.m. *Jazz If You Please* (a sinister daily broadcast of a music completely out of its natural setting, jazz that we do not see); 8 p.m. *Dinner Concert*; 8:30 p.m. *France-Musique Debate Concert* (Campra: a southern tradition at Versailles); 10 p. m. *Musicians at Rome* (Scarlatti, Rossini-Respighi, and Debussy, *La Damoiselle élue* [his submission from the School of Rome]); 11 p.m. *Night Music.*—This musical tidal wave is added to the program of France-Culture reported in the following note.—Indeed, music is part of culture. The distinction between music of culture and music of music completely escapes me. Above all, we must not forget that behind each emission, there is a man or woman who defends his or her salary aggressively. Someone who wants to touch any segment is immediately accused of putting guitar or jazz, and therefore the pillars of musical culture of our time, in danger.

5. Things have hardly changed afterwards. For Sat., Sept. 24, 1966, France-Culture offered: at 7:15 a.m. *A Symphonic Prelude*; at 8:30 a.m. *Classical Music*; at 9:15 a.m. *Introduction to Musical Languages of the Twentieth Century* (eleventh session of this cycle); 12:16 p.m. *Works of Beethoven*; 12:42 p.m. *Orchestra of Nice*; 1:40 p.m. *Music News*; 4 p.m. *Concert of French Music*; 5:34 p.m. *Works by Rimsky-Korsakov*; 8 p.m. *Chamber Orchestra of the ORTF*; 11:43 p.m. *Eine kleine Nachtmusik* by Mozart (one of the works most repeated over French airways).

its own resources are exhausted, the broadcaster appeals to the listeners and invites them to call in by phone the names of records they want to hear.[6] Finally, it recurs to the ultimate recourse: an hour is devoted to allow listeners to hear in advance important fragments of works that will be shortly transmitted by radio. Except for music really performed by two orchestras connected with French broadcasting, and not always heard "directly," the totality of this musical fleet is fed by recordings.

These facts are not reported here for their own sake but as attesting to a scarcely believable musical inflation caused by the mechanization of production and industrialization of diffusion. The most visible effect of this phenomenon upon the music lovers' aesthetic experience is musical surfeit. Each of us can consume only a certain quantity of music per week. When it is necessary to count the music by day, the task becomes formidable. There are only nine symphonies of Beethoven. Formerly, someone used to hear the *Ninth Symphony* with chorus once every three or four years. At present, one can hear it as many times as the programs have to fill up the time that the symphony's performance lasts. For longer voids, we dispose of the *Meistersingers*, of *Tristan*, or of any other work of similar length. The description of the facts would have no end. We will therefore limit ourselves to note that these musical sprees threaten to engender a fatigue from which music may suffer instead of being benefited.[7]

But that is not the essential thing. It is rather that what radio broadcasts is perhaps not exactly music, that the concerts it gives are not concerts, and that its listeners, who sense this confusedly, gradually cease

6. This sort of broadcast, currently popular in French radio is entitled: *Your Recordings Are Ours*. Record sellers are invited to take part in these broadcasts that are announced as done for their information, as well as that of their customers. It is an honest way of maintaining the principle that state radio broadcasting forbids all publicity.

7. We speak here about mechanization of music, but it is just as appropriate to talk of "musicalization" of the radio (E. Morin) and even "radiophonic musical saturation" (R. König). This is an evident phenomenon (one no longer knows what to play), about whose causes questions are raised (Casenueve, *Sociologie de la radio-télévision*, 53). Certainly, the principal cause is the preestablished harmony between the mass technique of radio broadcasting and the facility that recorded music provides as material to broadcast. Political or anecdotal information reaches its limit so rapidly that in France we are in the process of drowning it in the flood of insipid commentaries. Radio broadcast theater without television is the most disappointing genre: a spectacle that we do not see. Nothing equals the music record as a means of killing the time with which the radio does not know what to do: they have only to let it speak and sing. Eight tenths of radio broadcasts might be suppressed without drawback.

to behave toward it as if it could really keep its promises. Musical reality and its audible image are not of the same order. No microphone is as sensitive to the totality of sounds that the human ear perceives. As a musician has said—indeed, a musician completely won over to radio broadcasting of musical works—the microphone, this "electrical ear" that is inserted between real music and us, behaves completely differently from our physiological ear. The ear perceives sounds, that is, sensations that are psychological states. The microphone, which perceives nothing, which hears nothing, records the number of vibrations per second, which causes a corresponding auditory sensation. With the vibrations of the sound plate, it is necessary for us to remake the sounds that were previously recorded in that form. The sounds that the machine allows us to remake are therefore not of the same nature of those whose traces it preserves. If we can speak this way, the machine has recorded orchestra sounds; it produces phonograph sounds for us.

Beside this general difference, it will be noted that the machine allows a great many of these vibrations to disappear, especially for the high-pitched sounds. Many harmonic overtones are lost, which alters the qualities. What is more serious, since these qualities lose some of their own harmonics, these qualities tend to become uniform: "It follows that all these instruments are more or less stripped of their qualities, lose their individuality, and tend to blend into a mid-range tone, white and without contrast. Furthermore, their mutual relationships are modified, the alterations they undergo not being the same for all because within a symphonic orchestra, the wealth of harmonics varies with the families of instruments, and within each family, with the instruments themselves."[8]

8. On these matters, see Barraud. Notably, "Here the potentiometer manipulated by an artist intervenes, with the mission of 'compressing' the nuance, a euphemism that disguises an attack upon the work's integrity, a kind of emasculation of the music" (Barraud, "Musique, radiodiffusion et télévision," 2:1537). Again: "In the current state of affairs, a composer listening to his own music, continues to suffer cruelly when he sees his great, lyrical impulses retreat into the distance in the measure that they go higher and demand a greater and greater dynamism from the orchestra" (Barraud, "Musique, radiodiffusion et télévision," 2:1538–39). In fact, the violin played by a virtuoso in passages of this kind (for example, Beethoven's concerto or the Kreutzer sonata), sounds like a fiddle.—Regarding the different ways in which the human ear and the microphones perceive sounds, see Barraud, "Musique, radiodiffusion et télévision," 2:1538).—On the necessity of an *analytic* take of the sound mass: "What has been divided in the studio among several microphones arranged to pick up the level of a certain group, of a certain instrument in relation to others, according to the needs of the score, is reconstituted in the booth" (Barraud, "Musique, radiodiffusion

No less sensitive are the variations in intensity of sounds. It is necessary that an operator should moderate volumes, diminish what is *forte* and, by contrast, reenforce what is *pianissimo* in order that the sound emission should adapt to the ear's possibilities. Everything that the orchestra director has carefully balanced is seriously unbalanced. The restoration of the destroyed or threatened balance consequently becomes the work of a kind of orchestra leader who directs the microphone or groups of microphones and resolves the complex problems posed by what is called "production." The problems are such and so clearly unsolvable that the composition of music has come to be foreseen as written specifically with a view to its possible recording and broadcasting. With this slant, an anticipated aesthetic experience influences the production of the music itself, that is to say the art. More or less as novelists could write their work with a view to its possible adaptation to film, musicians will write their music with a view to its eventual radio broadcast.[9] Since we have just mentioned cinema, let us recall that this industrialization of

et télévision," 2:1539). In short, whatever happens, music transmitted by radio never will sound as good as what is directly heard in a concert hall (Barraud, "Musique, radiodiffusion et télévision," 2:1539). However, let us add that the issue is not simply to "diminish the distance between the two"; these are two musics that differ in species; even if perfect, the sound image of a piece of music will always be *something other* than the reality of which it is only the imitation.

9. The problem will change its nature if engineers bring to fruition the problem of not only mechanizing music in its reproduction and its diffusion, but in its production. Even then, the human element will remain decisive, because like the mathematical machine, the musical machine will only resolve problems whose data will have been provided to it. If it should come to its producing sonorous beauty of itself, that would fall under natural beauty rather than artistic beauty.—Cf. the relevant remarks of Gisèle Brelet, in Roland-Manuel, *Histoire de la musique*, 2:1196–97, and in a slightly different sense those of Jean-Étienne Marie, in Roland-Manuel, *Histoire de la musique*, 2:1464–65, where Edgard Varèse, *Déserts*, is cited as an example. The issue here is not the possibility of manufacturing electronic instruments of music. That has already been done. They have been constructed; music has been written especially conceived for them; and certain instruments (for example, Martenot's waves) are already in use. This time the issue is about machines to compose music. Since I do not feel at all qualified to form an opinion, I will simply recall the very prudent position of Jean-Étienne Marie, in Roland-Manuel, *Histoire de la musique*, 2:1465: "It is always risky to conjecture, but my current researches, if we want to keep from them only what is capable of making music progress, ought to be amplified in these two directions: that where music starting from premises posited by the composer would be accomplished by an electronic brain; which would involve a renewal of instrumental music by the combination of the machine and a living interpreter." On the "frightful complexity," see Marie, in Roland-Manuel, *Histoire de la musique*, 2:1464.

theater art itself involves a considerable consumption of music. To adapt to the needs of the film and be diffused with it, musical art must consent to impositions that modify its very substance.[10] But we must not detain ourselves on this slope, because all industrializations communicate; they fortify each other, thereby multiply their effects. Written for the microphone or magnetic band, mechanical music will always be specifically different from that music that it purports to reproduce and disseminate.

In a completely general way, it can be said that the flood of mechanical music necessarily modifies the listener's attitude toward the musical art. Among all the known public—someone who visits museums, someone who attends the courses of professors and other similar things—there seems to be nobody, except those who attend religious services, who can be compared in attention, respect, and even fervor to those who gather to listen to a concert. Wherever the noisy public gathers, it is to seek musical goodness as such. The fact is that those who have come to look for that goodness are committed to silence in order to be able to hear. Unless someone is alone at home and, first of all, without family, no music

10. Cinema, which is mass theater, has brought with it a quantitatively large musical production. "Movie music" can be the work of excellent musicians. There is no a priori reason why the music of a movie should not be a musical masterpiece. There are, however, difficulties. First, if the film is interesting and we follow it attentively, we do not hear the music. Next, the principle of its unity and continuity, if it has one, and therefore of its musical entity itself, is not in that music but in the images that the music accompanies. Although ballet music without ballet has invaded concerts, which furthermore indicates a certain lowering of musical sense in the public, movie music does not seem to have yet found a place in programs. In the United States, where many European composers can earn in a month and a half of mercenary work six months of free work, Hollywood composers are among the best paid in the world (around $25,000 for six weeks of their time and a score lasting forty-five minutes). But working conditions are quite arduous: "The music of soundtracks must be written to be adapted to fragments of action clocked to the second; it seldom has a satisfactory musical sense; and when we hear it without the movie, it generally no longer has any sense. . . . The producer can also complicate things in an instant to cram a popular tune into the film. The function of the tune in question is simply to help the film's success, and the music matters little" (*Time*, Jan. 17, 1964, 76 [no further bibliographic information available]). As for the use television makes of classical music, it is indescribable. In 1964, the commercials for an American detergent regularly introduced the advertisement by the first measures of the *scherzo* of Beethoven's *Ninth Symphony*. The essential point is that the blow to the kettledrum be there. A scene in the film takes place in a cemetery where pets are buried: dogs, cats, parrots, and so on. The deceased whose funeral is shown is a beloved python. The musical accompaniment borrows the opening of Mozart's *Ave Verum Corpus* (*CBS New York*, Mar. 1964 [no performer or more exact date given]). Mass music does not necessarily lead to such extremes, but it makes them possible and presents the temptation to recur to them.

lover will enjoy this privilege at home. Not everyone will want to listen to music at the same time as he does or to the same music. Unless he makes himself unbearable for others, he will have to put up with their interruptions, telephone calls, visits, with everything that experienced contemplatives used to call *diei malitia*, the day's evil. If he gets this peace from others, he destroys it himself. The solitary listener's attention is subject to fluctuations to which it is not subject in a concert hall. He can move without upsetting anyone, get up, change place, take many freedoms that the presence of others forbids in a public session. If the listener disciplines himself completely, perhaps he will experience an odd sensation of depression. There is nothing sadder than a Beethoven quartet that empties its sounds into a solitude without musicians to produce them or public to hear them. The impression becomes unreal and close to absurd, like the impression every spectacle produces that is mechanical and lacks finality.

The fact is that when art becomes mechanical, it is dehumanized and replaced by something else that can abound in all sorts of qualities but is only the phantom of real art. The ear perceives it immediately. Because real musical sound is produced by a human being, it is living. The violin participates in the lives of violinists through the extreme sensibility that they have in fingers, the wrist, and the musician's whole person. The kettledrummers' sticks only prolong their arms and their legs. When we speak of the pianists' touch, we know well that if their playing is personal to them, then indeed they are completely present in their fingers when they play. The voice is more evidently still the singers themselves, not only because it is personal to them but also because the flexibility of this supreme instrument permits the artists to put themselves in it completely and to give themselves to us in it. With poetry, music is perhaps the most intensely human relation that art can establish between the artist and us. We hear the human being in the musicians, and furthermore, that is why we applaud them when they become silent. We do not think of applauding a phonograph or a radio, which only makes us hear music without musicians.

To go further, it is perhaps appropriate to say that precisely because music implies a personal relation of human being to human being, it is essentially social. In this relation, perfect musical experience takes the form of the concert. Nowadays, some people think that they would be mistaken to go out of their way to hear music, since without leaving home, they can give themselves a concert. This is an error. To hear a concert or a lyric work, it used to be necessary to deserve them. One necessarily *went*

to the concert or did not hear it. Therefore, it was first necessary to desire the experience of the musically beautiful in order to take the trouble to meet it. Again, it was necessary to provide for the possibility and organize one's time for this encounter to be possible. The distance could be great and the time of the encounter inconvenient, but finally, once arrived, one had the feeling of having done something for beauty. Of all the ways to make music, the most modest is surely to pay for a seat at the concert, but it is a way. There was a time when Paris students, crazy about music, found themselves regularly at the Opéra Comique each time that *Pelléas and Mélisand* was advertised, in the desire to listen to the work certainly but also moved by the feeling that in taking the price of their seat from their modest resources, they help a work to survive whose future was still uncertain then. They did nothing but be there, but it was their own way to help this beauty that they loved to be reborn again for an evening and to continue to exist a little longer.

The concert is a social ceremony with a complexity that confounds our imagination. Little by little, the hall fills with hundreds of listeners who do not know each other but who assemble in this place with the same motive. The orchestra enters, musician by musician, each carrying his instrument, except for the heaviest. Each artist, since childhood, is a life destined to music, that most useless of the arts, and whom a kind of mysterious password leads to this strange encounter. After a short pause, the mysterious being who is the orchestra leader enters in turn. I admire the custom of certain countries where the orchestra rises to salute the conductor's entrance, because the conductor is the magician whose gesture will soon make beauty arise. But in those same countries, before going up to the stand, the leader shakes the hand of the first violinist, the concertmaster. Doing this, he weds his orchestra, he affirms his will to act only with it, to unite himself to it and the common life of the beauty that all of them together will to engender. We receive him ourselves with some applause, and he returns the greeting with a movement of his head. It is our manner, ours and his, to shake hands, to affirm our unanimous will that beauty should be born and that this is our only reason to be there.

The miracle can then be produced, and in this miracle, the music is inseparable from another, which is the birth of a "people." For what is a people, St. Augustine asked, but an assembly of persons united by the common love of the same good?[11] A concert hall is the place destined to

11. Augustine, *City of God*, bk. 19, ch. 24.

the birth of such a people united by the common love of the same beauty. It is born there, and as long as it lasts, those who have come to look for it together commune in the love they have for it. This people composed of those faithful to music lives by beauty's presence. That life is ephemeral like that of the music itself, yet a real one, strong and capable of affirming itself violently if it feels threatened. When the music becomes silent, this people is undone and disperses, but it is to be reborn at the next encounter for which all hope and about which they think with joy that it is preparing itself already.

The same thing happens when a few friends listen to a quartet of violins or play it themselves. A sonata for piano and violin, a piece written for piano alone, songs that a person sings under his breath, some musical composition that comes from we know not where, which one hums, asking, "Who is this by?"—this is not one of these cases where real music is a relation of person to person. That even holds in the extreme case where someone plays alone for just himself. Replace the musician by a machine, however perfect it may be, and the aesthetic experience is no longer the same. It changes in nature by changing in its cause and object.

If we are dealing with recorded music, the ear immediately knows that what it hears comes to it from a record. It is not that the execution is less perfect; on the contrary, it is often too perfect, and above all, it is always the same. The twentieth time we hear it, we wait in vain for the small accidental difference, even if only a little chance false note that would be the sign of life. Error never occurs, or if it occurs, it returns every time at the same fatal instant with merciless necessity.

If the music is transmitted directly from a performance, it is more alive because it is taken from life. The concert hall is there, with its noises, its manifestations of pleasure or displeasure, the hundred occurrences that the perfection of the recording upon a disk takes care to exclude to the detriment of any human plausibility. Yet, the listener still knows that he is not in contact with musical reality. Musical experience, which we just said is a human and social relation, is de-socialized and dehumanized.[12] I am cut off from the musicians, as they are cut off from me.

12. On the effect of dehumanization of art by the mechanization of mass means, see the energetic and accurate remarks in Fitch, "Forms of Plenty." The problem occurs in all of the fine arts. Concerning music, Fitch rightly noted the absence of listeners. It is a mistake to call these new arts "public arts," because, to the contrary, they have the effect of creating "a new form of culture made private and a new kind of audience that is public only in an exclusively statistical sense. It is an audience of dispersed individuals" (Fitch, "Forms of Plenty," 5). This could not be said better. Indeed, it is necessary

I am at home, not in a concert hall. The musicians themselves play for some microphones in the artificial silence of a recording session; they do not play for a public whose instantaneous response sustains them, keeps them breathless by its mere presence. As they do not play for someone, they no longer play for anyone. As for myself who listens, nobody plays for me any longer. Igor Stravinsky says he desires to *see* the musicians. One would at least like *to be able to see* them, because indeed they are part of the musical experience, being its cause. But I do not see them. I do not see the orchestra leader whose gesture, however, is directed to me as much as to the musicians.[13] The program has not been proposed to me but imposed. Furthermore, this music is delivered to my home. I did not desire it strongly enough to take the trouble to go to hear it. Its birth doesn't cost me anything. I am seated at my desk or stretched out in an armchair at the disposition of someone unknown. I turn a knob as one turns a faucet. At the moment when I write these lines, what is flowing is Mozart's *Symphony No. 33* in B flat major, K. 319. The newspaper says

to pulverize groups in order to obtain a mass, the latter not being made of any number of groups but rather of a sort of paste where individuals as such are incorporated. The traditional relations between artist and public are transformed. The object itself is transformed because, to return to Fitch, by preparing the object with a view to its mass distribution, the person who is in charge of the operation inevitably modifies its very form. Musical themes are extracted in order to make them tunes to sing, audible signatures or indications. The indefinite repetition of the same forms empties them of their emotive power (Fitch, "Forms of Plenty," 6). The central point of these remarks seems to me completely justified: "It belongs to the very nature of mass production to loosen the line of communication between artist and audience and give a private character to the conditions of this communication" (Fitch, "Forms of Plenty," 6). A sort of privatization of musical experience is therefore the paradoxical but inevitable result of its collectivization by mass media.

13. The mass media require such financial resources that their administration is more and more withdrawn from the initiative of responsible individuals but rather is leased to such individuals by financial and industrial groups, when it is not simply by the state, as is the case in France. There is good and bad in that. Formerly, an orchestra leader hesitated to burden his programs with new works, above all if they were of an unusual style and of new or scarcely known authors. The very life of concert associations depended on it. That is still the case in the measure that an orchestra is less generously subsidized. A radiophonic orchestra runs no risk; the worst that can happen is that the listener turns off the station and stops listening. The drawback is that, freed from the public routine in this way, music falls under the determination of cliques for whom everything that disturbs the ear's habits is regarded as good in itself. The most favored music then becomes that of the somewhat, although not excessively, innovative musician who can act upon the composition of the programs. With a little tact, such a musician can recall himself often to the public ear with no risk.

so, and since the program consists of information, it does not allow me to be unaware of these things. Now, there is music for every hour. This is the lunch hour. I therefore go to the dining room. Everyone is seated at the table, but we can let Mozart continue his song. He has become table music. He is not annoying and simply serves as the sound background to the family chatter. If the *presto* makes too much noise, Mozart becomes annoying. As they say, "He keeps us from talking." Someone gets up from the table then and turns the button to make him be quiet. Indeed, Mozart is silenced, but if I am the one who interrupts his song, I think that something in me must have changed for me to demonstrate such rudeness toward the Swan of Salzburg. It must be that I am no longer myself. Or can it perhaps be that it is the music that is no longer itself? For I am not at a concert but at a table. Someone talks to me, I answer, and I even end by experiencing a sort of embarrassment for Mozart from seeing him thus abandoned. It would be better, for him and for us, that he should be silent. How would I really understand about music, if in the *Dasein* of musical experience, with which we are dealing, the music's *Da* [there] and that of the listener are not the same? Can the music be present when the musicians are not there?

The most remarkable thing is that in certain cases and for certain works, the musicians have never been there. Not only is the concert (whose auditory image I hear because a turntable makes the French broadcasting system broadcast it at my will) a pseudo-concert played by a pseudo-orchestra, but it may even be that this orchestra that does not exist, has never existed. It is not necessary, it has even become practically impossible, that the disk broadcast on the radio should be the original recording of a concert or a theatrical performance. We no longer hear the music as the orchestra leader wanted it to be heard but rather as the person who puts it on the radio waves has decided to record them. Having controlled the volume of sounds allowed to each kind of instrument during the performance, he can then retouch, correct, and adapt the recorded sounds so as to obtain a combined effect that satisfies him. We then hear what he wants us to hear, not what was actually performed. We hear of four recordings by a single singer in four times and then recomposed, or of a certain concerto executed by the violin virtuoso and accompanied by the same soloist transformed into orchestra leader; such a recorded symphony is a synthetic product combining a certain performance on the violoncello by a group of artists with other artists whom they have never met.

In this way, it seems, we get recorded music that is more perfect, more brilliant, and more seductive to the ear than are authentic musical performances. Indeed, the microphone improves certain voices and certain tones. Accidents in performance can be corrected for the recording. Certain instrumentalists may even prefer to be heard through the scientific rigging of the magnetic band rather than modestly allowing their playing to be heard just as it is. If the remark attributed to him is authentic, the Canadian pianist Glenn Gould has said of public concerts: "This manner of presenting music is dated. If there exists a way of reaching audiences that has more future, it will be through recordings. Concerts as they are known today will not survive the twentieth century."

That is very possible. While the audiences forget the road to the concert hall, the musicians lose their taste for public recitals. Orchestras are replaced by machines. Programs are no longer chosen by orchestra directors who take a personal risk each time but by record-players that run no danger. Amateur pianists no longer dare to play for their families. The quartet of friends separates. The local chamber orchestra no longer dares to show itself, so much does it fear the comparison that the first passerby could make with any world-renowned orchestra. The first effect of the unceasingly growing diffusion of canned music is thus to dissolve particular societies, which are genuine societies, and to allow to subsist fragmented individuals, ready to let themselves be absorbed by the great mass society that will *musify* them and indoctrinate them at pleasure.

The remarkable case of music invites us to ask whether mass society is still truly a society, at least in the same sense as the groups of human beings that Augustine called peoples, which were united by the common, but free and personal, pursuit of the same good. We add nothing to the facts, not even the slightest reproach, by observing that mass music too often, and even most often, is reduced to the diffusion of musics that are not music, according to the whim of employees or functionaries who are not musicians. The reality of the musical substance vanishes for everyone. Since no one *makes* music any longer, no music remains to be heard.

The massification of music, like that of painting and drawing, is made possible by the invention and perfecting of a single technique, which is nothing other than printing. Paintings, statues, and even monuments are printed, as are symphonies and operas. By making records, music is printed to be put on sale.[14] Therefore, it is natural that we should

14. I acknowledge having been surprised myself reading the article "Records" in *Time*, Sept. 24, 1965. Reality went far beyond my timid imagination. Subtitles included

pass from these mass techniques to the printing of books, which is their prototype. This time, however, the conditions of the operation are so different that we can see nothing to say that might be understood as its condemnation. A printed painting, a printed symphony are no longer a painting or a symphony. By contrast, the manuscript literary work does not change in nature when it is printed. For once, the massification of a fine art seems possible without alteration of its products. So indeed it is, but only to a certain point that needs to be specified.

"The Age of Patchwork," "Plastic Surgery," "Splicing Life," and so forth. To capture a symphony on vinyl today, the score is divided into segments and recorded numerous times on some 45,000 feet of tape. The best passages are then teased out in around 250 pieces, put into order, and spliced in a single performance, perfect down to the least note, on a tape 3800 feet long. "Sometimes we distort the sounds to confuse people," a technician says. "I like nothing better than to have someone ask, 'What is that?'" If a singer does not feel fit on the day of recording, it is unimportant. He can add his part another day, even in the absence of the person with whom he is supposed to sing a duo. "A few years ago, when the late Kirsten Flagstad was unable to hit two high Cs during a *Tristan und Isolde* recording date, Elisabeth Schwarzkopf was called in and did it for her." To get a particular vocal effect in the first act of *Gotterdämmerung*, a London record producer, John Culshaw, "unabashedly transformed tenor Wolfgang Windgassen into a baritone by playing his voice at a slower speed. 'Had Wagner lived to know the possibilities of sound recording,'" Culshaw said by way of justification, "'I am sure that he would have wanted them used not only for the sake of music, but also for the drama.'"—The late Arthur Rodzinksi and the pianist Paul Badura-Skoda listened one day to a strip being played that they had recorded together. "Badura-Skoda exclaimed: 'Listen! Isn't that magnificent?' 'Yes,' replied the maestro dryly, 'don't you wish you could play that way?'"

3

Mass Literature

THE ORIGIN OF THE industrialization of the humanities is old, because, since the twelfth century, book selling began to be planned. Before the printing press, the existence of professional copyists and that of the Lendit Fair at St. Denis, where parchments and manuscripts were sold for previously set prices, give evidence that there was a community interested in the subject by that time. It is important to note that by the thirteenth century, the phenomenon was already tied to the needs of education. There were programs of education and authors included in the programs. Teachers and students needed to obtain them, and therefore it was necessary to produce them. This industrialization or preindustrialization was born of school needs, and this connection would continually become closer. The phenomenon crossed a threshold when the printing press permitted the multiplication of the copies of a book beyond any imaginable limit. When Dante died, almost nobody could have access to his work. Today, nobody can accurately say how many copies of the *Divine Comedy* exist, but the number is certainly large. I myself have six copies, probably more than Dante ever had or saw.

Today, however, the evolution of the book is crossing a new threshold. In every country with a sizable intellectual culture, publishers, who are book industrialists, have sought to manufacture books inexpensively.[1] Collections of so-called "popular" books in small format and sim-

1. The German collection Philipp Reclam and the English collection Penguin are recalled here only as symbols of many others. This general phenomenon still is waiting for its historian. There has also been one in France and doubtless in the majority of other European countries. Sainte-Beuve mentions the fact in a note of his prophetic

ply bound have been created since the nineteenth century in countries where the number of those able to read became large enough for an enterprise dedicated to disseminating books to be profitable. Here again, since alphabetization and literary culture are connected to schooling, industrialization of books is in great measure tied to the development of instruction. Today, this phenomenon has taken on major dimensions, beyond all proportion with what had previously been seen. According to trustworthy statistics, in the United States, a million paperback books have been sold per day in 1960.[2]

I cite the United States, because its statistics are accurate and available to everyone and because the phenomenon's immense dimensions make it more visible there than elsewhere.[3] The principle that governs

article "De la littérature industrielle," in *Portraits contemporains*, 1:497n1, in the edition I have before me: "The success of various little *libraries*, collections published in the so-called English format proves that good, well-filled, inexpensive books would have every chance of success; and still the choice has not always been careful." Concerning the United States, see the collection of lectures gathered under the title *Bowker Lectures on Book Publishing*. I will refer particularly to the lecture of Freeman Lewis, "Paper-Bound Books in America." The lecture is dated 1953, and the figures and statistics hold for that year and the immediately previous years.

2. Cerf, *Publishers on Publishing*, 474. In 1951, the American public bought around 230 million volumes in paperback format. Out of the five most popular authors of this time, three wrote detective stories, among them an erotic crime story of the lowest level.—Cf. Lewis, "Paper-Bound Books in America," 316. This booklet contains a short account of the paperback in the United States before its current explosion. The appendix, 323–35, contains useful lists of publications up to that time. These reports on an already old situation can be usefully compared to those that Frank Stanton gives in the briefer but more recent *Mass Media*: "More than a billion books are bought at present (1962) each year and 800 million are borrowed at the libraries against 500 millions in 1956. The paperbacks, of which 300 million were sold in 1961, include 21,000 titles in 1962 as against 15,000 in 1961, and they include not only classics of literature, history, and philosophy, but also practically all the books represent an effort at creation or at description and were published in bound editions during prior years" (Stanton, *Mass Media*, 5 of unpaginated text).—Paperbacks have invaded almost all free space in American bookstores. Some of them sell no other books (although none of them has all). Furthermore, they are sold in drugstores, in chain grocery stores, and of course, everywhere that tobacco, chocolate, and newspapers are sold. A catalogue of *Paperback Books in Print* is published quarterly with that title by R. R. Bowker, New York. Vol. 7 (Summer 1962) contains 223 pages of titles classified in 79 subjects. Note that the catalogue of *Paperback Books in Print*, vol. 8 (Spring 1963) contains 218,000 titles currently on sale.

3. Sainte-Beuve's prophetic article, "De la littérature industrielle," written in 1839, lets us be present at the phenomenon's first phases, but we see that we are dealing with two different although connected problems. On the one hand, the gradual

industrialization in North America is always to sell better and more cheaply. This is what explains the frightful, sometimes inhumane, competition that brings conflict into American big business. The detailed, long, expensive studies that precede the introduction of a new product to the American market account for a considerable part of the cost. This research has precisely the object of guaranteeing that the product will be a little less expensive than its rivals while being at least as good and, if possible, a little better. This must be true, and the public must perceive it, or at least it must be true enough for the public to believe it. Here is where publicity is involved. This colossal force, with its techniques of persuasion that are so interesting to study, undertakes to fill the gap between advertising and reality. In becoming big business, American books have followed the general rule. The effort is to produce books readable for many readers at lower prices. The result of the effort is now visible, and for different reasons everything that relates to books is affected by it. Public, authors, bookstores, all consumers of books are involved, and most take it into account.

In the judgment of American publishers, the paperback is probably "the biggest phenomenon in American publishing history." Only the periodical industry outstrips the book industry in this regard. It outstrips it in such a proportion that book publishing is almost insignificant compared to that of periodicals.[4] A special study of the effects of the peri-

transformation of the writer into businessman or, if one prefers, a professional man. In France, the transformation culminates with the foundation of the Société des Gens de Lettres by Louis Desnoyers (1802–1868). Its first president was Louis Villemain, and its second president was Balzac. Sainte-Beuve bitterly but shrewdly denounces the power of a class of writers for whom the only reason to write is to make money. The traits noted by Sainte-Beuve have become only more pronounced since then. Nowadays, any objective description of French literary practices gives the impression of satire. On the other hand, Sainte-Beuve discerns the beginnings of another phenomenon, that perhaps he does not distinguish clearly enough from the previous one: the birth of publishing conceived as big business. It goes without saying that the phenomenon has accelerated considerably since Sainte-Beuve's time by reason of the continual advances achieved in printing techniques. It is their direct effect. Writers are not its creators, because it takes place outside of them, in a world to which they have no access. This industrialization of book production is therefore distinct from the completely personal transformation that has made the art of writing not only a living but a trade.

4. In 1951, a single periodical, *Life*, sold 30 million copies more than the totality of paperbacks purchased in the same year. While some 230 million copies of paperbacks were being sold, magazines reached the figure approximately 3.5 billion. Even counting a sale of around 365 million copies of paperbacks, which is roughly the annual sale at the time when these lines are written (1964), the disproportion with some 4

odical on good literature would be extremely interesting. For example, Balzac published novels in serialized form, as did Dickens in England and Dostoevsky in Russia. Periodicals and daily newspapers have influenced the production of authors and the taste of reasons, but that would be too vast a subject. Therefore, let us keep to the book industry properly speaking. This is worthwhile, where we witness what has been called in America an authentic publishing "explosion." Logically, it is probable that good literature will undergo the influences that have arisen in its primary mode of expression.

The object of our reflection cannot be the book in general. There are books about everything. Insofar as books are a means of information, their multiplication is excellent. This is true at all levels and in all order. The Bible is probably the book of which the most copies have been sold. The nonreligious book with the largest circulation, if I am not mistaken, is an American book on the care of newborns. At a more disinterested level, the inexpensive book has given access to philosophical, scientific, historical, and other works, whose high price up to now made that difficult. We must include good literature in this list of subjects, in the measure that literary texts exist that are easy to find and priced fairly modestly in order for them to be accessible to a broad public. Today, it is possible to obtain an inexpensive copy of the masterpieces of Italian literature in one of the collections devoted to guaranteeing its diffusion. Dante and Petrarch never saw a printed book. Today, they would be very surprised to be able to obtain the *Divine Comedy* and the *Canzoniere* for modest amounts, simply by directing themselves to any bookstore in Italy or even abroad. They would be still more surprised to hear the bookstore ask, "How many of them do you want?" Doubtless it would take them some time to understand that their readers nowadays are innumerable. Perhaps Petrarch would be more surprised and at the same time more satisfied. But would they think that poetry fares better than in their time, that their readers enjoy it more and are more aware of its beauty? Supposing they think so, would they also deem that the modern book explosion is its cause? That is a different question.

A first comment concerns the nature of the event, which is essentially different from what we described under the heading of industrialization

billion magazines sold remains crushing. It will be noted that the American magazine often contains more material than a large volume. The difference from the book is that the periodical becomes out of date with the appearance of the next issue. Cf. Lewis, "Paper-Bound Books in America," 317.

of the visual arts and aesthetic experience of them. Photographed and printed sculpture, we said, is no longer sculpture. The painting reduced to the state of a plate decorating a book is no longer a painting. There has been a change of order. We can legitimately wonder whether, despite the book industry's pretenses, what it produces is still genuinely art. Art of the book, surely yes, but surely not art of sculpture or painting.

The case of literature is different. The first major revolution that took place in its history is now lost in the past. However, it was decisive. That was the moment when the word previously spoken became written. It is difficult to specify the consequences of this event because we no longer have direct experience of what spoken literature is. We know only written literature. We do know that, once written, literary works stop changing. If we think of that, it is surprising that when twentieth-century students nowadays recite for the first time "Arma virumque cano," they only re-peat, if possible down to the details of pronunciation, words chosen two thousand years ago by Virgil, which we recite today in the order he chose. If I recite the first verse of the *Divine Comedy*, I speak as Dante willed. He dictates to me both the words that he wants me to say and the order in which I must say them. Writing is the cause of this, and it is an extraordinary phenomenon, but nothing distinguishes printed words from spoken words in this regard.

The writers' condition has changed at the same time as that of their works. The *Divine Comedy* did not produce a fortune for Dante, and Petrarch was not paid for his sonnets. Moreover, Dante already knew working writers but denied they were of men of letters: "And I said to their shame that they have no right to bear it, because they do not seek literary culture for themselves, but to win honors or money by it; just as we should not call a cithara player someone who keeps a cithara in his house to rent it out without ever playing it."[5] There is room for a distinction here. Literary creation itself has never been paid and never will be. By its nature, it cannot be. We can assign a cost to the manuscript of a poem because it is a negotiable material object, but creating a poem cannot be priced at any determined value. Dante must have spent a certain amount of money in paper or parchment, in ink, and perhaps on the labor of copying. Petrarch hardly had to disburse anything but the price of some copybooks. We understand that their writings, which nobody possessed and from which nobody profited, had no value for them. Formerly, public

5. Dante, *Convivio*, 1:9.

or private patronage was the ultimate resource of writers. Those who lived only to write simply requested that they be given the means to live. The great writers of yesteryear were poor and resigned themselves to be so. Certain of them were rather dignified beggars, but others were shameless. The latter flattered the wealthy and important in order to get money in exchange for the glory that they were assured, but the writers were not acquainted with what we call today "living by one's pen."[6] Certain literary master singers like Aretino made dishonorable and profitable use of their pen at times but never commercial use.

It is necessary to distinguish the book, whose sale brings in money, from the literary creation, which does not have a price tag. Shakespeare and Molière lived off their theatrical activities because the spectators paid for their seats. Corneille and Racine were also remunerated from the income that the portrayal of their works brought to the theater, but what the sale of their writings in the form of printed books might have brought them was no doubt insignificant. However little it was, it was as

6. Perhaps the phenomenon took place earlier in England than on the continent. Pope is a clear case of writer and poet making his fortune with his writings and devoting himself to their exploitation. If we believe Sainte-Beuve in his article on industrial literature, although many writers may have accepted being paid in the seventeenth century, "ideas of liberality and disinterest were rightfully attached to beautiful works." The theater did pay (to Molière and even Racine), but "Boileau made a gift of his verses to Barbin and did not sell them. In all the majestic and varyingly continued masterpieces of those like Bossuet, Fenelon, or La Bruyère, and in those of Montesquieu or Buffon, we do not detect a door that leads into the backroom of the bookstore. Voltaire became rich rather through foreign speculation than by his books, which he, however, did not neglect. Diderot, destitute, gave his work more readily than he sold it." By contrast, Lesage wrote *Gil Blas* for the bookstore, and Beaumarchais, "the great corruptor, began to speculate with genius on the editions." Sainte-Beuve does not name anyone of his own time, but he certainly is thinking of Hugo. In any case, he sees very well that greed, to the degree with which it now rages among writers, is a relatively new motive, which combines with the passion for fame and with literary pride and especially takes itself to be the measure of talent or literary genius. The worst thing is that this evil has invaded even poetry. Literature has had many faces. Pure art has its cult, but we see that the appearances are changing. "Industry penetrates into the dream and makes it in its image, all the while making itself fantastic like the dream; *the demon of literary property* climbs into heads, and in some people seems to constitute a genuine Pindaric sickness, a St. Vitus dance that is strange to describe." The "fantastic" described by Sainte-Beuve doubtless is related to the project of Balzac, at the time president of the Société des Gens de Lettres, regarding those whom he called *the twelve* field-marshals: "A field-marshal in literature is one of those men, as you well know, who offer a *certain commercial space for exploitation.*" The expression and the italics are Sainte-Beuve's. Here he acts as a pioneer in sociology and economy of "the literary thing." See Sainte-Beuve, *Portraits contemporains,* 1:499–500.

booksellers that they were remunerated at that time, much more than as creators of literary beauty. The problem of remuneration of the writer becomes confused by this mixing of two different elements. We say that the writer makes books, not that he makes literary works; but except for his own manuscripts, sometimes illegible, he does not make books. When he has finished writing, he stands helplessly, work in hand, in the hope of a publisher. Writing is a work of the spirit, immaterial and free by its essence, without which there would not be a book; but a book is the work of a publisher who must commit to expenses that are often considerable, without which the book would no longer exist.

The history of *publisher's privilege* makes us see that since the seventeenth century, those who assume the expenses of publishing books have rightly wanted to reserve its profits for themselves. We also know that, since a country's laws had no power abroad, the practice was fairly quickly established of unauthorized printing in one country of writings already published in another one. The history of the copyright has been complicated, long, and is not yet finished. I do not think that there is reason to be scandalized, because if the author's contribution is essential and first, it has no common denominator with that of the publishers. Someone markets the fruit of his labor in publishing one of his works, but the author himself in no way enters into the production of the book. By being involved in it, he only makes extra expenses and problems for the publisher. A philosophy of "author's corrections" would perhaps help us to perceive the problem's fundamental difficulty. Could a writing's *meaning* be included in the book's cost price and sale price? From the moment that the sale of printed books represented a considerable revenue, it became difficult to admit that all those who contributed to the book's production except the author should be remunerated. Once there were successful authors and best sellers, the publishers chased them and offered to give them a share of the profits expected from the sale of the future book. From the moment that someone offered to purchase the fruit of their work from them, authors concluded that indeed it had market value. Thus the "rights of author" were born, whose legal history is also long and complex. Let us merely say that in the measure in which writers accept to draw on them, writers become in part the merchants of their own writings. In this same measure, they also makes themselves

responsible for the commercialization and industrialization of great literature. Is that good or bad? It is difficult to give that question a simple answer.[7]

The great modern writers themselves, to whom royalties were paid for certain of their works, did not write their masterpieces with more mercenary intentions than authors of centuries past. It is necessary to be totally ignorant of the psychology of writers to imagine the opposite. Possessed and obsessed with the love of the work to be done that artists of the written work carry within them, they think only of it. Gustave Flaubert, whom we see in his correspondence dragging Emma Bovary like a convict his ball and chain, is a faithful image of reality, although it is not always that dramatic. But let us consider Goethe, the most Olympian of poets. Does Goethe ever and in any circumstances whatever describe himself as writing *Faust* to make money? It is Faust who uses Goethe, and not the reverse. I deliberately choose as examples of works that, once published, became considerable economic factors, although, like Baudelaire's *Les fleurs du mal*, they made nothing or almost nothing for their

7. Here we are dealing with a most complex philosophical question. Since thought is immaterial, it does not produce "goods" that can be the object of a property right. I can steal a copy of the *Discourse on Method* (a work for which Descartes refused to be paid), but I cannot rob the idea that "common sense is the thing most widely shared in the world." Once understood, the concept belongs to all those who understand it, and since it is difficult to separate the concept from its expression, it is not clear how someone could be obliged to repeat something less well, under the pretext that it ought to be said differently. A book is an object of property. By taking it, somebody deprives me of it. But the ideas, images, or verses that the book contains can be simultaneously understood by a multitude. Nobody *possesses* them in the strict sense of the word. From there comes the extraordinary frequency of literary imitation, of borrowing, deliberately or not. From there also comes the reluctance of certain countries like the United States to join certain international agreements about literary property. Once the thought is expressed, it belongs to everybody. Writers themselves perceive this clearly. Architecture requires enormous, and sculpture considerable, expenditures. Painting itself is costly for the painter (although the buyer has the tendency to think that the painting does not cost the painter anything). Literature alone does not involve large expenses except, when we are dealing with an enterprise of organized literary production. Just as the scholar refuses to be paid for a discovery, but the engineer is paid for his industrial undertaking, the poet cannot be paid for his poetry; but since the book would not exist without it nor without him, it is difficult to refuse to acknowledge his right over the product of the sale for the poetry collections. Let us say a kind of right, because nobody truly has a property right over ideas that one forms nor over the words one pronounces. They are not goods, even consumer goods. We are completely in the metaphysical realm.

authors. The work itself is the real end that a purebred author proposes. Marcel Proust did not live for his work; his work devoured him.

However, things look different with the arrival of a new class of writers, mostly talented, but resolved to take advantage of the possibilities offered by the commercialization of literary affairs. With them, literature becomes a trade. Instead of trying to organize their life so as to reserve the possibility of writing, like the great creators, they propose to write to live, and as this is not easy, the problem of developing a career takes first place for them. Commercial success is a vital necessity for writers of this kind. The trade in which they work is perfectly honorable in itself. We reproach some of those who exercise it only with making themselves appear servants of letters, while on the contrary they serve themselves with letters and exploit them to their own profit.

Sainte-Beuve greeted the birth of this new profession and the social class that practices it, "people of letters." He did not like them very much, and they heartily returned the feeling. Louis Veuillot, who liked them even less, called them "literary folk." The members of these new social species, almost unknown before the nineteenth century, are writers who live off their participation in the profits from the commercial exploitation of their works. They do not live off their works but off their books. Their sense of forming a distinct class leads them to claim the title of writers in the strict sense of the word for themselves alone. Only they are pure blooded. They consider as amateurs, even amateurs who are geniuses, those for whom literary production is only a second trade or a nonpaid luxury. Professional writers often lack the rare opportunity of belonging to the restricted group of writers fortunate enough for their pens to be free.[8] They consequently dispose of much less freedom of spirit to devote

8. It could be suggested that the "human sciences" take an interest in the sociology of the writers' world. Perhaps there exists a literature of the comfortable bourgeoisie, recognizable by certain characteristics (in France, Gide, Proust, Mauriac). Some only earn more money from it but do not live off their pen. Those who do live off their pens are divided into at least two classes but from two different points of view. There are "professionals" who consider themselves the only true writers because they exercise no other remunerated activity, somewhat like journalists deny the title to those who, though writing for newspapers, do not have the journalist credential. They distinguish themselves from those whose writing is a second trade. Incidentally, it would be necessary to find out which are the true writers—those whom a real trade leaves free to write only what they feel like writing, when they feel like it, or the slaves of copyright who have no choice, since it is necessary for them to write or die. Among those whose pen, for any reason whatever, is free, we must distinguish between the writers whose principal goal or, still better, only goal is to produce beautiful writings desired for their

themselves to their art than someone whom a different trade frees from the slavery of those who must write in order to live. Professional writers cannot interrupt their production under the threat of seeing their income diminish and their names erased from public memory. In some measure, they are even obliged to conceive their production so as to lead to as wide a distribution as possible. Industrialization of books is not what has created professional writers, but it has called it forth, provoked it, made it rise from nothing, by creating the conditions that permit it to exist and to subsist by living from its art. Modern publishing needs writers called to success, because the book's cost forces the publication of writings that will interest a vast public of buyers. It needs them, and they need it. It needs their pens as they need its money. This coincidence of interests predetermines a profitable alliance of modern publishing and the professional writer. There are still and there always will be free pens. A Stéphane Mallarmé always remains an open possibility, but industrial literature with great output is probably permanently here. It is likely that its presence will exercise a discernible influence on the life of literature.

The most obvious of these effects is the extraordinary development of a particular literary genre, the novel. We know no example of a great literature having begun with prose nor consequently belonging to the genre that today we call fiction. *Gilgamesh*, the *Iliad*, the *Odyssey*, *Beowulf*, and all the sacred poems of India certainly contain fictional elements. We can even maintain that they are novels in verse. But these epics or epic recitations are essentially poems. It is noteworthy that

beauty and those who propose to introduce the literary beauty of which they are capable in writing, whose peculiar goal is different: public speaking, history, philosophy, and so forth. The first consider themselves the only true writers. In any case, they are the only ones whose writings strictly fall under one of the arts of the beautiful, in the sense defined in our *Arts of the Beautiful* [Introduction aux arts du beau], ch. 2. But here, as always when dealing with letters, we find Sainte-Beuve. In his article "De la littérature industrielle," after saying that industrial literature has come "to occupying the square almost without opposition and as if it alone existed," he notes, however, that there are "other existing literatures," for example, what can be called the literature "of the Academy of Inscriptions" (indeed, Ernest Renan). "There is still literature that can be called university literature, bordering on the other" (indeed, Taine, Boutroux, Bergson, Boissier, Bédier, Faguet, and so forth). Then he adds, expressing a very widespread opinion: "But it is necessary to say, with all the respect such works inspire, that the whole of a nation's literary glory is not there; a certain life, free and bold, always seeks adventure outside all these fences. The great field outside is where the imagination has all the opportunities to display itself" (Sainte-Beuve, "De la littérature industrielle," in *Portraits contemporains*, 1:489). Although Sainte-Beuve does not get to the heart of the matter, he has a sound sense of the right answer.

medieval epic cycles engendered prose doublets, but the poem is always the source of the novel. The novel never makes a corresponding poem arrive. If there exist exceptions to this rule, the fact remains that the prose novel occupies a meager place in the classical Greek and Latin literature and that except for *Don Quixote*, no fictional work permitted the novel to be classified among the great literary genres. Even Boccaccio in Italy and Rabelais in France, whose literary importance is beyond question, are rather narrators than novelists. In the seventeenth century, genuine novelists are not unusual, but compared to poets and orators, they do not count. Even in the eighteenth century, although the novelistic genre produces masterpieces, the genre remains the poor relative of great literature. The contrary is true nowadays. Since the beginning of the nineteenth century in all of Europe, novelists occupy the foreground of the literary scene. Dickens in England, Balzac in France, Manzoni in Italy, and Tolstoy in Russia—these names are only the signs of national schools of which we all can lay out the catalogue without consulting anything but our memories. In the literary production of modern countries belonging to Western civilization, the primacy of the novel is evident. At the same time, these are the most industrialized countries. The two phenomena are connected. Industrialized publishing must sell a great deal in order to lower the book's retail price. There exists only one literary genre capable of finding purchasers among all those who know how to read, even if they don't know anything else, and it is the novel.[9] Some among them

9. An investigation about the present situation of publishing would no doubt show that the situation varies according to the country, but that, as in everything that involves industry and commerce, Germany and the United State rather clearly indicate the general tendency of the evolution. The profession of publishing undergoes a kind of depersonalization that, still scarcely perceptible in small business, is more and more marked in the measure that the business grows in size. Even in France nowadays, it would be easy to indicate apparently different publishing houses that are controlled by a single group. Directors, themselves directed, replace the old publisher who used to choose the books to be published himself. He was free to produce second-rate novels but also to employ part of his profits to publish poetry, most often at a loss. On the present situation in the United States, see the very balanced article by Klein, "Anomic Age in Publishing." For the situation in France, see the recent announcement of the publishers revealing the financial agreement between the Union Fiancière de Paris and the Presses de la Cité. Since its creation in 1947, the latter publishing house has absorbed the corporations La Générale de Publicité Éditions GP, Le Livre Contemporain Associé, Dumont, Fleuve Noir, Le Carrousel, Éditions Artima, the Librairie Polytechnique Ch. Béranger. If we add cases where this company is the majority stockholder (and this is only one case), we go on forever. Three principal groups are currently discernible: attached to Hachette are the publications of Stock, Gasset, and Fayard;

read nothing else, but there is no mind, however refined, who is incapable of reading one. The philosopher A. N. Whitehead loved to read detective novels, but being a great logician, he always began at the end of the book. With his mind set thus at ease, he returned to the beginning to give himself the pleasure of seeing how the author prepared his ending. Because the novel directs itself to the imagination alone, or nearly so, it is the most cultivated literary genre by authors as well as readers. Women excel at it. This explains that the novel, formerly looked down upon by writers enamored with literary glory, nowadays offers the perfect solution to a problem whose components are multiple: what is the literary genre that probably will find the most readers, that can be printed in the greatest possible number of copies without risk of low sales, and that one can hope to sell most inexpensively? The only literary genre that satisfies these conditions is the novel.

The care with which publishers follow the curve of paperback book sales gives statistical confirmation to these observations. From the publisher's viewpoint, a good book is a book that sells well. There are rare exceptions, always explicable by extraliterary reasons, but the numbers of sales attest to the triumph of romantic literature. To avoid boring and furthermore obsolete statistics, I will simply mention a fact that seems significant. The advent of the best seller, a category still unheard of in the recent past, is a typical happening by itself. The excellent weekly *New York Times Literary Supplement* publishes a list of best-selling books each week. This list of twenty titles is divided into two lists of ten each. The first list is entirely devoted to fiction. In other words, in the eyes of these observers, the novel has an importance equal to that of all the rest of the literary production currently published in all classifications in the United States. Fiction counts for 50 percent and nonfiction for 50 percent. In nonfiction, successful books are most often historical works that know how to avoid or dissemble erudition, biographies, essays on recent or current events—nothing or almost nothing that falls under pure literature. A third, complementary list includes some book that are recommended despite the smaller number of sales. They are valued in order to compensate them for success that does not come.[10] This is all the more re-

with Gallimard, we find the publications of Denoël, Mercure de France, and Table Ronde; tied to Presses de la Cité, besides the already named satellites, there are Plon and Juliard. This is to say that all major publishing has been gradually taken over by the power of money.

10. Here is a French example, the June-July 1964 issue of the monthly literary

markable in that, contrary to the caricature that some offer of the United States, there is no country in the world where poetry is more cultivated, honored, and loved. Those American poets often find publishers, but the ratio of published poetry to novel remains negligible. It is a luxury that a publisher gives himself sometimes for his personal satisfaction. He does not always lose money in it, but what he might make in this adventure is completely insignificant in comparison with what successful novels can bring in. The need for huge printings has broken the old hierarchy of literary genres in benefit of the novel. The novel is the great winner of the unforeseen competition that industrialization of good literature has instituted among its species.

It becomes difficult to analyze the consequences of this fact, because they reinforce each other and multiply each other. It has changed literary criticism. A critic like Saint-Beuve gathered in his *Lundis* all the names that then graced good literature. If you glance over the indices of his critical reviews, you will find, besides the perennial classics and in their appropriate places, novelists, poets, orators, historians, all kinds of essayists, and philosophers. Nothing of what adorned the language escaped the critic's attention. Among the most beautiful of Sainte-Beuve's literary portraits, the perceptive articles on Joseph de Maistre must be counted, all the more remarkable in that Maistre's mind was at the opposite pole from Sainte-Beuve's. Today, at least in France, a major daily's literary criticism will hardly ever talk about a new work that is not a novel. "The important thing for me," one of those critics told me one day, "is to never miss the Goncourt Prize." We have come far since Villemain who, at the moment of taking up *Delphine* in a course on Germaine de Staël, declared to his audience: "You know, gentlemen, that we never talk about novels here." The novel has devoured criticism as it has devoured fine literature. What is not fictional literature is entrusted to critics who are no longer literary but "specialized."

By making literary production unbalanced, the novel has put itself in danger. It would be interesting to find out in what measure industrialization of the novel has affected its style. Sainte-Beuve already indicated abuse of dialogue, especially of exchanges of short answers, in order to

journal *Livre de France*, published by Librairie Hachette. Of thirty pages of text, seventeen are devoted to the novel (2–16 and 29). The other subjects share the rest. If we remove four pages of mere announcements of titles, p. 18 consisting of an advertisement of the *Grand Larousse*, we get a total of seventeen pages of reviews just of novels, against eight pages devoted to all other literary genres, including theater.

"shoot straight." He also noted the tendency to lengthen the narrative as much as possible, without any other foreseeable limit than the exhaustion of author, reader, or both.

The choice of subjects has certainly been affected. The king of the contemporary novel is the detective story, the heir of tales of adventures and the great-grandson of the stories of Lancelot in the prose of yesteryear. It is in vogue internationally, and the names of its authors are famous in the whole Western world. Furthermore, novels of this type are often products of specialized literary workshops that write to order according to the specifications of the person who signs the work. Perhaps it is more prudent not to name names.

At the same time as the adventure novel triumphs, an authentic epidemic of eroticism is being produced. There have always been erotic writers, but they were the exception, and their writings used to disappear into the *infernum*, the closets of libraries, and only meager information was given to the public about them. Today, eroticism is shamelessly displayed. The Marquis de Sade has become unexpectedly fashionable. Reeditions of Sade are decorated with philosophical and even moral commentaries, since sadism seems to respond to certain aspirations of our time. This pornography has recently been augmented with a female branch, thanks to novelists who perhaps seek to compensate thereby for certain frustrations. Even among some quite good and distinguished writers, not to say pious ones, we find a kind of discretely measured pornography to augment decreasing sales and make it clear that the author is not too far behind the times. Nothing is easier than to be more erotic than one's predecessor, and the phenomenon's monotony is easy to observe. Highly publicized trials constitute a fruitful advertisement for works that the prior generation might have found scandalous (*Lady Chatterley's Lover*). One thing is clear; a publication condemned is a publication sold. Censorship promotes the dissemination of the works. It is too obvious for it to be useful to insist.

I have said that these phenomena mutually reenforce each other. The perspective from which their collusion is best seen is literary publicity. The newspaper allows them to be joined and combined. Here again, Sainte-Beuve showed himself clairvoyant, because he was present at the beginnings of this new development. He saw a respected French newspaper agree for the first time to published the paid *announcement* of the publication of a book, and he was troubled. Without yet foreseeing the magnitude that this phenomenon was to assume one day, he perceived

the danger for the cultivation of letters in the fact of making oneself complicit with the forces of money. He likewise noted the appearance of the reminder of advertisement already made that was then called *réclame*, publicity,[11] and which was only a paid and commercialized literary criticism responsible for selling the book by praising its merits. Regular reviews are open to wide participation. A book's announcement is repeated several times, accompanied by extracts from already published reviews, sometimes reducing them to the single phrase that might pass for praise, truncated if it is necessary and, in any case, excluding the slightest reservation. The authors themselves have lost all shame. One no longer dares to thank someone for sending a book, because of the possibility the slightest courteous word may soon be repeated as a public praise with one's signature, in some daily or weekly. Naturally, to these forces are added those of erotic publicity. Modest and decent poetry does not always hesitate to support itself upon these impure allies in order to recruit readers. It is necessary to read certain of these documents to believe in their possibility.[12]

11. We can learn from Sainte-Beuve the origin of this French word, new for him in this sense, which he took the trouble to define: "For those who do not know, we will say that the *réclame*, publicity, is the little notice slipped in toward the end, inside the newspaper, ordinarily paid by the publisher, inserted the same day as the *announcement* or on the following day, briefly giving a short flattering judgement that prepares and colors that of the *article*" (Sainte-Beuve, "De la littérature industrielle," in *Portraits contemporains*, 1:493n1). Sainte-Beuve immediately notes that the acceptance of the mere advertisement has "rapid and infinite consequences." "In order to have the profit of the announcement, there is complaisance toward the books announced, which makes criticism lose its credibility." What would he say today? On p. 16, the June 4, 1964, *Figaro* published a publicity announcement measuring sixteen by twenty-five centimeters (seven and a half by ten inches) exactly in the middle of the "Short Announcements and Real Estate Guide." The writer whose work in question is presented as an item "of the best vintage" certainly does not dream of hiding the operation's commercial character. It is wine merchants' publicity.

12. See, for example, this excerpt from a Paris daily [source unidentified] of Jan. 26, 1964: "She Scandalizes Her Editor."—To manage to frighten a Paris editor in the century of "La Motocyclette" and the "History of O" is an exploit all the same, especially when we are dealing with a twenty-three-year-old female author, whose first book this is, which takes the form of a collection of poems. Edith F., who is Niçoise despite her flaxen hair, indeed has just seen her manuscript submitted to Gallimard rejected. Motive: the poems collected under the title *La bouche de mes songes* have been deemed too bold. Expressing her amazement, the young poet swears today that "if certain of her poems may seem erotic, for her part, their excesses have never appeared so." *La bouche de mes songes* will nevertheless be published at Éditions G., where Edith's poems do not seem to have provoked the same feelings. However, Edith asserts that she

The last advertising invention to be placed at the service of books is the literary prize. Cursed be the day when the first of these prizes was adopted by a large publishing house to increase its sales! Academic prizes are inoffensive, precisely because they do not go to writings produced to satisfy the great public. Also, they have almost no influence on book sales. It is quite different for the various prizes for novels. Each of these strange institutions carries each year to their point of maximum exasperation the different corrupting influences that threaten good literature. Everything finds a gathering place there: the personal vanity of jurors as well as prizewinners, intrigues that the press repeats and amplifies, criticism organized for or against this or that writer, publicity campaigns arranged and financed by the publisher's greed, press services on the scale of the financial interests at issue—we would not dare to enter into the detail of operations where scruples are not at issue. Simply to describe them sounds like satire. As certain horse races are disputed among two or three stables. the major literary prizes sometimes are reduced to competition between two or three "houses" working for the success of their protégés. A literary genre supported by such powerful forces of publicity cannot help eclipsing the others. The need to increase printings in order to maintain the book industry has altered the course of literary history by changing the condition of the publisher, the critic, the reader, and the writer.

Formerly, there was an extremely useful intermediary, the bookseller. A few of them felicitously still exist, but their kind is on the path to extinction. Who among us did not or does not still have "their" bookseller. Someone who knows the title of the book you are looking for, who informs you about the appearance of a work of the kind that he knows interests you. Bookstores are becoming more and more book depositories, where the booksellers are simple managers, and as they are overwhelmed by the avalanche of paperbacks, it is increasingly difficult for them to play the role of advisers to their clients the readers. The creation of book clubs was a first intent of large-scale publishing to direct the public taste by orienting its choices. Readers have nothing more to do than check the books they want from a prepared list. To entice them, they are offered several for nothing or nearly nothing. There will be time to pay for the others. Sifting the procedure to the realm of schools, there are surprising

will refrain from dedicating her book to her father: "He might react like Gallimard." The author's portrait is seen in a medallion facing the title that is spread out over three lines in large capital letters.

results: a strange conspiracy of pedagogues, industrialists of books, and the higher echelon of school administration undertake today in certain countries to rule over education by controlling the choice of books. Formerly, teachers used to choose the textbooks themselves. A little later, for reasons of convenience, the administration began to choose in place of the teacher. In a time when we are reaching the point where any quantity of books can be produced at will at an ever-increasing speed, it seems reasonable to organize teaching in function of book production. There exist cities where, in each class of certain schools, every student receives the supply of school books which he or she will need during the year directly from the publisher, with the necessary indications about the pace at which these books should be read. It will be difficult for the book industry to go further in its invasion of realms that it had the mission of serving.[13]

13. On this point, it is useful to read an article of William Emerson Hinchliff, head librarian of the Santa Barbara, California, public library, in *School Library Journal*, Sept. 15, 1961 [further bibliographic information unavailable]. Five percent of the time of teaching is used to borrow and return books to the library. Each student thus contributes fifty dollars of time per year. The library itself contributes an average of twenty-five cents to lend a book and put it back on the shelves. The librarian proposes a remedy whose concept will certainly please the book industrialists: "Saturation booking, massive blanketing of undergraduates [with] paperbacks, dealing with general instructions, the subjects, and the general courses, without it costing the students anything." The cost price (fifty dollars per student per year) does not exceed the resources of the elementary and secondary schools. From the material point of view, the essence of the project is that the school library will buy the books directly from the editor, with the largest possible discount on the list price. For the choice of books, "the faculty of each department in collaboration with library personnel, would design such courses on selections of the best available paperbacks." Through this unexpected angle, the mass book industry comes to control the very content of teaching. The school library will have to make portable cardboard boxes for only about fifteen volumes for each semester course and distribute them to the students the first day of class. The students will thus be provided with the weekly books they need to learn the course material. Thus understood, saturation booking could become a considerable force. With printing presses capable of producing paperback books at a rhythm of eighteen thousand copies per press per hour, the price of the volumes would be considerable lowered. "The explosive consumption of good books is the goal that summons us. The possibilites defy calculation." Cf. *Paperback Books in Print* 8, 32–34.

The plan to control education by the book is only a particular case of the book club phenomenon: elimination of the bookstore by direct distribution from the publisher to the public; choice of books made by the reader from a list established by the club's directors, who may furthermore be a publisher. After a period of prosperity, the book clubs seem to be in decline. The considerable discounts allowed on the sale price of books, all connected, lose much of their interest once the paperback or paperbound

What becomes of the author in all this? To tell the truth, this has been hardly considered. Writing is a domain where the offer far exceeds the demand. There are always authors ready to get themselves published, not only for free but at their expense. Moreover, as we have said, the author's and editor's contributions are essentially different in nature. The problem of what their relation *ought to be* does not therefore entail a solution. Let us limit ourselves to saying briefly how things are in a country where statistics are readily available. In 1952, the American public spent sixty-six million dollars buying paperbacks. Retail bookstores made twelve to fifteen million. Wholesalers around ten million. Authors' rights amounted to around four million dollars. The proportion is not very heavily in favor of the writers.[14] It is less than the tips hotels add to their bills for service, but formerly writers got almost nothing from the sale of their works. Descartes refused to be paid for his best seller *Discourse on Method*. I am ashamed to confess that his work has profited me more than him.[15]

put reading within reach of all purchasers. Cf. Fisher, "Book-Clubs." The conference [at which Fisher spoke] dates from 1947, but this piece is still worth reading.

14. Lewis, "Paper-Bound Books in America," 319.

15. I do not dare to immerse myself in the unsolvable problem of what good or bad influence literature in *digest* form might exercise on communication of ideas and knowledge. Examples are: *Masterpieces of World Literature in Digest Form*, Harper Brothers, in three series [first and second series, 1952; third series, 1960; there was a subsequent fourth series, 1969]. From the same publisher: "Essential for students, free for private libraries, *Masterpieces of World Philosophy in Summary Form*, edited by Frank A. Magill. In this last enormous tome, we find distilled the wisdom of the centuries, the key thinking of the greatest world philosophers from antiquity to our days. Its 1100 pages are easy to read; however, they are authoritative and give summaries of two hundred hugely influential philosophical works belonging to one hundred thirty-nine different thinkers. By far the most extensive and up-to-date book of its kind, it has been expressly prepared by twenty eminent professors of philosophy for the use of students and the public at large" and so on.—When we recall how scrupulously Bergson thought about each word, we are confused at the idea that he can be reduced to "summary form." Yet it is necessary, if mass society asks, that it be provided with a "mass Bergson." What should we think?—I regret that I have no information at all on the Frankfurt Book Fair, where for the eighteenth year, 2600 publishers come to meet each other to exchange their works in an atmosphere of collective madness where the taste for the hunt and passion for the game raise the bids. Three "five-legged sheep" were distinguished at this fair: the most bitterly disputed was William Manchester, *The Death of a President*; next, *The Pope Speaks*, by Jean Guitton, "of which one hundred sixty pages are written"; at this noble fair, Jean Guitton is sold by the foot; also Stéphane Groueff, *The Manhattan Project*, on the construction of the first atomic bomb (see *Le Monde*, Oct. 1, 1966 [no further bibliographic information available]).

I have spoken of publishers as if there still were publishers, but most remain in name only. Their real number decreases steadily. In reality, there are publishing companies, administered by directors and controlled by banks. The names Hetzel, Hachette, Calmann-Lévy formerly or even recently corresponded to some real person, to genuine creators, each one of whom had founded a publishing house made in his image and destined to publish a certain type of books of his choice and taste. Today, it is difficult to say what is hidden behind the names of publishers except company names and directors sometimes bereft of any personal literary competence but expert in the art of making money.

After writing these things, I felt a scruple. Hadn't I made the situation darker? The following lines in the October 31, 1964, *New Yorker* confirmed my feeling: "The book trade everywhere gives the impression of being weak in the knees. Big publishers are ingesting little ones, firms that have no interest in or knowledge of books are taking over old established houses, and those publishers who, as a matter of course, continue to bring out good books are being forced to rely increasingly for their profits on bestsellers, reference books, and such subsidiary rights as book clubs, serializations, and films."[16]

One would have to be blind not to see what a combination of hostile forces, although they have no intention of being that, has converged today against the *honestum* in all its forms.[17] Good literature is one of those forms, and the industrialization of the book is all the more serious in that this industrialization exploits good literature under the guise of serving it. The established hierarchy of literary genres, writers, critics, readers, bookstores, even publishers, everything that relates to books, has been changed by this evolution whose end cannot be foreseen.

16. "Profiles," 63.

17. Moreover, the saturation of the market by novels that imitate each other is perhaps in the process of modifying the situation. "Information, not the novel, is what occupies center state of publishing. . . . In his book, *Waiting for the End: The Crisis in American Culture, Race, and Sex*, New York: Stein and Day, 1964, Leslie Fiedler maintains that the novel may simply disappear. If that happens, it will be primarily because the artistic faith that used to sustain writers has died, and secondarily, because the need that the public asked them to satisfy is better satisfied by different media, let us say by pornography, television, movies, for example, and other forms of popular attraction" (*Time*, Dec. 16, 1967, 83 [actually, *Time* does not have a Dec. 16, 1967, issue; no further bibliographic information available]. In conclusion, if the novel must disappear some day, it will be for its high intellectual character. It will be missed.

There is, however, no reason to despair, This most impressive industrial mass would quickly melt away if it were not fed and maintained by a slender thread of disinterested literary creation. So far, industrial literature only rushes to help victory, it multiplies successful works, but it never runs any risk. Authentic literary life flows outside of industrial literature, which contains no power of invention within itself. Living literature is the work of still unknown or unrecognized authors, who take around masterpieces that nobody wants from publisher's office to publisher's office. Marcel Proust's *In the Shadow of Young Girls in Flower*, and Louis Hémon's *Maria Chapdelaine*, were works that later became powerful moneymaking machines after being initially rejected by the big publishing houses. In some cases, they were rejected by the public, since *Maria Chapdelaine* was first published as a serial in the periodical *Le Temps*, without attracting anyone's attention. In Canada, where it was published as a book for the first time, it found a publisher only because a printer was looking for work to keep his employees busy. In literature as elsewhere, art and money are certainly not necessarily hostile forces but of essentially different orders. The free little flame will doubtless never be smothered by the material force that threatens to extinguish it. From time to time, it will always be born from works written by uncertain and self-doubting authors, but authors that desire them for their beauty alone.

4

Liturgy and Mass Society

THE ARTS OF THE beautiful consist of personal creations intended for sensibilities similar to those of their creators. In all orders, we have seen works of art captured by mechanical forces capable of indefinitely multiplying their images and in this form putting them indirectly at the disposition of the masses. In the domain of the visual arts, of music, and even in one sense of good literature, this phenomenon poses problems for which perhaps we lack a satisfactory solution but of which philosophical reflection cannot be unaware. We can add to them the problem that modern forms of liturgy pose to old religions. Here, I will speak of the question from the point of view of the religious worship I know best, that of the Catholic, apostolic, and Roman Church. But it suffices to open a foreign weekly to see that the non-Catholic Christian churches grapple with the same problem. Is it credible that Christian worship should retain in the twentieth century the forms it had in St. Paul's time?

This is all the less credible in that everything contributes to making the problem particularly difficult to resolve in the case of Catholic worship. So far, we have asked ourselves what happens to the arts of the beautiful when the mass means of information take hold of their products to respond to the needs of the new mass societies. The liturgy, which consists of ceremonies and prayers arranged in a certain order, is the superlative religious art. There is no art that the liturgy cannot put to use: architecture, painting, music, literature, theater, even dance—all of it is mobilized or capable of being mobilized for the ends of religious worship. A glance at this immense field of possible research will allow us to be sure that certain phenomena, which otherwise would be meaningless,

become intelligible in the general framework of conflict that puts at odds the creations of the mind and the massive contemporary techniques at the service of their diffusion.

If there exist mass societies or those that have the vocation to be such, the Catholic Church is one. Let us recall the luminous definition offered by Edward Shils: "The new society is a mass society precisely in the sense that the mass of the population has been incorporated *into* the society."[1] There probably exists no real society where the population is totally incorporated into its mass. The distinction between alien and citizen is practically universal. One belongs to the Party or not in Russia. One is white or a person of color in the United States. It is preferable not to be Portuguese in Brazil. It is better to be rich than poor and an administrator than administered. Innumerable stratifications, different in nature, thus introduce real differentiations into societies that in their intentions are most egalitarian and communitarian.

The Catholic Church is no exception to the rule. It is better to be a priest than a layman and even than a simple monk, as were St. Benedict and St. Francis of Assisi. It is better to be a bishop or archbishop, if one can, rather than having the uncertain status of the domestic prelate of His Holiness. The cardinal, a hybrid politico-religious dignitary, is a clearly more striking personage than the others; and of course, the pope, surrounded by his court, stationed at the summit of his immense spiritual family in a solitude that his grandeur has created, is very far from answering to the concept of citizen of a mass society. Insofar as the Church over which he presides is a human, earthly, temporal society, loaded down with material interests, the pope is not incorporated into the mass. The astonishing garb with which high ecclesiastical dignitaries are decked out, the processions, parades, and all sorts of exhibitions, with appropriate setting and furniture, make it impossible for simple members of the faithful to imagine that they are part of a society in which all are incorporated in the same sense and to the same degree as they are.

Yet, all this staging, all this ecclesiastical pomp are only the outward embodiment in time and space of an authentically spiritual religious society, the Church of Christ. We can certainly say that with that of Abraham, whose mission it has assumed and whose elevation it guaranteed, it is the perfect type of mass society to which all its members belong in the same sense, in the same degree, endowed with the same means, and destined

1. Shils, "Mass Society," 288.

for the same supernatural end, since the true head of this society is God himself, before whom all human beings are equal. From its creation, the Church has wanted to be what today we call a mass society, where every Christian would be included in the same way as every other, enjoying all the privileges attached to the status of member by the simple fact of being integrated into the group by baptism and faith in Jesus Christ. In this sense, the pope is neither more nor less in the mass of the Church than are the most simple faithful or the tribal peoples whom the missionaries guide to human dignity at the same time as to Christian dignity. Current ecumenical endeavors have first of all the object of making the virtually universal and mass society actually become such.

Like every society of this kind, the Church needs massive means to assure its extension to the masses and their perfect integration, which is the Church's very end. Its primary activity is missionary; its primary means of propagation of the faith is preaching. Jesus Christ imposed it upon his apostles, and through them upon all future Christians, as their principal duty: "You, therefore, must go out, making disciples of all nations, and baptizing them in the name of the Father, and of the Son, and of the Holy Spirit, teaching them to observe all the commandments which I have given you" (Matt 28:19). The words *all nations* include the whole human race. The word *teaching* specifies that we are clearly dealing with a mission of information on a world scale.

Therefore, it seems that a sort of divine harmony predestines the Catholic Church (or the Christian church, if we admit the virtual unity of such a church made up of all Christian confessions) to put to work massive means to fulfill itself. It is inevitable that its means of recruitment should first be means of mass information for the masses. The Church in a sense is dedicated to mass media, and we will see that it knows this. The missionary epic story boggles the imagination of those who stop to consider it. As vanguard of the apostolic groups, the missionary endeavor testifies to the necessity imposed upon the Church of propagating its truth by all means, but we could say that contemplative men and women entirely devote their lives to the same goal by other methods.

Vatican II inaugurated a new conciliar style, about which the historians will certainly say that it was influenced by mass societies and the methods they employ. The Church had never gathered a council whose members represented the catholicity of all parts of the world, of all races, and all nations. It had never convoked representatives of schismatic churches and separated Christendoms. For the first time, the Church

disposed of means of mass communication such as radio, television, its own press, and that of the main civilized countries. We are near enough to the event to remember having been somewhat surprised by this mobilization of so many modern publicity techniques put at the service of religion. Certainly, it was the first time that the Church could set them in motion on such a large scale, but it did so. It even drew attention to its determination to employ them.[2] Finally and above all, the popes' insistence on the concept of ecumenism, which was the particular mark of the council, can be connected, not in its origin but in the choice of time and means, to this general movement that nowadays leads the most developed societies in the direction of more and more marked expansion and integration. Perhaps it is inevitable that societies close in on themselves in the measure to which they extend, in order to prevent possible disintegration resulting from their extension.

This movement, to which we are too close to see in its entirety, allows us to understand better certain problems as old as the Church itself,[3] which perhaps are situated for the first time in their correct perspective. Since the Church has always employed temporal techniques, it has always put the resources of the visual arts, music, and literature to work. It has done this so freely that it is impossible to write the history of art in certain periods and certain countries without giving a preponderant place

2. Second Vatican Council, *Moyens de communication sociale*, 3:391–408. Fr. Émile Gabel, the editor and translator of this document, points out: "The decree on the means of social communication was promulgated the same day as the dogmatic constitution on liturgy. The coincidence has much to teach us. Through the liturgy, we enter into communication with God. By all these modern means, human beings enter into communication between themselves" (Gabel, in Second Vatican Council, *Moyens de communication sociale*, 389).—Let us add that worship and the liturgy, paradigmatic collective means, can become mass means or "mass instruments of communication and information" when public ceremonies are directed to large gatherings, like certain masses celebrated outdoors in stadiums ordinarily reserved for athletic events and when broadcast over radio and television.

3. Medieval pilgrimages and even the crusades have some relation to the techniques of mass communications. Popular predication carried out by orators like Bernard of Clairvaux, Peter the Hermit, Anthony of Padua, Vincent Ferrer, and others of the same caliber, did not differ essentially from oratorical propaganda of modern political tribunes. The latter is the same thing with the microphone added. Oberammergau and other similar manifestations simply continue the medieval tradition, for example, *Le Mystère de la Passion* by Arnoul Gréban, of which a remarkable critical edition has just been published by Professor Omer Jodogne of the University of Leuven. This astonishing work, an authentic summa of theology, both scholarly and biblical, is completely made for the mass media of religious information.

to what is called religious art. On the other hand, the Church has never cultivated art for art, literature, or philosophy for their own sake, or any temporal technology for the peculiar goals of this technology, but always with a view to its own goals. Insofar as the liturgy is the place where all the means of information disposed by religion converge, it is also the place of the principal questions posed by the use of mass techniques.

Until now, the Church has not accepted that image and reality are equivalent for religious ceremonies. The faithful who can attend Sunday mass are not authorized to limit themselves to a mass on the radio or even television, heard and seen by them on a screen. We can easily imagine the reasons for the Church's attitude or at least certain of them. Those who think they attend a concert by listening to a radio broadcast, even one called "live," are free to cherish this illusion. However, the Church knows very well that a reality's image is not that reality; that a social act ceases to be itself when the participant excuses him- or herself from participating in it; and that in its very physical reality, a liturgy requires that those attending participate in it directly, without limiting themselves to look at it. The argument nevertheless remains possible. It is easy to anticipate that it will be asked how the image of a mass on the retina differs according to whether the mass is seen directly or projected on a screen. I happened myself to hear a midnight mass at St. Patrick's in New York City from inside a confessional where the crowd had shut me up. Did I participate better in the liturgical act being present without seeing it than I would have done absent but seeing it? However that may be, it cannot be disputed that the mass means of information are henceforth available to the Church in all the circumstances in which it wishes to have recourse to them: the election or funeral of a pope, the spectacle of a General Council with its staging, its vestments, its processions, its music, and the colorful crowd in which all parts of the world are represented. As a mass society with global dimensions, the Church eagerly grasps, hoping for the best, the mass media that modern science and industry put at its disposition. Seeing the ease with which the Church installs itself upon the waves, one would almost say that it has only just found the means corresponding to its end.

The visual arts associated with worship, from architecture that constructs churches to painting and the decorative arts that furnish them, naturally follow the usual fate. The places of worship, whose towers once dominated urban landscapes, nowadays are sunk in the jungle of buildings that surround and sometimes dominate them as skyscrapers do in

New York. Built with "modern" materials, which today are artificial ones, decorated and furnished with objects manufactured in bulk, these religious buildings can be bought with preestablished plans, including their complete sculptured, painted, woven decorations cast upon models that can be replicated at the lowest price. It is useless to stir up again the polemics about the industrialization of the visual arts. That we are dealing with religious arts does not change the problem at all. What is new is that the Church has become aware of itself as a mass society and consequently is dedicated to systematically putting the appropriate means into practice.

For the masses to be integrated into society, their artistic preferences must find satisfaction in it. It is a waste of time to want radio and television broadcasting according to the taste of elites. If the elites want media that satisfy them, it is up to them to obtain them. The dismay of cultivated persons in the face of what mass media offer them is understandable, but they are not the ones that it is sought to satisfy. After having conducted an honorable fight to maintain the rights of art, it only remains to them to be resigned. In the Church, the periods where religious art was the work of the masses and expressed their taste ordinarily are regarded as barbarian periods. Progressively invaded by the refined art of Greece, Rome, and Florence, Western Christian art today sees itself abandoned in favor of new styles. It is improbable that the Church will seek to galvanize forms of religious art that are now too Western, too academic, or too refined in order to respond to the taste of races and cultures alien to the Greco-Roman tradition, which furthermore are diverse among themselves. The only universal form of taste is bad taste. It has its rights. The Christian whose salvation is aided by the Sacred Hearts hated by Huysmans and the Virgins, according to the canons of average taste, would be wrong in having qualms about it. Becoming indignant about the advertising of this tackiness in religious periodicals shows that we do not understand the nature of the problem. The Church will never disown an art form destined by its very mediocrity to stock the mass media with images adapted to the crowds that are their public. The perennial nature of bad religious art is explained because art for beauty cannot be turned into the same thing as art for the propagation of the faith. When the two interests coincide, that is accidental. We should not even be scandalized that beauty should be made ugly sometimes, or at least consent to being made more common and a little vulgar if that is necessary to open hearts to the truth. A radical misunderstanding holds between those who want religious art to remain the art of an elite and those who, in an age when the Church

wants to fully achieve its destiny as mass society, want above all to give it the means to succeed.

Nowhere has the Church succeeded better at making visible its resolve to reach the masses by mass means than in its effort to make the vernacular languages turn into so many liturgical languages. Since a great many liturgical prayers are sung, it is necessary to proceed to a musical reform at the same time as to this literary reform. The two reforms are pursued simultaneously, not without encountering resistance and troubling those who, taught to pray in a certain way, find themselves today in a Church that calls itself the same, although its way of praying is alien to them. Each time that a reform takes place, a generation is sacrificed.

The abundant spiritual difficulties caused reveal a decided will on the part of the head of the Church to integrate the greatest possible number of faithful as tightly as possible into the body of the religious society. Only two possible solutions are conceivable for the problem of the liturgical language: a single common language for all the faithful or as many languages as are necessary so that everyone, without exception, can participate equally in the liturgy and draw the same benefits from it. To acknowledge as liturgical languages only two scholarly tongues, Latin and patristic Greek, or three by adding Slavonic to them, is to divide Christendom into unequal societies with a kind of religious elite to whom direct access to sacred texts is reserved in contrast to others, including the immense mass of simple believers who are incapable of directly participating in the treasure of revelation, prayer, and worship. A mass society cannot perpetually put up with such an inner scission. The immense, formal, and if necessary, threatening will to impose on all the faithful, without exception, the use of vernacular tongues in prayer and worship, an unprecedented event in the history of the Church, is better understood if we see in it a particular case of the movement of massification that currently drives the societies that are most alive. It is worthy of note that, in the absence of being able to incorporate everyone by means of a single common language, the Church would sacrifice heroically the unity of the means to best assure the unity of the end. Nothing shows better where the Church situates the essence of its mission. It must speak all languages in order "to teach all nations." It will do so, because it is necessary that all Christians can recognize their own language in that of the Church, if it is desired that they find a homeland there. We will therefore resign ourselves to the plurality of liturgical languages in order to guarantee the equal participation of all in the very source of salvation.

The vernacular languages are promoted to the rank of mass means at the service of the Church's ends, but the endeavor does not lack difficulties.

Strictly speaking, no perfect translation is possible. Each language is a system of signs and meanings that can coincide with others on certain points but about which it cannot be hoped that any other system of signs should always furnish the exact equivalent word for word and sentence for sentence. Nonetheless, it is possible to find sufficiently accurate equivalents for every liturgical formula when translating from Latin to French. Different systems of signs can be utilized to make them express the same sense, and it is improbable that Christians raised in the practice of prayer and of the liturgy in the vernacular should find the least difficulty in it. To then reestablish the use of liturgical Latin or of any other scholarly language would even become impossible.

Certain signs make us think that the massification of religion cannot be limited to the formulation of belief but be pushed to the point where, if it is absolutely necessary to assure the total integration of all the faithful to the masses, substitution of new concepts for the ancient ones would be accepted. Moreover, it is inevitable that ultimately the problem should be posed, because once the words change, the meaning is more or less deeply affected. When we think about the jealous care that the Church has taken with dogmatic, liturgical, and sacramental formulas where the faith is expressed,[4] we measure the intensity of the impulse that

4. We falsify the problem by saying that Latin is a dead language and that it is urgent to replace it with a vernacular language. Cicero's Latin is dead, the Church's is living, because far from simply borrowing from the Roman people, the Church has shaped it to its own uses and in view of its own needs. Church Latin is neither more or less beautiful than French or English. It does not enter into comparison with the models of the classical language because it is irreplaceable, in the sense that it is born from the very effort of the ecclesiastical writers to translate the Old and New Testaments (untranslatable into literary Latin) in order to create a theological language capable of expressing the truth of dogma in its rigor and in its subtleties. Like the Greek of the fathers of the Eastern Churches, for Western Christianity, Latin is the only maternal language, the only one of which it can be said that the cause of its birth was to express the Christian faith, and it remains its only reason for being. It is not a language borrowed by the Church but created by her for the needs of the faith. In this regard, it enjoys a unique privilege without any relation to the taste of antiquity, the respect for tradition, or the refusal to change habits. It is the only language in which Western Christians understand themselves perfectly and are absolutely sure of what they say. From there, heartbreak is perceived in the words of Pope Paul VI at the moment of sacrificing what he so exactly calls the Church's "own language," this Latin that is a "sacred language" precisely because it was born of the exercise of sacred functions and of the necessity to spread the *sacra scriptura, the sacra doctrina*. Cf. "Discours de Paul

carries it toward this more and more spiritually integrated society,[5] by seeing it accepts as equivalent formulas that at first sight are not evidently so. As the only competent judge in the matter, the Church is mistress in its own house and beyond any objection. This fact only illustrates better the depth of the revolution that the Church imposes on itself in its sovereign freedom.

The case of *consubstantial* is particularly worthy of attention, because it had remained inalterable since the Council of Nicaea in 325,[6] incorporated into the liturgy by the credo of the mass and the Preface of the Holy Trinity, and inseparable, for every Catholic born before the liturgical reform, from the very faith for which he would have preferred to die than to deny. However, maintained in the Latin text of the symbol as the authentic expression of this faith, the word *consubstantial* has been excluded from the French text of this prayer. It is a phenomenon worthy of attention and even, in a sense, passionately interesting.

It is all the more so in that the problem was simple. The issue was to translate into French the Latin text of the creed, in which St. Thomas heard "the fathers" speaking.[7] This text, which is recited or sung every day

VI sur la liturgie," in Second Vatican Council, *Liturgie*, 242.

5. The concern to integrate Christians into the Church as completely as possible is expressed in the language of our time in Paul VI's speech at the closure of the second session of the Council, Dec. 4, 1963; then in his remarks to the members of the Consilium, Oct. 29, 1964; finally and above all in his declaration on Jan. 13, 1965, to the chaplains and members of the Italian Catholic Action. The object of the liturgical reform is "to make every Christian a living, acting member of the Mystical Body," to elevate him or her to "participate personally in the most noble, beautiful efficacious and mysterious action that human beings can exercise in their pilgrimage on earth; and to insert themselves into the process of evolution of their destiny, to intercede between the world and God, which is precisely the action of the holy liturgy." Today the Church promises this action with a new fervor "and with modern principles" (Second Vatican Council, *Liturgie*, 236). Cf. "community requirement" (Second Vatican Council, *Liturgie*, 238); "the Church above all is a religious society, a community of prayer, a people" (Second Vatican Council, *Liturgie*, 230).

6. The Nicene Creed: "ἔk tès ousias tou patros . . . hoc est de substantia patris . . . omoousion tò patros . . . unius substantiae cum Patre" (Denzinger, *Enchiridion Symbolorum*, 30). Those who say of the Son that he is *ex alia subsistentia vel essentia* than the Father are anathematized by the Catholic and apostolic Church. The words *ousia*, *substantia*, *unius substantiae* have the object of excluding any possible ambiguity about the unity of the three divine persons.

7. "Contra illud vero quod dicitur eum [i.e. Filium] non esse eiusdem substantiae cum Patre, additur in Symbolo: *consubstantialem Patri*" (Aquinas, "In Symbolorum Apostolorum exposito," 166 [§890]).

at mass, professes faith in God the Father, then in Jesus Christ, only son of God, *genitum non factum, consubstantialem Patri.* There is no difficulty in translation: "begotten not made, consubstantial with the Father." The translators of the text into the modern language have, however, translated *consubstantialem Patri* by the words "of the same nature as the Father," as if the liturgical text said *connaturalem Patri.* Many of those who heard this new expression for the first time were surprised but, believing it was a simple mistake, they kept quiet. When no rectification occurred, some expressed their surprise and drew the attention of the ecclesiastical authorities to this strange problem. Nothing happened, because far from straightening out the apparently incorrect translation, the new liturgists replaced *substance* by *nature* everywhere the opportunity arose. The Preface of the Holy Trinity does not permit any of the faithful to be unaware of it; the Son is one with the Father, "not in the unity of one person, but in the Trinity of a single substance." A few lines further on, the same liturgical text proposes another formula for the same dogmatic truth: "*et in personis proprietas, et in* essentia *unitas.*"[8] Therefore, unity of substance or unity of being is all the same. During all the centuries that the Church chanted and recited these words, it had time to think about the word *nature,* but the idea did not come up. One wonders why it has suddenly seemed urgent to recur to it.

The point of this choice is solely to avoid saying something else. The French text of the new liturgy has no intention of affirming that the Son is *of the same nature* as the Father, but rather of not affirming that the Son and the Father *are of the same substance.* What makes the problem

8. The preface's very simple text has aroused difficulties for the translators resolved to change it. Here is a first attempt: "You three distinct persons are only one nature." "We adore you three distinct persons, their one nature, and their equal majesty" (*Manuel des Paroisses,* 21). The same manual's credo presents the Son as "having the same nature as the Father." I have later heard different translations: "not in the unity of persons, but in the community of their natures" and again "in the Trinity of persons and in the unity of their nature." The Latin text says: "non in unius singularitate personae, sed in unius Trinitate substantiae." In English, that would be "not in the singularity of a single person, but in the Trinity of a single substance." The Latin here is difficult to replace, because the word *Trinitas* still lets us perceive the meaning of two roots, *tri* and *unitas.* To say in English "the unity of persons" is to use inexact language, because the persons are not one but three. If we say "the Trinity of persons," it is useless to add "and in the unity of their nature," because we have already said it, the Trinity of persons being their "tri-unity." Cf. Aquinas, *Summa theologiae,* I, q. 31, a. 1, ad. 1: "Hoc nomen Trinitas, secundum etymologiam vocabuli, videtur significare unam essentiam trium personarum; secundum quod dicitur Trinitas, quasi *trium unitas.*"

interesting is that the French creed no longer wishes to deny that the Father and the Son are of the same substance, or, as the Preface of the Holy Trinity still says, of the same "essence" or being. The authors of this text certainly do not doubt it, or otherwise it would not be enough for them to change the translation of the Roman liturgy's text; it would be necessary for them to suppress it. As long as the Son and the Father remain *in unius Trinitate substantiae*, what the French sing or do not sing makes no difference to the matter. Accordingly, one may ask about the reasons of this peculiarity.

One fact invites us to look for them in France itself, because in other countries containing a considerable number of Catholics, at least two of them have not thought they ought to modify the wording of their credo. It remains in Italy, mother of our Western literature, where the Son is still *della stessa sostanza del Padre*. In the United States also, where a largely Irish clergy watches attentively to prevent any possible deviation, the Son remains *of one substance with* the Father. Accordingly, in these two cases, it is perfectly clear that there is only a single divine being, common, if one can say that, to the Father and to the Son, If we are careful, there we have everything that the texts of the symbol and of the preface mean to affirm with a clarity such that no ambiguity, uncertainty, or hesitation are possible. God's unicity comes first: *Credo in unum Deum*. The preface especially written for the Holy Trinity affirms it all the more strongly: *Qui cum unigenito Filio tuo et Spiritu Sancto, unus es Deus, unus es Dominus.* The rest of these two liturgical texts must be understood in the light of this fact. When the symbol says that the Son is consubstantial with the Father, or the preface affirms that God is one "in the Trinity of a single substance," the verbal root and the word *substance* are only there to affirm this unity of the divine being without possible ambiguity. To say that the divine Trinity is a single substance or to say that there is only one God, is all the same.

It must be further understood that the word *substance* means nothing else here. No philosophical concept enters into play. Besides, it would not be easy to find a definition of substance about which, limiting ourselves to those who admit its validity, all philosophers were in agreement. Different scholastic definitions of substance are known, beside that of Aristotle himself. Those who deny nowadays any philosophical validity to this concept about which they form the oddest notion can say only that they reject it in any sense whatsoever. The dogmatic formula of the symbol and the preface remains entirely alien to these controversies, because

the word *substance* in them connotes only the concept of an individual being that is one, unique, indivisible in itself, and actually existing. The God of Catholic faith is one, first as every real being is one, but so much more one that its transcendent unicity is going to permit about it further affirmations that would not be conceived from the point of view of our own relative and imperfect substantial unity. Accordingly, it is very important to understand that the illiterate person who says, "I believe in one God, the Father almighty, and in one Lord Jesus Christ . . . consubstantial with the Father" and the theologian who pronounces the same words with his mind full of philosophical, theological, and historical memories say identically the same thing. The concept of substance signifies nothing more for one than for the other. It just means that there is only one God and that this God is one. That is all.

No doubt it will be asked why make use of this scholarly word in a context where its technical meaning is not at issue. The first response is that indeed this word is not necessary. It has been chosen because a better one, or even one as good, has not been found in Latin. St. Thomas Aquinas, whose theological authority is not slight, is one of those who do not like to speak of God as a substance. The reasons for that may be learned by turning to *Summa theologiae*, I, question 29, article 4, where the weakness of human language is clearly seen, even in the mouth of the most illustrious theologians, when it is necessary to speak of God. That is a labyrinth whose exit we are never sure we have found. In what concerns *substance*, the word cannot mean anything that in God would be found under his nature or under his essence. Such propositions mean nothing, but it is what the word *substance* suggests directly to the mind. According to Thomas Aquinas, who is not fond of applying the word to God, it "corresponds to God insofar as it means *exist by oneself*."[9] I do not think I exaggerate by saying that when a Christian declares that the Son is "consubstantial" with the Father, he rarely thinks of God's *perseity*. He probably thinks that the Son is identically the same God as the Father, because the substance of one of the divine persons is the same as that of the other. The two persons are one and the same *being*. There is nothing to add.

Consequently, the word *substance* suffices. Where the substance is one, nature is also one. We would achieve the same degree of precision by replacing *substance* with *being* or, as does the preface that we mentioned,

9. Aquinas, *Summa theologiae*, I, q. 29, ad. 4.

by *essentia*. But the Latin word *essentia* retains its original links with the verb *esse*, whereas the French word *essence* means that which constitutes the specific nature of a being. To say that the Son is of the same essence as the Father would be to say that he is of the same nature. Therefore, it seems good to prefer this last word. Again, we could translate *essentia* by *entity*, because the latter term comes from *ens, entis,* and means the state of that which is a *be-ing*. But here again the French has allowed the word to lose its force, because even when it does not mean an entity, an abstract noun taken as a real being, the strongest sense that can be given it is that of an essence or nature, conceived as endowed with reality. Again, *nature* is better in French than what we might want as a replacement.

However, *nature* is only a last resort and does not solve the problem, as St. Thomas Aquinas, desiring to avoid *substance*, never employs *natura* without adding *essentia* to it and inversely. Many examples are found in the *Summa contra Gentiles*, IV, 7: *Est ergo eadem essentia et natura Patris et Filii* (Therefore the essence and nature of Father and Son is the same). *Oportet quod eadem sit numero natura et essentia Patris et Filii* (It is necessary that the nature and essence of Father and Son be numerically the same). *Sequitur de necessitate quod sit eadem numero natura et essentia in Patre et Filio* (It follows by necessity that nature and essence in Father and Son are the same in number).[10] Consequently, both words are necessary, because to say that the Son is of the same nature as the Father is to say that he, too, is of divine nature and, in consequence, that he is God. But to say that the Son is of the same entity or being as the Father, in sort of the same *essentia*, is to say that he is not only a god but the same God: *Cum enim ex scripturis divinis ostensum sit Patris et Filii eadem numero essentiam esse et naturam divinam secundum quam uterque verus dicitur Deus, oportet Patrem et Filium non duos deos, sed unum Deum Esse* (For since it has been shown by the divine Scriptures that the *essence* and the *divine nature* of Father and Son is the same in number, *according to* which both are called true God, it is necessary that Father and Son be not two gods, but one God).[11] Because the two persons have the same nature, both are divine; because they have the same being, they are one single and the same God.

Such being the data of the problem posed to the translators, either we translate *consubstantialem* by *consubstantial*, as had always been done

10. Aquinas, *Summa contra Gentiles*, IV.7.

11. Aquinas, *Summa contra Gentiles*, IV.8.

before Vatican II; or else we replace *substance* by *nature*, but adding *being* (*essentiam*), as Thomas Aquinas took care to do. This would give us *of the same nature and being as the Father* a longer formula than *consubtantial*, but dogmatically beyond reproach. The last alternative would be to mention neither substance or nature but simply say *of the same being as the Father*, because in God substance and nature are identically the being itself, *esse*. Of these possible solutions, each of which had its advantages and disadvantages, none has been used. It was preferred to introduce a new solution, which unquestionbly was adopted for good and serious reasons. But since we were not told what they are, we typical members of the faithful found ourselves involved in the new mass church, no longer being able to do anything but dream about what had happened to us.

Some of the authors of the liturgical reform probably thought that the faithful would not pose questions. This is a psychological error. Novel forms of prayer cannot be imposed upon believers raised in the conviction that the substance of dogma is untouchable without inspiring some surprise in them. The word *nature* is familiar to them, and its introduction creates no difficulty. What surprises is that the word *substance* is eliminated. With it disappears what John Duns Scotus quite properly called consubstantiality of origin, which is the very relation of Son to Father, within the Trinity. The authors of the reformed liturgy knew this, of course. They also had to be aware of the situation they created by their decision, because the new liturgical text is not optional; it is obligatory. The member of the faithful who insists on singing the credo in Latin rather than French in order to preserve *consubstantial with the Father* demonstrates a lack of discipline and a spirit of rebellion, whose gravity, since I am not a theologian, I cannot evaluate. A priest who insists in proclaiming the Son consubstantial with the Father could, I imagine, come to be the object of serious warnings and then sanctions. Therefore, the fact is that consubstantiality has been eliminated in favor of connaturality. The authors of the liturgical reform cannot have failed to see the consequences of their decision. The first and principal one is that the new symbol fails to affirm the Trinity's unicity. It does not deny it, but it no longer teaches it, and by imposing this omission upon the faithful, it forbids them to continue to profess it, as they had always done since the Council of Nicaea. Because if the Son is of the same nature as the Father, he is God like the Father, but if he is not of the same substance or of the same being as the Father, he can be a second god, and meanwhile the Holy Spirit is a third. Certainly it is not said that the Son is a god other

than the Father. It is merely forbidden to employ the only dogmatic formula that excludes all possibility of error in this regard. *Haec praepositio de*, St. Thomas firmly observes, *semper denotat consubstantialitatem.*[12]

Should we attribute a desire for ecumenism to the reformers, which makes them soften certain formulations of the dogma in order to facilitate its acceptability to different religions? That is not very likely, because the dogma of the Holy Trinity, cornerstone of Christianity, is also the stumbling block that thwarts any possibility of agreement with Judaism and Islam. For these two religions, Christianity is polytheism. Although Christians until now could deny that, since the three divine persons are only one and the same God, they no longer can do so, if they are French. For if the three persons have only the nature in common, not the substance or the being, each of them is a god like the two others. Just as a father and his son are two humans of the same nature, the Father and the Son are two gods.

This is not what was meant, but then why replace the appropriate term by one that is not so? I do not know, but I must first report that, of all the priests to whom I have posed the question, none seem to have thought that this change of a word could have the least importance. I would add that, when pressed a little, they have expressed the opinion that the reformers no doubt wanted to avoid the word *substance* as too technical or too scholarly, saying nothing to the mass of simple faithful, whereas the meaning of *nature* is understandable and known to them. That may be, but the object of the symbol is not to make the mystery be understood but to define it. It is not defined by saying that the Son is of the same nature as the Father, because that is true of all sons. That a son was not of the same nature as his father would be an unfathomable mystery. By affirming that they are that, we say nothing at all, except a truth of the same order as those made famous by the name of Monsieur de la Palisse.[13] In fact, the desire was to speak a mass language to the masses. *Substance* is a scholarly word; *nature* is simpler and better for ordinary folk. Accordingly, *substance* it will be, even if that is not the right word. Whatever the future of the new expression may be, the mere fact that it could be proposed and accepted at some point is an important lesson in itself.

12. Aquinas, *Summa theologiae*, I, q. 41, a. 3, ad. 2.
13. [Translator: I.e., it is a truism or tautology.]

We are not discussing the problem here for its own sake but as an example of this truth, common to painting, music, literature, and to the liturgy itself, that all massification entails popularization. The abandonment of *consubstantiality* would be a theological monstrosity, unless those who favor it think that at bottom it is unimportant; that nature and substance are the same thing; and that if want to win over the masses or not to lose them, it is necessary to adjust ourselves to their intellectual level. However, giving them the impression that they comprehend a mystery is not a profitable operation in the long term. We commit a similar misunderstanding by starting from the principle that the religious masses love vulgarity. It is completely the opposite. It would be better to admit without gloss that God is a single being in three persons, and to say this truth in the starkness of its exact theological formula, rather than to serve up to the crowds an adulterated theology, always good enough for them, while reserving the truth for the schools where *sacra doctrina* is taught as an esoteric science reserved to the initiated. Covering up a mystery is not a good method to make it accepted. Despising the crowds is not a good way to win their approval. The people are never vulgar; rather, they detest those who affect vulgarity in the hope of pleasing them.

The Church herself wants nothing of the kind. She even knows that she must expect deviations of this kind from the moment when she renounced the privilege that her liturgical language enjoyed for so many centuries. Pope Paul VI clearly defined the stakes and the risks of the reform in his remarks of March 7, 1965, to the crowd gathered in St. Peter's Square in Rome. His principal motive was clearly defined there: "The good of the people requires this concern to make possible the active participation of the faithful in the Church's public cult." In order to "make its prayer intelligible," the Church has consequently sacrificed Latin, "its own language," "which is a sacred language, serious, beautiful, very expressive, and elegant." Then, laying bare the heart of his thinking on the issue, the pontiff added that the Church "has sacrificed centuries-old traditions and above all the unity of language among its different peoples for the good of a greater universality, in order to reach all."[14]

We could not express better the difficulty that mass societies must overcome and that their efforts of massification very rarely completely vanquish. In order that all the faithful may really participate in the worship that is her very life, the Church regretfully decides to accept,

14. Paul VI, "Omilia de Paolo VI."

to recommend, and if necessary, impose the use of modern languages as liturgical languages. The division of Christians into two orders, those who know the liturgical language and comprehend its sense, and those who by not knowing it can follow the liturgical action at which they are present only indirectly and imperfectly, is going to give way to the immense society of the faithful who will all participate in the celebration of the same worship understood in the same sense. Except that, in order for this result to be possible, the Church must sacrifice the unity of its language to obtain the unity of meaning. This is what Paul VI's own words signify when, pointing out with unsurpassable power the paradoxical nature of this situation, he speaks of sacrificing "the unity of language among the different peoples" of the Church with a view of achieving greater universality, that of all Christians. In fact, we have just seen the problem's difficulty, because to assure its own ecumenism, the Church of France has just separated itself from a broader ecumenism: it no longer has the same credo as Rome. *La messa della communità cristiana* is not the whole Church's mass. To make itself ecumenical in France, it loses its universality.

To break up and divide in order to unify and assimilate is the dilemma with which all mass societies grapple in their effort to enlarge themselves. There, as elsewhere, extension is in inverse proportion to comprehension. The more mass societies absorb different elements, the less their massiveness succeeds in maintaining itself. The French who believe in the one, indivisible republic forget that the people of Nantes are also Bretons, those of Saint-Jean-de-Luz are Basques, those of Perpignan Catalonians, those of Ajaccio Corsicans, those of Chambéry Savoyards, those of Strasbourg Alsatians, of Dunkirk Flemings, and those of Nice Niçois. We could make the list longer. The United Kingdom of Great Britain and Ireland remains only incompletely united and with great difficulty, because neither the Welsh nor the Scots are English. Canada or the United States are not mass societies in the full conceptual sense of the term, and it is probable that the vast society of nations to which the world aspires has no obstacle to overcome worse than the nations themselves. They must be broken up and returned to their constituent ethnic elements before the unity to which they aspire can be established, not only in the acceptance of their very fertile individual differences but as their guarantee. The gray paste that French bureaucracy has made of France lets us anticipate what a genuinely integrated universal mass society would be. The Church enjoys a unique privilege insofar as its true

unity is totally spiritual in essence and consequently capable of finally overcoming all the obstacles that her temporal condition opposes to it. It will have to struggle always, just the same, to overcome them and that its victories, constantly put into question, not turn into defeats. Vatican Council II is a brilliant manifestation of the Church's vitality but also of the difficulties with which it will always have to struggle. The lucidity of vision with which the Church contemplates problems where her very life is at stake is bound up with the clairvoyance that makes her discern what is accessory and secondary from the one thing necessary that she has the mission to maintain. It is inevitable that sometimes we lose sight of it under the parasitical overgrowths that cover it. The Church is an authentically mass society only in the measure in which this *unum necessarium* is the bond and common good of all its faithful. One can be a more or less good Christian, but there is only one manner, the same for everyone, of being it or not being it.

The inevitable opposition and misunderstanding that the Church's updating provokes are tied to the nature of a mass society. Just as it is not necessary that all Christians speak the same language as a condition for all to be in communion in the same faith, likewise it is necessary that its art, literature, practices, worship, and liturgy should not be bound to the taste and knowledge of an intellectual or social elite. That would be to bind its future to that of minorities who are certainly open but restricted, whereas the Christian message is directed to all. A lowering of all levels inevitably accompanies every change of this sort. It is certainly necessary that the artists, the writers, perhaps even the philosophers and theologians accept thinking and praying like everyone, in order not to exclude from worship those who cannot participate in it in the way that corresponds to the elites. There will always be chapels for the outliers, but when we reflect that Christianity by essence is a society open to all human beings of all races and cultures, or lack of cultures, and that its message can reach all of them in its integrity, we understand that its worship, its liturgy, and even its teaching must also make themselves as accessible as possible.

The immensity of the problem is such that our gaze loses itself in details, but we can focus upon certain particular cases where its principal data stand out by themselves. Joris-Karl Huysmans initially wanted to call one of his books *The Two Faces of Lourdes*. He finally published it with the title by which it is known, *The Crowds of Lourdes* (*Les foules de Lourdes*). The book testifies very strongly to the passionate seriousness and deep intuition that inspired his judgment on a town, a worship, and

a liturgy, all of which wounded his taste and his way of feeling. As the first title suggests, the book draws a great contrast. On the one hand, there is the commercialism that abounds around the grotto of the apparitions (although the grotto itself is perfectly free of it), the vast and sometimes crude appearance of gatherings of thirty or fifty thousand pilgrims, the ugliness of the buildings and of their so-called artistic decorations, the coarseness of the hymns interminably worn out by countless false voices in a flow where polytonality owes nothing to musical art. Yet along with that, in that very thing, there is also a religious exaltation that touches everyone, a disregard for human respect that is found only at Lourdes; the pilgrims feel that Lourdes is not the cause of prayer but the place where they have the ability to pray; all this arises from the phenomenon that indeed is "the crowds of Lourdes." Where do they come from? Why do they come? What is the meaning of the ebb and flow, which carries the pilgrims toward the grotto, leads them toward their provisional accommodations, and then casts this human tide back toward the shore of the stream, the rosary, and the esplanade where the processions always end? We do not know, but they are there, and in their presence, the reality of Lourdes is summed up. Huysmans's aesthetic judgments were justifiable from the point of view of art, but perhaps he was able to find in his second title, so felicitously chosen, something that pacifies the conflict he thought he perceived between the two faces of Lourdes, because Lourdes has only one face. It must be taken as it is or left alone.

The area of the grotto of the apparitions is the place of a mass society, if ever there was one. Its power of absorption and assimilation is such that it instantaneously and totally integrates people from the moment they set foot in its area. Coming from all countries, speaking the most various languages, sometimes even professing religions that are not only non-Catholic but non-Christian, this people always finds a motive of remaining the same, all the while unceasingly renovating itself. In the moments when Huysmans's ill humor as a justly offended aesthete allowed him to see things as they are, he felt that the liturgies of Lourdes are just as they must be to open hearts to the message that the place presents them.[15] Those responsible for this annoying setting do no harm to

15. Huysmans's wavering is observed in his judgment on the obsessive processional chant whose memory so many pilgrims, incapable of abandoning it, take away with them in music boxes: "Finally, at the close, for the departure, the famous chant arousing the crowds with its refrain *Ave Maria*. The music is by Darros, the chapel master here. It is the Church's march, its *Père la victoire* or its *En revenant de la revue*.

persons whose refined personal taste sets them against it, because it is not impossible that an artistic people should wish to feed on beauty or at least that the excess of ugliness should annoy them, but it is more probable that the taste of multitudes will carry it always toward what panders to their abilities. That taste neither looks nor listens, or else it perceives only the beauty that it is made to see or hear, which can be seen in ugliness and indulges their taste for simple pleasures that are indefinitely repeated. The artists toward whom Huysmans shows himself so severe are themselves part of the crowds for whom they work. The mass media are just as necessary to mass religious societies as to any other. The religious society is invited to speak a language that is not that of the fine arts and good literature in order to make itself understood by all. To a mass religious society, give mass worship, liturgy, and arts. The concern to arrange and guide reforms where so many spiritual interests are in play belongs neither to the sociologist or to the philosopher. But to observe the effects of the growing massification of means of information upon the methods of apostolate used by a two-thousand-year-old Church is an object for reflection of the highest interest.

It does not seem that the Church itself has yet measured the whole extent of the problem. Vatican II discerned its nature very well. It saw clearly what problems the growing influence that the means of mass information exercise upon Christians, often unknown to them. But to what point the Church can be obligated to use them herself or already uses

It is coarse but stirring, very well made for crowds, it must be confessed. There is an electricity here, gold, noise, something rabble-rousing. The point is that if this were naive, it would be admirable" (Huysmans, *Foules de Lourdes*, 215 [*Carnet*, Mar. 15, 1903]). If this sort of popular lament is a chant that is "very well made for crowds," it is a perfect success. As for the naive character whose absence is lamented, the critic himself is the one who lacks it. The *Lourdes Ave Maria* is sung in the torchlight procession where each person carries a candle, whose cardboard shell shelters the flame, and sings the sixty verses of the hymn. During the large pilgrimages, the hymn is still too short. Is the hymn vulgar? Rabble-rousing? Very different impressions are possible. It seems to me exactly adapted to what Spaniards call the "processional gait," neither quick nor shuffling but moving *andante*, properly. As for its naive quality, consider: "She is afraid / Of an immortal lily; / She has as her belt / A ribbon from heaven. / We see a rose / On her blessed feet / Freshly opened / In Paradise. Ave, Ave," and so on. This astonishing collection of clichés offended Huysmans's literary taste, but there is a naiveté in the cliché whose meaning the refined person misses: "To the throne of grace / The path is known / The pilgrim passes / And passes without end." The complaint is without end too. Besides, in itself, the Ave Maria is already a mass liturgy: "To say the rosary is a medium, a vehicle, it is prayer put within the reach of everyone" (Baudelaire, *Fusées*, §17).

them without having clear awareness of it, the Council decree does not clearly state.[16]

The Council fathers were not always familiar with current modern sociological usage. Some of them knew it, but it is still fluid, and since it is translated as badly in Latin as it is in French, in the absence of deciding to speak American English, the fathers had to be content with approximations to equivalences.

In the title of the council decree, *mass media of information* or *mass media of communication* become *means of social communication*, which translates rather badly the expression's primary sense. Let us note, however, that this sense is exactly grasped by the authors of the decree *Inter Mirifica*. Among the marvelous technical discoveries in which the Church is interested, "it is necessary to assign a special place to the means that, by their nature, are apt to influence not only individuals, but also masses as such, and even all humanity. This is the case of the press, the cinema, radio, television, and other technologies of the same kind. One can indeed call them 'means of social communication.'"[17] The Church has evidently acknowledged itself to be predestined to use these new means to

16. The decree on means of social communication, *Inter Mirifica*, presented by Fr. Emile Gabel (Second Vatican Council, *Moyens de communication sociale*, 3:375–89), is the only one that encountered 503 opposing comments. See on this point, 3:378–80; regarding the "most important defects" of the text that was finally voted upon, see 3:380–83; particularly to be noted is the comment: "the decree is reserved in regard to the science of means of social communication" (3:382). That is true, but there is so much of a jumble in this science that perhaps having taken the lead in this reservedness is not always to be lamented.

17. The word *social* does not translate the meaning of the word *mass*. On the contrary, it blurs the distinction between *society* pure and simple and *mass society*. Within any society, all communications are social, but not all are mass communications, any more than all societies are mass societies. I have heard a communist poet become indignant upon hearing *mass media* translated into French as *means of information of the masses*. However, that is what they are, because they are given only in massive doses to reach the masses. But I imagine that this communist understood by the word mass the *Lumpenproletariat* or *proletariat of the rabble*, about which Karl Marx speaks in the *Communist Manifesto*, which is indeed different. The American term is not clearer regarding the sense of *mass*. To the contrary, it seems that the sense of *media* is well rendered as *instruments* in the translations of Council texts. The French word *moyens*, correct in itself, is a bit weak to convey the American connotations of *medium* and *media*. The point is not only about the channels through which the communication passes and is distributed but about active distributors of communication. Given the impossibility of foreseeing the duration of a technical language that perhaps is completely provisional, it was a good idea not to bind decrees intended to remain in vigor for a long time to it.

work "for the extension and consolidation of the kingdom of God." More precisely, remembering that it was founded by Jesus Christ to preach the gospel of salvation to every human being, "the Catholic Church considers it also to be its duty, on the one hand, to employ the instruments of social communication to announce the message of salvation and, on the other hand, to teach people the proper use of these means."

The Council's wise recommendations about the education of the producers and spectators, readers or listeners, as well as their respective responsibilities, makes us see more clearly still how seriously the Church takes this modern massification of its message. The pope assumes "the supreme pastoral charges in the area of means of communication." A special commission of the Holy See will assist in this task; bishops are invited to watch over this message in their dioceses; and "national offices for press, cinema, radio, and television" will be established at the national level.

The employment of mass techniques will pose inevitable problems everywhere. It is chimerical to imagine in any order that the elites will raise the masses to their art. It is not even healthy to suggest that, in the absence of success, the elites might try to limit the invasion of all orders of intellectual, artistic, and moral activity by mass means that tend more and more to make these activities serve the elites' own ends. That would not be fair. The masses have the right to their own culture and to the means that suit it. One can even be astonished that the masses do not seize the totality of the mass means of communication and information. Accordingly, the Catholic press will also be obliged to create a mass press, for the masses and at their level. Those who reproach the Catholic press for doing this will only be showing that they are mistaken about the direction of a general revolution whose influence no one can avoid and in which a society with a universal vocation like the Church has to take part.

One of the most important features of the problem of modernizing the liturgy is combined with the problem of the industrialization of books. As its name indicates, the Bible is the paradigmatic book, the book of books. It is also the best business in the publishing industry, because it is always the book that has sold the greatest number of copies, and the rhythm of sales gives no indications of slowing down. At the same time that selling Bibles is good business, it is a good work. What is more satisfying than to make one's fortune by spreading God's word, outside of which there is no salvation for human beings? *Omne tulit punctum* . . . [Horace: "He wins everyone's approval . . ."] Therefore, it is not surprising that the

twentieth-century biblical renewal, purely religious in origin and always selfless in essence, should be accompanied by an astonishing succession of publishing and bookselling operations that would merit study for their own sakes.[18] There is no liturgy without the Bible. From the moment in which it is decided that Scripture will be at everyone's disposition in all national languages, that readings during the mass from the Epistles and Gospels will be in modern languages, that the psalms will be next, an immense market that past centuries did not succeed in saturating will find itself totally and completely rejuvenated. Never has a religious movement had larger and more profitable industrial and commercial consequences.

In a secondary way, we will simply indicate that a publishing operation conducted in the "modern" spirit that animates and sustains book industrialization naturally sets in motion all the techniques of publicity and commercial distribution: "Eighty-eight color reproductions on glossy paper, of paintings that are the pride of museums and private collections in Europe and America, Michelangelo, Titian, Rembrandt, Murillo, Veronese and so on." To enhance the flavor of this collection, it is specified that "many of these reproductions are completely unknown by the general public, since the originals are carefully guarded by their owners." Consequently, while the Christian enjoys possessing images of our Savior, so to speak exclusively, the publishers' public relations calculates with satisfaction that "the Book of Books has its place in the bosom of every Catholic home." If this is true, what an operation! Let us therefore use the purchase order. The number of all the copies to be sent, payable in twelve installments, is left blank on the form, for the subscriber's choice.

It would be naive to be surprised by these things and pharisaical to be scandalized by them. Religious life transpires in a time and a place; modern piety cannot be like seventeenth-century pieties. It would be just as absurd to protest against the unspeakable mental poverty of the drawings called comic strips where in weekly publications the adventures of Cleopatra, the druid Panoramix, Asterix, or Numérobis are described. Details like this are signs of the winds of panic that seem to pass over certain sectors, where we see the will to reconquer the crowds in the

18. The new translations of the Bible are not the only thing at issue. Obtaining new books that contain the French text now obligatory for celebration of the Mass of the Francophone faithful is an important industrial undertaking. Catholicism is not alone in this endeavor. According to *Time* magazine of July 22, 1966, the Methodists had put into use that same week a revised version of their collection of religious hymns. It was distributed throughout the pews of Methodist Churches "with the largest advance sale of any book in U.S. publishing history: 2,154,000 copies" ("Hymns").

face of their increasing disaffection in regard to the Christian religion. One should not misunderstand the aim of these remarks. Their point of departure is that the press apostolate is a "genuine modern apostolate," that this apostolate is the work of a combatant who battles in life because "television, radio, daily papers, and news are in life." Of course, in modern life, the daily papers must be modern newspapers; and if modernity requires the silliness of comic strips, that literature for the illiterate, the authentic modern apostle will not hesitate to follow the crowd. This is another way of making oneself all things to all men.[19]

Vatican II cannot be held responsible for the applications made of its principles, but the fact that certain practices, which have been introduced into traditional liturgy recently and disconcert us, could legitimately appeal to the spirit of Vatican II makes us see to what point the phenomenon of mass media goes beyond the level of the accidental and anecdotal. It is very true that the Council decreed their general mobilization at the service of the evangelization of the crowds. Therefore, we should not be surprised that even in the service of good, the employment of such impure means sometimes brings certain impurity; but even the concept of adulteration is fixed only by a relation to a prior concept of purity. When we say that religious worship is loaded with artistic degradations, we do so starting from a certain totally or primarily aesthetic concept of the arts of the beautiful. We fail to ask ourselves whether pursuing a strictly or principally aesthetic goal is not to introduce an essential impurity into the pursuit of its proper goal, which is essentially religious.

The problems concerning relations between art and religion ought first to be viewed from this point of view. Religion should be careful not to disdain the resources of art, but they directly interest it only in the measure in which art facilitates religion's essential task as teacher of humankind. The endless discussions between artists, lay people, priests,

19. See, for example, *Fripounet et Marisette*, a weekly publication for children in its twenty-sixth year, where drawings and images have almost completely eliminated printed text. *Le Pèlerin* ("The Pilgrim of the Twentieth Century") claims to follow the Council's directives: "Press militant; authentic modern apostolate . . . This apostolate responds to one of the demands of the modern world. It is certainly an action in the world, in life. Television, radio, daily papers, and news are in life. It is an important sector of the modern world. It responds to a desire of the Church. Read paragraph 14 on the means of social communication" and so on (Guichardan, "Editorial").—This tone certainly corresponds to the 'press militants,'" the aristocracy of the whole modern mass, consisting in fact in the elite of the crowds, which the militants are.—Cf. Gurgand, "Phénomène Astérix."

and religious on the relations of religion and beauty, as well as the place of beauty in religious life, rest in large measure on the ignorance of a fact: in its origin, and still today, the Church is and wants to remain a mass religion, the perfect type of the mass society in which all citizens are thoroughly incorporated. Consequently, it is inevitable that the Church should be a society destined to mass media. In one sense, Vatican II itself has been an effort, unprecedented in its scale, of mass propaganda and action. The accent so strongly placed upon the problems of ecumenism has been an attempt at mass Catholicization. The Council's technique of organization, with its use of translation, of television and radio broadcasting, of propagation by the press, and images in all their forms, has manifested to all eyes and ears the fact that ties every mass society to the employment of means of information for the masses. It is unavoidable that loss of quality should accompany these crises of massification; the bread dough is not made with grains of wheat but with flour. The homogenization required to obtain a mass that can be molded at will cannot be achieved without pain. The essential point is that these changes of form should not entail any loss of substance. The danger is only too real for religious faith, as we have seen it is in other orders. Instead of massifying religion by faith, today, we see attempts to massify faith under the weight of mass media. Having sacralized the mass media, there is an attempt to desacralize even faith.

"Taking everything into careful consideration," the Catholic Bishop of Indore (Maya Pradesh, India) said recently, "the belief in divine inspiration has probably caused more harm than good to religion during several centuries and still causes it."[20] His personal criterion of moral truth is "the good of humanity." The bishop does not say how to decide this good, but many others seem to count on the mass media themselves to reveal it to us. Starting from the principle that religion cannot live without information, another up-to-date theologian infers that if only as means of preaching the good news, mass media take on sacred value, as does the opinion that they interpret: "Public opinion, all powerful, omnipresent and subtle, has its source in the freedom and the breadth of information that nourish it. But it also has its sensible signs, its 'sacraments,' as Cardinal Feltin wrote (*Documentation catholique*, 1418 [1964], 276). These sacraments are the means of communication that express

20. Simmons, "Catholic Church," 431n. In this article, the Catholic bishop of Indore, India, develops ideas he had expressed at the Council on Oct. 6, 1965 (*Quis custodiet custodes?*).

and form it. . . . Press, radio, cinema, television are so many 'sacraments' of public opinion."[21] Only priests can dedicate such a fervent worship to the profane and push the boundaries of naiveté so far back. For when we realize what an obscure concoction manufactures this much-vaunted public opinion, we wonder whether the religion that is the soul of the liturgy is not on the path to succumbing to the mass of its new means and being dissolved. In this order, as in others, the triumph of quantity is paid with a loss of quality that come to annihilate it.

The same kind of phenomenon is found in all orders. The mechanical multiplication and industrial commercialization of products of the mind everywhere replaces reality by image and production by reproduction. Then what is communicated disappears under the communication. The means becomes the end, which entails a complete reversal of values. The painter's picture no longer counts; what counts is the perfection of its reproduction. The musical work disappears behind the record, leaving the field free for the quarrelsome chatter of record critics, which is itself lengthened by the triple or quadruple repetition of the same work, though not of the same recording. In what concerns radio broadcasting, persons who let themselves be committed to it quickly understand that the important thing is not the subject, the fact, or the person involved but definitely the *broadcast*, which becomes its own goal. From there come the broadcasts about broadcast and the "yesterday you heard" that prepare the "tomorrow you will hear."

There is nothing to be gained from revising all the different orders in this regard, because we would observe the phenomenon's universality even in the order of "literary matters" where the modern publisher is close to thinking that publicity makes the book. This is probably the meaning (or one of the meanings) of Marshall McLuhan's spiritual formula, "The medium is the message." Taken literally, it would be senseless, because the reproduction is not the painting, nor is the record the music, and the telegram is not the news; but it is very true that in each of these orders, the means of communication ends by eliminating the communication, the mass media become their own goal. Even if all music on

21. Régis, "Opinion publique." It will be prudent to keep to the text itself of the Council in the decree *Inter Mirifica* (*De Instrumentis Communicationis Socialis*), promulgated Dec. 4, 1963, in Second Vatican Council, *Seize documents conciliaires*, 519–29. The need to form specialists with a view to the employment of these new media makes only more urgent the retention of a basic theological formation protected against all aberrations.

earth suddenly became silent, we would have something to listen to for centuries. All the museums could go up in flames without the art editors being forced to diminish their production. As long as the negatives exist, nothing is lost. As for books, an individual prototype would suffice to resupply all humanity with copies. The liturgy will fare better as long as it has the courage to maintain the principle that a broadcast mass is not a mass, but we seldom hear this principle recalled in the course of the broadcasts themselves. Moreover, an almost superhuman effort would be needed, one that would go against the grain of what is required of the orator, because insofar as the latter works for a mass medium, success consists in his making everything happen as if the image that is broadcast in all directions were practically equivalent to the reality. It can happen that it is better than the reality. As long as it continues to be understood that the image of a higher reality is incommensurate with a lower reality, nothing will be lost.

Those who involve themselves in such reflections will avoid the illusion that they could effectively praise or blame what is happening. We are dealing with facts against which nobody can do anything, and conditioned as we are by the immense pressures that mass societies exercise upon all their members, we are becoming less and less capable of discerning.

Nowadays, developed societies are distinguished from underdeveloped societies, which are more politely labeled *societies in the process of development*. At bottom, it is the old distinction between civilized and uncivilized. Nowadays, the savages are those who still do not enjoy mass means of social communication, to speak in the language of Vatican II, but we may wonder if human beings do not regress in the measure that civilization progresses. We need to hurry the full-time schooling of people of color in the whole world. Yet, if we imagine an intellectual and a simply normal person grappling with the task of surviving, we will certainly think that the chances are not on the side of the intellectual, who hardly enters in contact with nature except by concepts, tools, and interposed props.

In 1870, Sir Joseph Dubuc decided to travel to Manitoba and visit a Métis community for whom their hero and martyr, the unfortunate Louis Riel, was laboring. Dubuc first visited the Saint Croix mission served by Father Genin. "The priest's house has two stories. One of the sides of the lower level is occupied by Father Genin. The other by a Canadian family. The upper floor serves as chapel. This missionary's house touches

the soul, with its poverty, its isolation, its destitution. It must be seen to be pictured. In the evening we attended the prayer service as well as the salutation and benediction in the little chapel. Some thirty Métis were present. The singing was in the Cree language of the Métis women." As we see, there is no need of a Council to authorize the vernacular. The caravan had traveled all day. At evening, "it is the women who set up the tents, go to look for water, and prepare the meal." After supper, the men tell their war and hunting stories, surely inventing the best ones. "Next came the songs. One of them sung and danced in Sioux. This dance did not consist of meaningless leaps and gestures. It is an authentic representation by which the dance shows us, through pantomime, a warrior who looks for his enemy, finds him, kills him, scalps him, and saves his own scalp, all the while uttering muted cries and sharing the song, which also has its originality."[22]

We should feel sorry for these poor Métis. Nowadays, a good television would liberate them from the chapel and the priest. They would be made to see a real mass, like those of the cities, and hear a real sermon delivered by a real preacher. Why would they need to sing and dance, since they would be made to hear real singers, real dancers, and real mimes? We are there. There are those who prefer to follow the services on the small screen rather than cross the street to be really present. When we lose contact in this way, the current no longer passes. Soon it becomes too painful to press the television button. After being contented with the image, we dispense with the reality.

22. The details are taken from Dubuc, "Correspondance de Sir Joseph Dubuc."

Three Essays concerning Étienne Gilson on Bergson, Christian Philosophy, and Art

Henri Gouhier

All classical French art, so rich in masterpieces, has pro-
duced them only despite the fatal and perfectly false prin-
ciple that nothing is beautiful but the true, the true alone
is lovable.

Étienne Gilson
Introduction aux arts du beau

Gouhier's Preface

I THANK MY COLLEAGUE Nicolas Grimaldi, who has done me the great favor of rereading my text.

The text of the first two essays has been deciphered by Madame Lina Lanoir, that of the third essay by Madame Béatrice Compain-Gouhier.

Introduction

FR. LAURENCE K. SHOOK of Toronto has published an important biography of Étienne Gilson. Will we let 1984 end without recalling that it is the first centenary of Gilson's birth? He was born in Paris on Friday the thirteenth in June, 1884. But the word *centenary* does not just evoke memories of a distant past. Étienne Gilson was still among us almost yesterday. He died September 19, 1978, leaving the manuscripts of two books, *L'athéisme difficile* and *Constantes philosophiques de l'être*, published in 1979 and 1983, the latter work being in part a reflection upon "the new adventure of being" that "the Heidegger case" represents.

Pondering Gilson's long life and considerable body of work, we would simply underline two essential facts. The first is that, from 1926 on, Gilson had two careers: one at Paris and the other first at Harvard and then at Toronto. Gilson taught the history of philosophy at Lille before 1914 and at Strasbourg upon his return from a prisoner of war camp at the end of World War I. At the opening of the academic year in October 1921, he arrived at the Sorbonne, where the teaching of the history of medieval philosophy had just been introduced. It is unnecessary to recall the impulse Gilson gave to this area and the importance of his own works, notably on St. Thomas, St. Bonaventure, and St. Augustine. In 1923, he became a professor at the Collège de France, holding a chair of history of philosophy in the Middle Ages until his retirement in 1951. His works and the scholarly level of his collections very quickly acquired international repute. In 1926 and 1927, he also taught the history of medieval philosophy at Harvard University. Then the Basilian Fathers of St. Michael's College proposed to him the creation of an Institute of Medieval Studies at the University of Toronto. The institute opened on September 30, 1929, and from then on, every year, from the middle of September to the end of December, Étienne Gilson was at Toronto. With

its splendid library and thousands of microfilms of manuscripts for study of medieval civilization in its different facets—philosophy, theology, liturgy, paleography, history of art, history of institutions—Gilson made the institute the most complete center of its kind in North America. Even after relinquishing his leadership role, Gilson continued to spend part of the year at Toronto. His last stay was in 1971 when he was eighty-seven years old. When we add to his courses at Toronto the numerous lectures Gilson gave in universities in the United States, it is not surprising that as a professor and lecturer, Gilson became also a writer in English. Part of his work was edited in the United States, notably one of his most important books, *The Unity of Philosophical Experience* (New York, 1937).

His doctoral thesis, *Theology and the Cartesian Doctrine of Freedom*, had shown us the young Étienne Gilson discovering the need to be acquainted with medieval doctrines to understand well the genuine novelty of Cartesian philosophy. It was natural that he should continue to study those doctrines for their own sake. Gilson's name certainly is linked in the first place to the impressive historical sector of his bibliography where we find major syntheses like *The Spirit of Medieval Philosophy* alongside detailed and purely technical, so to speak, analyses like the ones he published in his journal *Archives d'histoire doctrinale et littéraire du moyen âge*. Still, if Gilson devoted himself to the history of philosophy, it was in order to look for philosophy in it. Taking Bergson's courses at the Collège de France, he had perceived that his vocation was in that quest. He subsequently searched objectively, as a historian must do, what truth was for each philosopher he studied. In seeking at length what truth was for St. Thomas, he found his own. Gilson the philosopher is as relevant as Gilson the historian of philosophy. It is important to recall this point.

However, let us be clear: Gilson the philosopher is first of all the metaphysician who never ceased to meditate upon the God of Exodus, who told Moses "I am who I am" (Exod 3:14). Gilson is also the person who was always interested in humanity and reflected on the many experiences that reveal its aspirations and inspirations. In this regard, the close analyses that Gilson devotes to human love in the masterpiece that is *Heloise and Abelard*, in his books on Dante and Beatrice, and lastly in the *Choir of Muses*, where we again meet Petrarch and Laura, Richard Wagner and Mathilde Wesendonk, Auguste Comte and Clotilde de Vaux, and others . . . But what always deeply moved him is the mystery of artistic creation. At a young age, he attended the first enactment of *Pelléas*, and a pro-Debussy demonstration landed him in a police station.

His extraordinary musical memory permitted him to write to a friend in 1974: "I have all of *Parsifal* in my heart." The diversity of Étienne Gilson's interests offered him the possibility of writing an authentic philosophy of art, or rather of the fine arts, in which painting had to occupy the place of honor. Let us simply recall the lectures given in the National Gallery of Art in Washington DC, published as *Painting and Reality* (*Peinture et réalité*), where the distinction between "painting" and "imagery" makes us understand at least that a canvas without imagery is not opposed to the essence of painting.

Étienne Gilson was elected to the Académie française on October 25, 1946.

First Essay

Gilson and Bergson

1. Thanks

IN THE INAUGURAL LECTURE to his course on the history of medieval philosophy at the Collège de France, Étienne Gilson dwelt at length upon a debt he owed: "In this very place I contracted a debt during those admirable lessons that were the most intense and highest intellectual joys for all his students." These are not ritual courtesies, because Gilson continues: "From his teachings, so rich in many regards, the historian will retain the desire to reconnect, beyond the expressions by which the philosopher's thought is put forth, with the simple movement that engenders them, runs through them, and confers an indivisible unity upon them." Here we have a new professor's expression of thanks in the form of a brief but luminous exposition of what a history of philosophy inspired by Bergson's teaching would be. This historian "will retain from it the feeling that our historical concepts are in constant need of being made more supple and of being recast, as it were, in order to adhere more exactly to the reality they express."[1]

Which of Bergson's courses did Gilson take at the Collège de France? My reading has turned up only a few indications.

We can believe that Gilson speaks from personal recollection when we read in *From Aristotle to Darwin and Back Again* (*D'Aristôte à Darwin et retour*): "Those who heard Bergson lecture at the Collège de France ...

1. "Le moyen Âge et le naturalisme antique," in Gilson, *Héloïse et Abelard*, n.p.

perhaps took away the impression that all was over with this type of evo-
lutionism." In fact, Bergson himself would later say: "Spencerian evolu-
tionism has to be recast just about completely." Gilson specifies: "Be it
only to integrate therein the 'real duration', which Spencer had excluded
from it."[2]

Again, the image of Bergson's smile brings back to Gilson a remi-
niscence of the lectures on Spencer. We are at a colloquium in 1959:
"The issue is an expression of Plotinus, the only thing upon which I
heard Bergson pronounce himself in regard to this philosopher, but it
was in the same style as numerous expressions I heard him employ on
the subject of Spencer." When Bergson related Plotinus's words on ac-
tion as weakened contemplation, "his face lit up with the smile we knew
well, which started from his eyes and descended to the corners of his
lips." Why was there this "amusement"—the word occurs twice—"except
because it was exactly the contrary of what he had always taught us."[3] By
way of translation, according to Gilson, Bergson had the air of taking
seriously a pretentiously philosophical expression that all his listeners
knew to be exactly the opposite of his thinking.

Gilson must have heard Bergson at the Collège de France during
the three years he studied at the Sorbonne, 1904–1905 for the degree
[license] in philosophy; 1905–1906 for the diploma in advanced stud-
ies in philosophy; 1906–1907 for the competitive teaching examination
[agrégation]. We read in the Collège's annual catalogue, "In 1904–05,
Professor Bergson will deal with the Evolution of the Problem of Free-
dom and will comment upon some passages of Herbert Spencer's *First
Principles*."[4] Bergson requested a leave of absence of 1905–1906. He was
replaced by Couturat.[5]

. In his brief statement in the catalogue, Bergson specifies: "Year
1906–07, Bergson will deal with Theories of the Will. In the other
course, 'He will study some chapters of Herbert Spencer's *Principles of
Psychology*."[6] "The Friday course has been devoted to the analysis of the

2. Gilson, *From Aristotle to Darwin*, 109.

3. Gilson, quoted in *Bulletin de la Société française de philosophie* 54 (1959),
227–28.

4. Bergson, *Mélanges*, 648–49.

5. Bergson, *Mélanges*, 661, 664.

6. Bergson, *Mélanges*, 684.

will and more particularly to effort viewed in three forms: muscular effort, effort of attention, voluntary effort."[7]

Thus, during his three years at the Sorbonne, Gilson was able to attend two courses of Bergson, one on freedom and another on effort; he was able to attend, and perhaps participate in, two series of explanations of texts of Spencer. There is no doubt that Gilson attended at least one course on Spencer. He gave his future biographer recollections of the lessons on effort,[8] and we can suppose that he attended the course on the evolution of the problem of freedom.

In his notes, Étienne Gilson most certainly had carefully recorded the lectures of Bergson who spoke slowly. Gilson's biographer asked him what had become of them. "They were stolen or at least they disappeared during the first German occupation of the North of France."[9] Indeed, we recall that Gilson had been named lecturer at the Faculty of Arts and Humanities of the University of Lille in 1913.

The Bergson that young Gilson heard at the Collège de France had enjoyed a great reputation as a professor. His name was also attached to two books, *Time and Free Will: An Essay on the Immediate Data of Consciousness* and *Matter and Memory*.[10] Gilson declared, "In 1905, I read the book [*Time and Free Will*] for the first time." No doubt that must be understood as during the course of the academic year 1904–1905. "Nothing will ever revive for me the sheer delight of the first contact. I would read and read again the first chapter, so clear was it that Bergson had carried the day in it."[11]

But 1907 had another surprise for the "young friends of metaphysics." "At last we could read, as in a sort of intellectual trance, the view of the world depicted in *Creative Evolution*."[12] Let us put ourselves in the

7. Bergson, *Mélanges*, 684. There is a long report of this course by Paul Fontana published in two issues of *Revue de Philosophie*, July 1 and Oct. 1, 1905, reproduced in *Mélanges*. The author of the report did not personally hear all the lectures. Some reports were composed with the help of notes of members of the audiences. Also, some passages suggest an article on Bergson rather than a report. That said, it is still an important document.

8. Shook, *Étienne Gilson*, 19. The author mentions a lecture on Henry James. It should read William James.

9. Shook, *Étienne Gilson*, 19.

10. Bergson, *Éssai sur les donées immédiates* [Time and Free Will]; and *Mattière et mémoire* [Matter and Memory].

11. Gilson, *Philosopher and Theology*, 117.

12. Gilson, *Philosopher and Theology*, 119.

place of these young people in a hall at the Collège de France, listening to
Bergson analyze the different forms of effort and comment on the pages
of Spencer. We may imagine their excitement to realize that *L'Évolution
créatrice* was among the newly appeared books in bookstore windows.

Gilson never failed to say what he owed to Bergson. Yet he did not
seem to seek occasions to dwell upon themes in Bergsonian philosophy.
More exactly, Gilson's observation is that we must grasp the historical
impact of Bergsonism, which is relatively independent of its content and
subsists, whatever the reservations that this or that Bergsonian thesis
may provoke.

Let us go to the 1959 colloquium that commemorated the centenary
of Bergson's birth. Father Tonquédec recalled that Bergsonian theology
is not Catholic theology. As often happens, the discussion drifted from
question to question. Then Étienne Gilson stood up with a declaration
that we must not forget:[13]

> I am going to request your permission to return to Henri Berg-
> son for an instant. I will not speak of him as a historian, because
> he was not an object of history for me. We lived intellectually by
> him and with him, and between the moment at which he engen-
> dered us into philosophical and metaphysical life and now, there
> is no interruption of continuity.

We know that between these two periods there was the discovery of
Thomism in Gilson's life, but the colloquium is certainly the occasion
to say that this discovery was of a different order. "This is why when I
take myself back to 1905–06 and when I hear the way he is criticized by
theologians of all confessions, I feel very surprised."[14] Then comes the
heart of the matter:[15]

> As a matter of fact, who gave metaphysics back to us at a mo-
> ment when it was said that metaphysics was dead? Bergson.
> Who is it that taught us to pose again, in precise, intelligible
> terms, problems like that of freedom, the nature of the soul, its
> immortality, the original nature of the universe? Bergson. In
> that time he was not accused of lacking theological insight. On
> the contrary, he was accused of working for the priests.

13. *Bulletin* (1960), 277–78 [single page number unspecified].

14. *Bulletin* (1960), 278. In Gilson's memoir, the date used is that of the end of the
school year; 1905 is employed, instead of 1904–1905.

15. *Bulletin* (1960), 277–78 [single page number unspecified].

Gilson excluded any possibility of ambiguity in the phrase "working for the priests":

> To tell the truth, nothing was further from his intentions. Bergson was no more a theologian than Aristotle had been. There was no revelation for him, he was a pure philosopher. We listened to him as a philosopher, and he formed us philosophically.

And, as if Gilson could hear the query "And your Thomism?," he remarks, "What we became later, sometimes in paths very different from his, we became thanks to him."

In this whole piece, *we* is not a royal *we* but plural. Gilson speaks for himself and for others:[16]

> Allow me to point out—I am acting out of gratitude at this moment—that if many of us have preserved our religion or found it again, it is not to the manuals of neo-Scholastic philosophy according to the mind of St. Thomas Aquinas that they owe it. . . . It is for this that I wanted quite simply to thank him.

2. The Philosopher and Theology

The philosopher who thanked Bergson at the colloquium commemorating the centenary of his birth was the Gilson of 1959, and he thanked the Bergson of 1907. No doubt between 1907 and Bergson's death at the beginning of January 1941, his work progressed, and it is evident that Gilson is aware of the existence of *The Two Sources of Morality and Religion*. Nevertheless, what makes there be *before* Bergson and *after* Bergson in the history of philosophy belongs to what is essential in rediscovered metaphysics. We can reject the criticism of the idea of nothingness proposed by *Creative Evolution*. One may choose not to follow the author of *The Two Sources*. The thanks of 1959 remain identical, which simply shows us that at this date the Gilson of 1907 survived with the non-Bergsonian Bergson of the last book.

What is conveyed between the lines, at the end of the 1959 expression of thanks would in the following year, 1960, occupy three chapters of the intellectual biography that is *The Philosopher and Theology*: chapter 6, "The Bergson Affair"; chapter 7, "Wisdom Takes a Holiday"; and chapter

16. *Bulletin* (1960), 277–78 [single page number unspecified].

8, "The Uninvited Handmaiden" [La revanche de Bergson, literally, Bergson's Revenge].

The narrative is complicated because there are at least four characters on stage: first, Gilson of 1907 in the phase of Bergson of the same period; second, Gilson as he sees himself after *The Two Sources*; third, Gilson the Thomist or, more precisely, Thomism seen by Gilson; fourth, neo-Thomism, which seems to Gilson to understand neither Bergson nor St. Thomas.

Let us attempt to extract what directly concerns the relation between Gilson and Bergson.

Étienne Gilson begins by dividing the history of Bergson's thinking in two: "To form a just idea of what this philosophy meant to us, one date should be kept in mind. Bergson was and remains, before anything else in my mind, the man whose first philosophical career ended, so to speak, with *Creative Evolution*." We might say that Gilson thinks of Bergsonism as having the dynamic structure of the vital impetus, the *élan vital*: "Whatever he published between *An Essay on the Immediate Data of Consciousness* and *Creative Evolution* came to us as from one single vein." Didn't these writings "read, and reread, and meditated" provide us with a vision "of the world and of man through whom the world arrives at self-awareness"? In short, the theme of Bergson the educator takes the role of an explanation. "We had the feeling of being formed by him and, as it were, introduced to a vision." A strange bifurcation takes place here.

"Speaking for myself," Gilson writes, "I can say that the Bergsonian revelation ended in 1907, the year when *Creative Evolution* was published."[17] We would rather expect to find the young Gilson impatient to know the continuation, curious to discover what the master is going to invent. It is necessary to quote his testimony verbatim.

"By that time [which is to say, by 1907], Bergson had given me all the help I could expect from him, and he had said everything that was profitable to me in his message." Gilson insists: "I continued to ponder his great books, but with the feeling that no new revelation was to be expected from him. What he still could say, however precious it might be, would expand his message without enriching it."[18]

These three words at the end would have deserved definitions clarifying their difference in meaning. But it is necessary to understand what

17. Gilson, *Philosopher and Theology*, 108.
18. Gilson, *Philosopher and Theology*, 108.

had taken place in Gilson's mind. Philosophically, he had been on the wrong path. Bergson put him on the right one. What was done was definitively done. It is possible to go forward on the right path, but it is no longer necessary to find a different one.

In this matter, we are not dealing with subjective impressions. The Bergsonism of 1907 had objectively run its course, and this opinion gains plausibility from the direction of the investigation that announced the Bergsonism to come.

"During the long interval of twenty-five years that separate *Creative Evolution* from *The Two Sources of Morality and Religion*, we knew that he was applying his genius to these problems," that is to say, to the problems of morality and religion. "But we were awaiting the fruits of his meditation without any impatience." Then, he utters the words that introduce a break between what Gilson called the two panels of Bergson's philosophical career. "In fact we were expecting nothing from him."[19]

Very soon after 1907, it was known that the author of *Creative Evolution* directed his investigations toward matters of ethics and aesthetics.[20] He did not speak of mystics solely in conversations with friends like Benrubi[21] or Joseph Lotte.[22] In a communication to the Academy of Moral and Political Sciences on Henri Delacroix's book *Études d'histoire et de psychologie du mysticisme*, Bergson articulated the philosophical attention that he devoted to their activity.[23] Since the passage we will read, in its precision and profundity, is by the great writer who became the author of *The Philosopher and Theology* in 1960, what he says is probably the exact expression of what he thought. If what had to follow *Creative Evolution* is a book on morality and religion, Gilson felt he was out of the game. Why?

Henri Bergson is a philosopher. His writings up to 1907 are philosophical. Bergsonism is a philosophy. If Bergson confronts problems of religion, he cannot do other than approach them as a philosopher. But religion and its problems are outside of philosophy. It is understandable that Gilson expects nothing from an investigation that has no chance of

19. Gilson, *Philosopher and Theology*, 108.

20. Gouhier, *Bergson et le Christ*, chs. 3 and 4; see also Gouhier, *Bergson dans l'histoire*, chs. 8, 9, and 11.

21. Benrubi, *Souvenirs sur H. Bergson*, 32 (conversation of Oct. 24, 1909); 48 (conversation of May 31, 1910).

22. Lotte, "Entretien avec Henri Bergson" (Apr. 21, 1911).

23. Bergson, *Mélanges*, 788–90 (Jan. 30, 1990).

encountering its object. Gilson is no longer on the same wavelength as Bergson, as we would say nowadays. "His philosophy of nature had been for us a liberation. In this respect I had contracted toward him a debt that nothing will ever make me deny." Bergson's genius is not at issue, and Gilson does not change a word in the thanks expressed some months earlier. "But the situation was different as far as religion was concerned. I had one, I knew what it was, and my very effort to deepen my knowledge of its nature turned me away from attempting other approaches." Then everything is stated in a short sentence: "While I was thus living my religion, Bergson was still looking for one."[24]

Doubtless, Gilson and his young Catholic friends could and perhaps even ought to have appreciated, as Catholics, what a *philosophy* provided them, showing that *philosophical* problems like those of freedom, the soul, even of its immortality, were still possible. But if the issue was strictly *religious* problems—let us recall that the period of modernism[25] is not so far away—"How could I hope to receive enlightenment from him on an order of facts whose meaning he could not penetrate for lack of personal experience?"[26]

Here there is something that must be understood: "personal experience" is not in the plural. Accordingly, let us not think of what William James calls "the varieties of religious experience." Let us not think of visions and special instances of contemplation, of intuitions that transcend the awareness of self... "Personal experience" in the singular, as the context is going to show, is the experience of a life like that of Étienne Gilson's within the Catholic religion: he received the sacrament of baptism, he made certain commitments through his godfather as spokesman; he was brought up in a primary school of the Brothers of the Christian Schools,[27] then in the minor seminary of Notre-Dame-des-Champs. We are in a world of someone who says religion means revelation of truths that involve salvation and constitute a *sacred doctrine* also called *theology*. But let us permit Étienne Gilson to say what the Christian who wants to be a philosopher will confront.

24. Gilson, *Philosopher and Theology*, 108–9. Let us recall that the permission to print the work is dated Mar. 14, 1960. The thanks was expressed in the session of May 19, 1959.

25. Gilson makes several allusions to modernism in *Philosopher and Theology*, 52, 57, 127, 143, 176, 230–31.

26. Gilson, *Philosopher and Theology*, 109.

27. Translator: Now the De La Salle Brothers.

"As it is constituted, theology is not the work of any man but of the Church, and no individual without extreme temerity can undertake to reform it. Beside the word of God, theology includes articles of faith, and dogmas that explicate them, conciliar decisions and their interpretations by great theologians when these are approved by the Church."[28] Let us specify further: "The competence of the Holy See in matters of philosophy is related to it apostolic mission. Jesus told his apostles and consequently the Church: 'Going therefore, teach ye all nations [Matt 28:19].'"[29]

Therefore, his sense of belonging to such a world is "the personal experience" that Bergson did not have, even could not have. This is the reason for Gilson's rejection when *The Two Sources of Morality and Religion* appeared in March 1932.

Gilson received the book. "Something unexpected then happened to me, and I cannot explain it clearly. Still less can I justify it, for I am aware that there was an element of irrationality, not to say unreasonableness, in my reaction." Indeed, "after sending the author the usual compliments, I had the book carefully bound and placed it on a shelf in my library where it was to remain unread for years whose number I would be ashamed to acknowledge." Gilson felt he did not need to read it to know that it did not rise above the level of philosophy. "That he, Bergson, could have embarked under my very eyes on a venture that was bound to fail, this was too much for me."[30]

"A kind of anguish held me back on the threshold of this last masterpiece, and it was only much later, after I had learned to my own satisfaction the meaning of such words as 'faith' and 'theology,' that I could open the book without misgivings." These pages were written in 1960, twenty-eight years after the publication of *The Two Sources*. "Much later" is a very vague expression, but Gilson's memory of reading was not: "From the very first page the old charm worked again." Someone might have told Gilson that, after all, the first part on the sources of morality does fall under philosophy *stricto sensu*, but he hastened on to the part on sources of religion. "I had to lay the book down for short intervals, and at times to interrupt my readings. I felt like a man who wanted to slow down the tempo of a piece of music in order to prevent it from passing

28. Gilson, *Philosopher and Theology*, 120.

29. Gilson, *Philosopher and Theology*, 185.

30. Gilson, *Philosopher and Theology*, 109.

away, unmindful that it was necessary for it to pass in order to be."[31] Before reading, Gilson foresaw the "disaster," but, he said, "I did not want to witness it."[32] During and afterwards, he realized, "My worst fears were more than justified."

The condemnation that follows is irrevocable. "It was not this or that idea, this or that development that was out of focus; the whole book was out of focus. The author had established himself outside the focus of his subject and had remained there."[33] And how would he not remain there?

"It would seem that the religious education of Bergson was not continued very far."[34] Consequently, even if this sort of expression simplifies something more complex, it can be admitted that Bergson was outside the Jewish and Christian religions, something that Gilson underscores by using the words *pagan* and *paganism* in this context.[35] "A stranger to the Christian faith, ignoring the supernatural order as extraneous to the domain of philosophy, Bergson nevertheless attempted a philosophical interpretation of a religion in which everything is supernatural and grace."[36] It is not obvious what, within philosophy, would impel the philosopher Bergson to emerge from it. There is no conceivable movement that would go from reason or from an intuition to faith. Still, wouldn't a movement in the opposite direction be possible, faith enlightening reason, philosophy becoming the handmaiden of theology? Yes, but that would be another story, the story of the Christian who also wants to be a philosopher.

3. The Presence of Bergson

Étienne Gilson pauses for a long time in the face of this other story, observing that it has remained in the status of what is possible: "The new Aristotle has not found his new Thomas Aquinas."[37]

31. Gilson, *Philosopher and Theology*, 110.

32. Gilson, *Philosopher and Theology*, 109.

33. Gilson, *Philosopher and Theology*, 110.

34. Gilson, *Philosopher and Theology*, 112. "To an outside observer," Gilson says, intending to underscore the limited nature of his point.

35. Gilson, *Philosopher and Theology*, 116, 119, 123.

36. Gilson, *Philosopher and Theology*, 165.

37. Gilson, *Philosopher and Theology*, 144. See below, second essay.

Here we have a new philosophy whose novelty is justified by its agreement with scientific progress. Descartes had pondered what its relation to theology could be and answered that it would provide theology with the same services as the old philosophy. Thus, "he undertook to show that one could very well speak of the mystery of transubstantiation in terms of his own notion of matter, of substance, and of accidents."[38] The relation between philosophy and theology will go from the first to the second: at the beginning, there is a new philosophy, and philosophy then proceeds to the required adaptation. Furthermore, this was what St. Thomas had done with Aristotelianism.

No, Gilson declares. The philosopher Descartes Cartesianizes theology, or if we prefer, he invents a Cartesian theology. A new theology must correspond to the new philosophy. The theologian Thomas Aquinas does exactly the opposite; it is philosophy that must be adjusted to theology. The latter comes at the beginning because it is the sacred doctrine that defends the Church's faith. Evidently, it is not conceivable that every inventor of a philosophical system finds himself *ipso facto* invited to reform theology. It belongs to the theologian to see whether the novelties of philosophy can be assimilated theologically.[39]

The example of Thomas Aquinas clarifies the question. Some have talked of baptized Aristotelianism. The theologians of the Thomist schools have spoken as if the baptism had not deeply changed the Aristotelianism that ceased to be that of Aristotle: the theologian Thomas Aquinas's reason, guided by faith, created an original philosophy that is precisely what Étienne Gilson intends to rediscover in his works on medieval philosophy. Let us think, for example, of what the immobile Prime Mover and the eternity of the world become in order to include the god of Aristotle within the great current of Christian thought; it was first necessary that it should cease to be Aristotle's god to become the God of Scripture.[40]

Accordingly, we come back to our question: what is the relation of Bergson's new philosophy to theology?

The point is not to "Bergsonize St. Thomas."[41] Nor is it to invite a Bergsonian philosopher to invent a Bergsonian theology. But there seems

38. Gilson, *Philosopher and Theology*, 120.
39. Gilson, *Philosopher and Theology*, 120–21.
40. Gilson, *Philosopher and Theology*, 146.
41. Gilson, *Philosopher and Theology*, 172.

to be no reason why a Christian theologian could not do with Bergson what St. Thomas had done for Aristotle.

"One can easily imagine St. Thomas's attitude to such a situation. Or rather, we need not imagine it, we know it." Gilson lets "the twentieth-century St. Thomas" speak. Like the thirteenth-century Thomas, he would have said: "Still another philosophy! What is it worth? Let us eliminate what is false in it; let us see what is true and lead it to its own perfection."[42]

"What was needed was another Thomas Aquinas. We are still waiting for him."[43]

The question that immediately comes to mind is so obvious that we hardly dare to formulate it: "What are you waiting for, Professor Gilson, in order to devote yourself to the labor that you define so precisely?"

Curiously, just after World War I, circumstances brought Bergson and Gilson together in a dialogue that is like an unfinished sketch of what we imagine when Bergson writes *The Two Sources*.

We are at Strasbourg. The important figures in each discipline come to give a lecture at the university. Bergson delivers his on May 9, 1919.[44]

Étienne Gilson had just been named professor at the Faculty of Arts and Humanities in Strasbourg. Thus he quite naturally met with Bergson, a visit that Bergson "himself had provoked because he knew I desired it." This lets us suppose that Bergson received an old participant in his course at the Collège de France, an attentive reader of his books, already known as a medievalist and historian of religious thought, because of his thesis. It explains the immediate meaning attributed to the interview with Bergson.

After a few words on the history of medieval philosophy, Bergson asks Gilson quite directly, "Why don't you direct your research toward the philosophy of religion? You are the man to handle this problem and, as I believe, will have a good chance of success."[45]

What follows shows us how different the knowledge of what is contemporary can be from what will someday be historical. "What a proposal," Gilson thought then. "Philosophy and religion together all at once . . . Moreover, a proposal coming from Bergson who so far had given

42. Gilson, *Philosopher and Theology*, 122.

43. Gilson, *Philosopher and Theology*, 119.

44. Gilson, *Philosopher and Theology*, 166. Gilson writes, "It was, I believe, in 1920." On this lecture and the exact date, see Bergson, *Mélanges*, 1316–19.

45. Gilson, *Philosopher and Theology*, 166.

no indications that he was interested in this problem." This was the case for the Bergson of 1907, who was the only one that Gilson was going to know for such a long time. But during this same period, the historian finds many things showing that Bergson, on the contrary, was interested in these questions. Let us recall the replies to Fr. Tonquédec published in 1912. Further still, it is only much later that Gilson would understand why Bergson had spoken of "psychical research" in his Strasbourg lecture.[46] The invitation extended to Gilson to orient himself toward the philosophy of religion was simply one more fact showing how Bergson was concerned with questions that led him groping toward *The Two Sources*.[47]

"In the seconds of silence that followed . . . I could not hesitate on the answer to give," Gilson comments. But there are different ways of saying no, and he responded, "Why don't you undertake such a piece of research yourself?" Bergson could only accept this elegant way of not answering and also find the last word. He answered, smiling, "Descartes did not very much like to publish his thoughts in matters of morals and religion. He wanted to preserve his peace of mind . . ." Gilson simply added, "We laughed. We had understood each other. The offer of this perilous mission was not renewed."[48]

Under this playfulness perhaps lies the sketch that will appear later of the deep relation between theology and philosophy, faith and reason. During the few seconds seeking the answer he found, Gilson considered that such a mission could not be entrusted to "a young apprentice still in the process of getting acquainted with his own theology." In other words, it corresponds to a theologian to undertake the investigation recommended by Bergson.[49]

Possibly, Gilson's "Why don't you?" directed to Bergson at Strasbourg in 1919 was an elegant way of getting himself out of a predicament. What is sure is that a day would come when he would see clearly and distinctly the vantage point in which the relation of reason to faith and

46. Gilson, *Philosopher and Theology*, 166.

47. Gilson, *Philosopher and Theology*, 196. Gilson recognizes this when he writes: "At least thirteen years before the publication of *The Two Sources*, Bergson had directly come to grips with this immense problem" (Gilson, *Philosopher and Theology*, 167). Cf. "Compte rendu de l'âme humaine," lecture at Strasbourg, in Bergson, *Mélanges*, 1317–18.—During the same period, 1919, *Spiritual Energy* appeared, in which Bergson published the French version of a lecture given in London in 1913, "Phantoms of the Living," as well as "Psychic Research."

48. Gilson, *Philosopher and Theology*, 167.

49. Gilson, *Philosopher and Theology*, 166–67.

philosophy to theology must be viewed: by going from the second to the first, faith guiding reason, theology inspiring philosophy. When Gilson finalized his critique of Christian philosophy, what we need according to him is not a great philosopher—since we have Bergson—but a great theologian. A great philosopher, even Bergson, could not fill the role.

References to Bergson are very frequent in Gilson's work and in his letters or conversations.[50] But apart from Gilson's long meditation on Bergson and theology, there is little critical textual study of analysis of particular themes in Bergson. However, let us keep in mind two very different but equally important topics of investigation. The first is an overview of Bergsonism as part of a general history of philosophy. The second is a critical study on Bergsonism and teleology.

In *Recent Philosophy*, the section on Bergson is found in part 2, "Maine de Biran's French Posterity"; Bergson comes after Félix Ravaisson, Jules Lachelier, and Émile Boutroux.[51]

The exposition of Bergson's philosophy is remarkable. Gilson's density and precision allow him to deal with all the essential themes of Bergsonian philosophy and even to give an idea of the polemic they provoke. He follows an order that is both chronological and philosophical:

> Method
>
> Soul and Liberty
>
> The World and Creative Evolution
>
> Morality and Religion

If Bergsonism's philosophy of religion can be considered his last word, it is thereby the last word of the spiritualist realism inaugurated by Maine de Biran. *The Two Sources* is a masterpiece.

We find Bergson fully conscious of the problems left unresolved by the notion of *vital impetus* in which we might see "a substitute for the religious notion of God." Perhaps Gilson seeks to diminish the philosophical importance Bergson gives to this study. Between *Creative Evolution* and *The Two Sources of Morality and Religion*, there is a twenty-five-year interval during which he never stopped thinking about the subject. Of course, Bergson will approach these new problems with the method that

50. We would mention particularly Gilson, "Ce que nous devons," and Gilson, "Plaidoyer pour la servante," in *Athéisme difficile* (1979), 82–83.

51. Gilson et al., *Recent Philosophy* (1962) and (1966). Gilson is the general editor, as well as the author of the introduction and the part on French and Italian philosophy.

produced his proofs in the prior works. This method consists firstly of discovering the experiences upon which the truths set forth will have a solid foundation. Here, Gilson emphasizes something new and unexpected: when he discovered the experience of mystics, "for the first time Bergson was condemned to write about facts he only knew from hearsay." Bergson "perhaps was applying a ready-made method to the solving of a problem exceeding its possibilities."[52]

This is certainly the gist of the conclusion that Étienne Gilson believes can be drawn from his pages on Bergson in his history of philosophy, *From Hegel to the Present*. "The fecundity and the limits of the Bergsonian method are apparent." We must consider as decisively and definitively established that Bergson has provided speculative metaphysics with its justification; the same goes for his critique of a kind of scientism that attempts to be mistaken for a philosophy. But Bergson's evident desire to pursue his demonstration to a point where metaphysics would coincide with what is taught in Christianity had to be frustrated. For metaphysical empiricism, necessarily, would not attain what belongs to the supernatural order in Christianity.

Let us note that the concept of *supernatural* in Gilson's thinking immediately requires that of a Church with its two sides: on the one hand, it appears as a dogmatic, static, and closed society; on the other hand, it is an eminently open and dynamic society but in the order of sanctity, which cannot find a place in Bergsonism. The problem posed here can be resolved only by faith, and faith is beyond the boundary of philosophy. "Metaphysics can go as far as Plotinus, it stops short of Saint Paul."[53]

This is why, despite his profound desire to become a Christian, Bergson could never connect with the Church. In the modernist period, there were Christian philosophers who believed they could undertake a Bergsonian reform of classic (which is to say, Thomistic) theology. That was not the case with Bergson. He never had the idea of reforming the theology of St. Thomas, about which he knew "next to nothing." That said, remembering his own experience, Gilson was eager to recall a certain influence of Bergson, who "has greatly helped some Christian philosophies to reevaluate and revivify the dynamic elements included by Thomas Aquinas in his own doctrine."[54]

52. Gilson, *Recent Philosophy*, 314.

53. Gilson, *Recent Philosophy*, 316.

54. Gilson, *Recent Philosophy*, 317.

4. Gilson as Critic of Bergsonism

Étienne Gilson's enthusiasm about Bergson never excluded critical reflection. It would have been banal to accuse Bergson of having disqualified intelligence and particularly to regard him as in irreducible opposition to Thomism. This issue directly concerned the theme of *The Philosopher and Theology*, and Gilson thought that it was useful first to set things straight: "His philosophical speculation was imbued with such respect for the methods of science that one suspects some misunderstanding behind the reproach."

Except that, "starting from what was then the accepted notion of intelligence, Bergson undertook the task of submitting it to a much needed critique." Indeed, "he opposed the bad use men make of intelligence."[55] Nevertheless, it must be acknowledged that "one of the most objectionable points of Bergson's doctrine was his criticism of intelligence, taking the word in the sense in which he himself used it." Without going any further, Gilson made it understood that he was not in agreement on one point: "It is at least doubtful that the fundamental opposition introduced by the philosopher between intellection and intuition was philosophically grounded." Let us emphasize *fundamental*. It is, in fact, tempting, to ask, if the distinction between intellection and intuition is not opposition, what is left of Bergsonism?[56]

If being is duration, if to be is to last, the knowledge of that which has duration evidently does not come under the same faculties as knowledge of what does not have duration. It is necessary that we comprehend when Gilson writes referring to Bergson that "the only problem he had raised was whether the intellect was equally fit to know all the different types of reality given in experience."[57]

It is not Bergson but Gilson who raises the issue. Indeed, Bergson does not have to pose it. Experience situates him in the presence of a distinction between intellection and intuition, which is an opposition between the conceptual grasp of the real that has duration and the immediate grasp of the real in its duration. Gilson is outside Bergsonism when the distinction between intellection and intuition ceases to be an opposition and becomes an intellection at two levels or from two points of view.

55. Gilson, *Philosopher and Theology*, 114.
56. Gilson, *Philosopher and Theology*, 137.
57. Gilson, *Philosopher and Theology*, 138.

Everything is stated, and pleasantly stated, in *The Philosopher and Theology*. But a dozen years later, we reencounter Gilson, the critic of Bergsonism, in a strictly philosophical exposition written without auto-biographical concerns. It is the chapter on Bergsonism and teleology in *From Aristotle to Darwin and Back Again*, published in 1971, presented as a series of distinctions where usage has created confusion.[58]

On the one hand, under the names of Lamarck and Darwin, there are observations, inductions, and hypotheses—in short, there is scientific research. On the other hand, under the word *evolution* employed by Spencer, there is a labor that presents itself as scientific, but in which we see a form of *scientism*, a vast panorama of the history of animal species from their origins, a history that depicts a progression.

According to Gilson, Bergson does not perceive this distinction. He takes the word *evolution* where he finds it in the works of Spencer with its two components; it means that despite lacunae, there is a totality of the animal world taken since its origins, and despite what we would perhaps call flaws, a kind of progression. We repeat that Spencer presents this evolution as scientific. If Bergson rejects this claim of Spencer, it is not by comparison to the works of Lamarck or Darwin, but because he sees scientism in the work of Spencer, and he is going to criticize it as such.

What Bergson does not see in Spencer's evolutionism is time or, more exactly, what Bergson calls duration. But duration is essential precisely in the most rigorously philosophical sense of the word. Here, it is the essence of evolution, that which makes it creative. Therefore, Spencer's work is an evolutionism without evolution.

Accordingly, from Gilson's point of view, under the name of evolution and believing he is carrying out a scientific endeavor, Spencer has constructed a philosophy. For Bergson, not only are we not dealing with science, but we are not dealing with evolutionism. The point of Bergsonism is to put true evolutionism in place of the false one; it thus replaces one philosophy by another. "In this sense," Gilson writes, "Bergson is a continuation of Spencer."[59]

The principle of creative evolution is "what Bergson constantly calls life." If we keep to what is essential, it will be understood as the collection of natural forces at work in living beings. "Bergson speaks of it as a *vis a tergo*, a force from behind, a sort of vital push, what he calls the vital

58. "Bergsonism and Teleology," in Gilson, *From Aristotle to Darwin*, ch. 4.
59. Gilson, *From Aristotle to Darwin*, 109.

impetus."[60] But when, in summing up Bergson, Gilson refers to "the *élan vital*, that creative push whose presence Bergson perceives in the origin of living species,"[61] he must also observe "the gratuitousness of attributing creation to 'life' and the exclusion of intelligence which it presumes."[62]

Consequently, between Bergson and Gilson, there is a radical opposition within the vital impetus, a kind of metaphysical "slippage." Gilson considers, "For once, Bergson lost his way, on the way down from the Plotinian hypostases; he put 'life' above intellect, the first born son of the One."[63]

The question posed by Gilson in a Plotinian context is evidently not what would be imposed by a Bergsonian context. The issue is to find out whether "a gratuitous push" is "gratuitously" added to "an impetus called *vital.*"

Bergson's readers, and sometimes even his historians, have not examined his concept of creation closely enough. However, an almost commonplace distinction illuminates it completely, the distinction between *discover* and *invent*: "Discovery is concerned with what already exists, actually or virtually, sooner or later; therefore, it is sure to come. Invention gives being to what was not; it might never come."[64]

It is certainly necessary to see a challenge to reason there. Bergson multiplies provocative expressions. In a talk, he introduces the notion of creation in a definition of spirit. "By spirit we must understand a reality that is capable of drawing more from itself than it contains." Bergson insists: "Philosophy bears on an object that has as its essential property . . . to draw out of its depths not only everything there is but more than there is."[65] And again, in a meeting in England: "If the spiritual power exists, where and in what would it be distinguished from other forces, if not by the capacity of drawing from itself more than it contains?"[66]

When Bergson reencounters the irreducible reality of the free act, he quite naturally chooses the word *causality* to describe it. But this causality in the free act is an immediate datum of consciousness and, as

60. Gilson, *From Aristotle to Darwin*, 111.

61. Gilson, *From Aristotle to Darwin*, 117.

62. Gilson, *From Aristotle to Darwin*, 122.

63. Gilson, *From Aristotle to Darwin*, 122–23.

64. Bergson, *Pensée et Mouvant*, 62.

65. Talk at Reverend Hollard's meeting (May 14, 1911), in Bergson, *Mélanges*, 887.

66. Bergson, "Conscience et vie," 22.

such, without relationship nor even resemblance to physical causality: "If the causal relation still exists in the world of internal facts, it cannot *resemble in any fashion* what we call causality in nature."[67] Therefore, Bergson begins by expressing the distinction and adding adjectives to the noun: "physical causality," "psychological causality." But a moment comes when the philosopher can no longer use the same word with two opposite meanings. Bergson therefore leaves the word *causality* where he needs to specify "physical," and he says creation where he used to say "psychological causality."

It is indispensable to clear up any ambiguity in the word *causality*, because we are dealing with two fundamentally opposed expositions of it in Bergsonism. A classical definition of the principle of causality indicates that there is no more in the effect than in the cause, because this *more* would be without a cause. This definition makes two aspects of causality stand out: on the one hand, it clearly seems to be a variation of the principle of identity; on the other hand, it is explicitly opposed to a creation. Causality "implies that *nothing is created* in the passage from one moment to the following moment." Creation "implies, *on the contrary*, by the very act something that did not exist in the antecedents."[68]

Accordingly, there is nothing gratuitous in Bergson's line of thought that isolates the faculty of creating and separates it from intelligence. If the act of creating is not submitted to the principle of causality and even is contrary, how could it depend on an "intelligence," where the principle of causality is the directing principle of thought? Certainly, Gilson can ask the reason for attributing creation to life, when life is the vital impetus. But there are serious reasons to exclude a creative intelligence from the response.

In the chapter "Bergsonism and Finality" in *From Aristotle to Darwin*, philosophy overtakes history, which does not keep us from saying that history summons philosophy. The work's complete title tells which philosophy: *From Aristotle to Darwin and Back Again*, evidently back to Aristotle.[69] The classical problem of finality offers occasions to clarify this

67. Bergson, *Essai sur donées immédiates*, 153 (132; emphasis added). A few lines further on, Bergson speaks of "apparent analogies," as if he had wanted ahead of time to clearly signal that he is not even dealing with analogies.

68. Bergson to Léon Brunschvicg (Apr. 4, 1903), in Bergson, *Mélanges*, 585 (emphasis in original).—On the question of creation, see Polin, "Bergson," esp. 120–23; Gouhier, *Bergson dans l'histoire*, ch. 4, "Causality and Creation."

69. On Bergson and Aristotle, see Gilson, *From Aristotle to Darwin*, 114–18.

theme of return. Following a tactic customary in his thinking, Bergson begins by imagining two absolutely opposed limit positions: "radical mechanism" and "radical finalism." The odd thing is that both doctrines are unacceptable for the same reasons. In the one and the other, we are in a universe where "there is nothing unforeseen, no invention or creation," where there is only time without duration that consequently is not time. This is certainly true for "radical mechanism," but is it so for "radical finalism"? Finality drags us along in a universe where "things and beings only act to carry out a program once it is traced." "Finalism thus understood is only inverted mechanism." In fact, "it substitutes the attraction of the future for the impulsion of the past."[70]

The idea of return to Aristotle has slipped into this dissertation on Bergsonism and finality. Bergson has just posited or rather proposed a vital impetus at the origin of animal species.[71] The mechanistic explanation has been rejected. It certainly is necessary to turn toward "the doctrine of finality, which says that the parts have been assembled according to a preconceived plan, with a view to an end. In this, it likens the labor of nature to that of the workman, who also proceeds by the assemblage of parts with a view to the realization of an idea or to the imitation of a model." But then, where is the difference with a mechanism? Certainly, the too obviously anthropomorphic concept has been eliminated, but the doctrine still "holds that nature has worked like a human being by bringing parts together."[72] Commenting on this passage, Gilson recognizes in it a doctrine of finality attributed to Aristotle.[73]

From there comes a deeper investigation that, summing up, boils down to two demonstrations.

1. We are dealing with a "badly understood Aristotelianism."

2. Genuine Aristotelianism is not as far from Bergson as he believes.

"It is true precisely that Aristotle's concept of final cause was inspired by the example of artistic, artisan, or work activity." Bergson is right to recall that and, on this occasion, to criticize a "doctrine of finality" that shows us nature acting as human beings act. But this anthropomorphic representation of nature is not that of Aristotle. According to Gilson,

70. Bergson, *Creative Evolution*, 45.

71. Bergson, *Creative Evolution*, 95ff.

72. Bergson, *Creative Evolution*, 99.

73. Gilson, *From Aristotle to Darwin*, 114–18.

Aristotle's representation is even strictly the opposite: "It is art that imitates nature and not the reverse." What follows clarifies that reverse. "Unlike art, nature does not calculate, reflect, or choose." Gilson even adds: "This is indeed why, when nothing happens to disturb her activity, nature does not make mistakes," and "nature does nothing in vain."[74]

Once mechanism is excluded, a certain finalism is inevitable, as Bergson himself admits,[75] and *ipso facto* a certain anthropomorphism. This finalism is not one that supposes nature is made in the image of the human being who calculates, who reflects, who chooses, and so forth; not "inadequate formalism wherein living things change only in order to accomplish predetermined ends" but "the true finalism, that of forms immanent in nature and working from within to incarnate themselves there by modeling matter according to their law."[76]

Is this immanent finality, which is no longer the "caricature of finalism"[77] where nature is not imagined as an architect that executes a plan, so different from the one Bergson wanted to uncover? "With him the naïve notion of the production of the present by the future ceased to exist."[78] The issue evidently is not of philosophical kinship but of a common attitude toward determinism of the future. Bergson's critique of the teleology attributed to Aristotle "led him to revive true Aristotelianism and to restore to it the place usurped by false Aristotelianism."[79]

Bergson, says Gilson, was right to reject the teleology falsely attributed to Aristotle, "but he ought perhaps to have made an effort to comprehend true finalism." Still, Gilson knows perfectly that Bergson was unable to want to make this effort, since "his critique of intelligence . . . overlooks the possibility."[80] "Bergson's critique of intelligence was one of the most objectionable points of his doctrine."[81]

Let us indicate a passage showing that Gilson clearly sees the opposition between reason and creative power, opposition that is much less

74. Gilson, *From Aristotle to Darwin*, 114. See 9, 12–13, 217n16.

75. Gilson, *From Aristotle to Darwin*, 113–14 and 119–20.

76. Gilson, *From Aristotle to Darwin*, 117–18.

77. Gilson, *From Aristotle to Darwin*, 118.

78. Gilson, *From Aristotle to Darwin*, 119.

79. Gilson, *From Aristotle to Darwin*, 117.

80. Gilson, *From Aristotle to Darwin*, 117–18.

81. Gilson, *Philosopher and Theology*, 137.

radical, to be sure, when the creative power is an intellect. Gilson writes, regarding Bergson:

> His remarkable failure to appreciate the true nature of intellect, which he obstinately continued to see as only the faculty of associating like with like, of perceiving, and also of producing repetition—a calculating machine—leads him to situate elsewhere the source of invention, of creation, of all that by which the solution of a problem exceeds the simple sum of the items given.[82]

Gilson respects Bergson's thinking too much to fail to add: "It would be useless to ask Bergson to disown what he held as the mainspring of his dialectic; that is, the unfitness of intelligence to create something new. Intelligence's natural calling is geometry."[83]

82. Gilson, *From Aristotle to Darwin*, 120–21.
83. Gilson, *From Aristotle to Darwin*, 120.

Second Essay

Étienne Gilson and the Concept of Christian Philosophy

1. Émile Bréhier and the Concept of Christian Philosophy

IF WE WANT TO have an idea of the research and controversies about the concept of Christian philosophy in 1925 and the following years, it would be tempting to say, "In the beginning was a chapter written by Émile Bréhier at the end of the second section of volume 1 of his *History of Philosophy*." This section dealt with the Hellenistic and Roman period. Before entering the Middle Ages, Bréhier added a chapter, "Hellenism and Christianity in the First Centuries of Our Era."[1]

Writing a general history of philosophy, Émile Bréhier inevitably had to arrive at a moment when he needed to ask himself about the reciprocal behavior of Hellenism and Christianity. It is a historical issue and linked to a certain period, for which the historian seeks an answer.

First comes a warning: "It would be dangerous to confuse Christianity itself with the interpretation that is given to it after many centuries have elapsed."[2] "Christianity itself," therefore, means the Christianity of the origins.

"At its beginnings, Christianity is not at all speculative. It is an effort at mutual help, both spiritual and material in the communities."[3]

1. This chapter also appeared as an article in the *Revue philosophique* in 1927; see Bréhier, ""Héllenisme et christianisme."

2. Bréhier, *Histoire de la philosophie*, 1:493.

3. Bréhier, *Histoire de la philosophie*, 1:493.

Moreover, "Christianity's natural spontaneous form is not written didactic teaching," or at least there are only "occasional writings, epistles, parables."[4] In short, there is "no coherent, rational, doctrinal exposition."[5] There is "total absence of reasoned, theoretical views on the universe and God."[6]

By contrast, "around the time of the Christian era, Greek philosophy had formed the image of a universe completely penetrated with reason, stripped of mystery." All practical wisdom "is directed by this naturalism. In its consolation, its counsels, its direction of conscience, there is always the same refrain: why weep, fear, or trouble oneself in a world where eventually everything happens at its place and time?"[7]

Understandably, it was impossible to make Hellenism and Christianity fit into each other, and Bréhier expresses this impossibility on two occasions when the phrase "Christian philosophy" appears in his writings. "In any case," he writes, "during the first five centuries of our era, there is no peculiar Christian philosophy implying a fundamentally original and different set of intellectual values from those of the pagan thinkers."[8] Perhaps the second passage is more significant, because it announces a program of investigation: "In this chapter and the following ones, we hope . . . to show that the development of philosophical thinking was not powerfully influenced by the advent of Christianity and, to sum up our thinking, that there is no Christian philosophy."[9]

Therefore, in this chapter of his *History of Philosophy*, Émile Bréhier situates a break, if we may call it that, between Christianity and Greek philosophy. Closest to its origin, in the Gospels, Christianity contains no philosophical structure even implicitly, while Greek philosophy, despite its diversity, can be placed under the label of rationalism. But it is difficult to draw boundaries within history, most particularly if we are dealing with history of ideas. In the first of the two passages where Bréhier uses the phrase "Christian philosophy," he no longer talks about Gospel Christianity. He has not found "Christian philosophy during the first five centuries of our era," which is to say, during the period covered

4. Bréhier, *Histoire de la philosophie*, 1:486–87.

5. Bréhier, *Histoire de la philosophie*, 1:486.

6. Bréhier, *Histoire de la philosophie*, 1:487.

7. Bréhier, *Histoire de la philosophie*, 1:486–87.

8. Bréhier, *Histoire de la philosophie*, 1:493.

9. Bréhier, *Histoire de la philosophie*, 1:454.

by the chapter on "Hellenism and Christianity in the First Centuries of our Era," a chapter that includes part of patristics. In the second volume, we find that Bréhier has given the expression "Christian philosophy" an indefinite extension governed by its comprehension, which does not correspond to any set of particular cases.

Such indeed seems to be the direction of Bréhier's thinking when we see how it led to the article published in the April–June 1931 *Revue de métaphysique*: "And Is There Christian Philosophy?" Here we are not dealing with the time of the Gospels nor with the five first centuries of our era but with Christian philosophy as such. To briefly characterize the nature of Bréhier's corrections, Bréhier substitutes a logical truth for an empirical truth.

Reviewing the entirety of Western philosophy, Bréhier finds no idea that would be at the same time philosophical and specifically Christian in nature. In the patristic period and in the Middle Ages, Bréhier dwells upon St. Augustine and St. Thomas, but what is philosophical in their doctrines is Greek. In the centuries of the modern period, rationalisms, whether Cartesian or Hegelian, again play the role that Greek rationalism had. Bréhier goes as far as Maurice Blondel, whose philosophy of action is so closely related to apologetics. Consequently, for Bréhier, we are dealing with alternatives, and the concept of Christian philosophy is contradictory in itself. Either it is Christian and not philosophy, or it is philosophy and not Christian. Bréhier discovers a passage of Feuerbach that, with small variations, will be quoted often in the discussions on Christian philosophy: "We can no more speak of Christian philosophy than of Christian mathematics or Christian physics."[10]

It is quite legitimate to view these two articles by Émile Bréhier as two stages on the same journey. But placed in their historical context, they unfold in a cultural environment where another historian, Étienne Gilson, is already grappling with the same subject. Xavier Léon arranged a meeting of the two.

Opening the Société française de philosophie's March 21, 1931, session,[11] Xavier Léon said to Étienne Gilson, "When you returned from America" (in Dec. 1930), "you came, as always, to get my news."[12] Léon

10. Bréhier, "Y a-t-il une philosophie chrétienne?," 162.

11. The *Bulletin de la Société française de philosophie* 31 (1931) consists of a report of this session of the French Society of Philosophy.

12. Letter to Henri Gouhier, Dec. 4, 1930: "I have just returned a few days ago." A letter dated Nov. 10, 1930, was sent from the Pontifical Institute of Mediaeval Studies,

Brunschvicg was there. The conversation was about his second article on "True and False Conversion," soon to appear in *La revue de métaphysique et de morale*, in which Gilson "would be a bit challenged under the guise of St. Thomas." The discussion was so "scintillating" that almost the next day, Xavier Léon wrote to Gilson to propose to take it up again in order to make it the object of a session of the association. Gilson accepted: "Except that you have expanded the debate and not limited it to Thomist philosophy. You have proposed 'The Concept of Christian Philosophy.'" Then came the happy coincidence: "Precisely last summer, Bréhier sent me an article that has almost the same title: 'Is There a Christian Philosophy'?"[13]

What had been Gilson's trajectory?

2. Thomism and Étienne Gilson

At the Société française de philosophie, Étienne Gilson declared to Jacques Maritain: "As a professional historian, it was the study of the history of medieval philosophy that led me to pose the problem of Christian philosophy—and not the theoretical posing of the problem that led me to the study of history." Gilson was specific: he began by being a historian of modern philosophy, and it was within this history that the author of *Theology and the Cartesian Doctrine of Freedom* encountered the history of medieval philosophy. He recalled, "I first studied the influence of medieval philosophy on certain aspects of modern philosophy, and next medieval philosophy itself." It was then that an idea occurred to him that would produce a major turn in his career: "I finally asked myself how it was that both were so different from Greek philosophy." Gilson added, "It was only then and rather late that the problem of influence exercised by Christianity on the development of medieval philosophy presented itself to my mind. . . . In the notion of Christian philosophy I seek a conceptual translation of what I believe is a historically observable object: philosophy in its Christian state."[14]

Gilson recalls that his reflection on Christian philosophy originated in his work as a historian of philosophy; he gave Maritain no date. What is certain is that in 1925 he used the concept of Christian philosophy and knew its problems.

University of Toronto. [Current location of letters unverified.]

13. *Bulletin* (1931), 42.

14. *Bulletin* (1931), 72.

By then, Gilson was already the author of a considerably output. Without speaking of his thesis on Descartes, he had written important articles gathered in *Études de philosophie médiévale* (*Studies in Medieval Philosophy*) (1921), from which I will mention only "The Meaning of Christian Rationalism" and "The Historical Significance of Thomism";[15] *La philosophie au moyen âge* (1922), initially appeared in two volumes in the Payot Collection;[16] *La Philosophie de Saint Bonaventure* (*The Philosophy of Saint Bonaventure*), whose preface is dated April 26, 1924; two editions of *Le Thomisme* (1920 and 1921), to which Gilson added a third revised, enlarged edition in 1927, whose preface is dated June 12, 1925.[17]

In the new part of this third edition of *Le Thomisme*, the frequently used expression "philosophy of St. Thomas" requires an explanation. "What then is this philosophy? St. Thomas has never practiced or conceived it except in its proper place within the hierarchic structure of Christian wisdom, and therefore, no doubt, it never occurred to him to detach it and to give it a special name. Yet it might have a name, because it existed and had a name long before St. Thomas transformed it and marked it with his impress: it is the *Christian Philosophy*."[18]

Thus, in Thomism, philosophy always appears only with theology, and nothing invites it to show itself in its own voice. But this voice had existed for a long time before St. Thomas, and Gilson gives the definition of Christian philosophy: "We mean by this a philosophy which intends to be a rational interpretation of data, but considers as an essential element of those data the religious faith, the object of which is defined by the Christian revelation." Gilson found the expression in a biography of St. Thomas published in the eighteenth century.[19] He always seems careful to give this expression a connotation such that "the role assigned

15. The doctoral thesis was *Doctrine cartésienne de la liberté et la théologie* [Theology and the Cartesian Doctrine of Freedom].

16. Republished or rather done over in a single volume, second revised edition, 1944. [The translator's copy is a single-volume 1925 reprint covering from the Carolingian renaissance to Eckhart, the period it describes as medieval philosophy.]

17. The first edition of *Le Thomisme* was published by Vix in Strasbourg, 1920, and then at Paris by Vrin in 1922. We quote here according to the third revised and enlarged edition (1927). *Le Thomisme* has been translated into English as both *The Philosophy of St. Thomas Aquinas* and as *The Christian Philosophy of St. Thomas Aquinas*.

18. Gilson, *Philosophy of St. Thomas Aquinas* (1929), 28–29.

19. Gilson, *Philosophy of St. Thomas Aquinas* (1929), 29. Cf. Touron, *Vie de S. Thomas*. Although it was published in 1737, there is a 1927 edition and a 2014 reproduction by Nabu Press.

to reason and the place assigned to philosophy may vary endlessly." In particular, he sought a definition that would suit as well and even better St. Thomas than St. Bonaventure, about whom Gilson had just written a large book (1924), and St. Augustine, on whom he was preparing another.[20] The notion of giving the expression Christian philosophy a particular sense—perhaps we would say technical sense today—came to Gilson as he reflected on what he found in Thomism under the word *philosophy*. He tried to express it in a text that is more of a particular approach than a definition.

If we understand Gilson correctly, St. Augustine and St. Bonaventure had the intention of elaborating a doctrine that would be Christian. They treated secular science as suspect. It is certainly a handmaiden of the faith but one to be employed "by directing and commanding her."[21] However, all Gilson's prior works had showed him that St. Thomas had a radically different attitude that renewed the concept of Christian philosophy by renewing that of philosophy. The fundamental role of this passage included in the text of *Thomisme* is proven by the fact that Gilson devoted to the concept of Christian philosophy the whole preface added to the third edition, a preface, as we saw, dated June 12, 1925.

According to Gilson, St. Thomas renewed the old problem of reason and faith and all its variations, by introducing on reason's side of the relation a philosophy as purely and also perfectly rational as Aristotle's could be. "The discovery of his metaphysics and his physics," Gilson writes, "produced such an impression on thirteenth century minds that Aristotle rapidly came to be identified with philosophical reason." "Aristotelianism," adds Gilson, "was not a philosophy; it was *the* philosophy."[22] If the independence of reason in physics and metaphysics is stamped into the historical significance of Thomism, then for Gilson, "We would have to recognize that Thomism is one of the most significant manifestations of human reasons's independence."[23] In this sense, "Thomas Aquinas is

20. Gilson, *Introduction à l'étude de saint Augustine* [The Christian Philosophy of Saint Augustine].

21. Gilson, *Studies in Medieval Philosophy*, 34–44 (*Études de philosophie médiévale*, 50). [Translator: Gouhier cites p. 52, corresponding to ch. 3, "Double Truth"; but the sense seems to indicate ch. 2, "The Handmaiden of Theology."]

22. Gilson, *Studies in Medieval Philosophy*, 46–47.

23. "The Historical Significance of Thomism," in Gilson, *Studies in Medieval Philosophy*, 70. In this study, Gilson always cites along with Thomas Aquinas his teacher, Albertus Magnus.

the first modern philosopher in the full sense of the word," since "he is the first Westerner whose thought is not the prisoner of a dogma or a system."[24]

In 1925, Étienne Gilson reread his *Thomisme* and decided to take up the question again: "How can we speak about St. Thomas's philosophy?" But after what his research on Thomism had shown him, this question became an objection. Gilson knew it well, and the preface of the third edition is intended precisely to put the matter in focus. "St. Thomas has been turned into a pure philosopher." Isn't this the height of paradox, since Thomas never spoke of philosophy except in the context of theology? But the texts are there. "It honestly does not seem possible to us to consider the philosophy of St. Thomas as anything other than the purely rational solution of a uniquely philosophical problem." And again, "When Thomas is situated in the historical tradition it indeed appears as the original solution to a problem that is already centuries old in the period when St. Thomas undertakes its solution: in what conditions in general is a Christian philosophy possible?" A concise expression dispenses with a long explanation: "For a Christian philosophy to be possible," St. Thomas answers, "it is first necessary for it to be a philosophy."[25]

The importance of what the third edition of *Le Thomisme* teaches us cannot be emphasized enough. Gilson had not encountered the question of Christian philosophy in Émile Bréhier's *Histoire de la philosophie*. We are dealing with two journeys that do not have the same point of departure and that are not driven by the same concerns.

In the measure in which we can specify dates, everything leads us to believe that the first passages of Gilson on Christian philosophy are prior to those by Bréhier on the same subject. The preface to the third edition of *Le Thomisme* is dated 1925. The chapter in Bréhier's book appears in 1927. Émile Bréhier's thinking on Christian philosophy, or rather on the absence of Christian philosophy, appears with all its significance and historical consequences in the April 1931 *Revue de métaphysique* article. In short, Gilson only really becomes acquainted with Bréhier's thesis at the meeting held at his request, in the course of which Bréhier presents the main points of his article then in press.

24. Gilson, *Studies in Medieval Philosophy*, v.

25. Gilson, *Thomisme* (1927), 9. [Translator: The English translation of this 3rd ed. has its own author's preface and was in preparation at the same time as the 3rd French ed.]

That said, the chronology is unimportant here. Writing a general history of philosophy, Bréhier naturally arrives at the period in which the question is posed about the behavior of Christian thought in a history of ideas where the Greeks are king. Initially, Bréhier's passages on Christian philosophy belong to occasional works. It does not seem that Bréhier returned to the subject later.

Étienne Gilson's perspective is quite different. As a professor of medieval philosophy, he encounters the problem of the agreement of faith with reason in each author. Because of the presence of Aristotle on the side of reason, this problem is what we know well today as the relation of faith to science, which is to say, of faith with a reason not depending on revelation. Acceptance of this situation is precisely Thomism's historical significance. For this new situation, there is a new expression: Gilson calls *Christian* a philosophy as purely rational as physics or mathematics and yet in perfect agreement with faith. According to Gilson, the concept of Christian philosophy originates at the confluence of circumstances represented by Thomism. From this fact, Thomism becomes the model of every philosophy capable of coexisting with revelation, without ceasing to be philosophy in the strict sense. We therefore understand that the concept and problem of Christian philosophy are fundamental themes in Gilson's reflection upon "the natural and supernatural."

In fact, upon Gilson's return from America in December 1930, when he proposes to Xavier Léon to hold a meeting on "The Concept of Christian Philosophy," he is dealing precisely with the subject of his recent projects.

3. "An Incredible Story"

In the letter of November 10, 1930, already quoted, we read, "I returned four days ago, and I feel in fine fettle."[26] "Currently, I am occupied with my Gifford Lectures, which are in their third version, but it is the good one." Gilson continues: "The other two refused to function and even to yield to violence, while so far the latter engenders its own chapters with the spontaneity of a living being." When he adds: "But what a story! What won't people say! Brunschvicg and Fr. Mandonnet are going to combine to anathematize me,"[27] we cannot help thinking of the first two lectures,

26. See 115n12 above, regarding letter to Henri Gouhier.
27. Letter to Henri Gouhier, Nov. 10, 1930. [Current location of letter unverified.]

which became the first chapters of *The Spirit of Medieval Philosophy*, entitled (ch. 1) "The Problem of Christian Philosophy" and (ch. 2) "The Concept of Christian Philosophy."

These two chapters have a curious history that Gilson told six or seven years later in *Christianisme et philosophie*.[28] He had just characterized the heart of the debate provoked by the concept of Christian philosophy by declaring: "The issue is simply to find out whether it is admitted or it is denied that the exercise of a natural reason recognized by revelation is still a rational exercise and whether the philosophy that it engenders merits the denomination of philosophy." The text becomes a confidence. "I am reproached for being obstinate in maintaining the expression 'Christian Philosophy.' Well, my personal reasons are not secret. They are attached to a history that is brief and so simple that I am going to tell it without hoping that people will be willing to believe it." The unexpected story follows. "I wrote the first volume of *The Spirit of Medieval Philosophy* that became Chapter 3 to the end, without thinking about the concept of Christian philosophy. It is then that I hit upon it, and since it seemed to me to give a unity to the philosophy that I was busy writing, I wrote the first two chapters on this concept."[29]

"I was rather happy about my discovery," says Gilson. What Gilson confides to us in *Christianisme et philosophie* is very important. Taken literally, it introduces a before and an after into the history of his thinking, a before and an after the "discovery" of the concept of Christian philosophy. But in writing the pages that would be the third and subsequent chapters of *The Spirit of Medieval Philosophy*, he declares that he was doing Christian philosophy without knowing it. Still, it is difficult for us to believe that Gilson forgot what he wrote in the third edition of *Thomisme*, notably in the 1925 preface. "Taken literally" signifies that the incredible history tells what took place in Gilson's mind while he wrote the first series of his Gifford Lectures. It is a fact that he was not thinking about Christian philosophy; it was a discovery, a perception that came to him while he was occupied in making coherent the philosophy he attempted to put down on paper. The continuation of Gilson's confidence to us seems to justify this reading. Since Gilson appropriates the concept of Christian philosophy, he seeks to know its history, which is not surprising. From there comes the idea of adding "Biographical Notes to Serve

28. Gilson, *Christianisme et philosophie*, 128–29.
29. Gilson, *Christianisme et philosophie*, 129.

the History of the Concept of Christian Philosophy" to the text of the Gifford Lectures and to its notes. This new labor undertaken by Gilson makes clear his interest in this biographical appendix.[30]

Let us return to Gilson's account in *Christianisme et philosophie*. Without even starting a new paragraph, he mentions another step: "I was happy about my discovery, when, as I went on to study the documents related to this concept and rediscovered the Encyclical *Aeterni Patris*, which," he confesses, "I had forgotten," he observed, "that Pope Leo XIII said everything that had to be said about the meaning and teaching of Christian philosophy."[31] Thereafter, fidelity to the encyclical *Aeterni Patris*, in some way, is part of the definition of Christian philosophy.

It is important that in the biographical notes published in 1932, and hence before *Christianisme et philosophie* (1936), a whole page is devoted to Gilson's own works, cited with exact references, even with corrections remitting to passages that permit us to situate texts in a history of Christian philosophy, where the expression is not used. Of course, the passages of the third edition of *Thomisme* are indicated, except for those of the 1925 preface.[32]

Another fact must be pointed out. In the first two very important studies that Gilson publishes on Christian philosophy, the statement to the Société française de philosophie and the first chapters of *The Spirit of Medieval Philosophy*, Gilson does not cite Bréhier's two studies. He was not an author who forgets to indicate his sources and still less one who hid his disagreements. Looking closely, it becomes clear that we are dealing with two parallel itineraries, and the long dialogue at the Société française de philosophie really consists of two monologues. But in a bibliographical sketch of the history of Christian philosophy, there can be no question of omitting Bréhier's two studies, and we can be sure that Gilson never even considered it.[33] He gives them a whole page. Bréhier's name will reenter the narrative of adventure that was the pursuit of this concept of Christian philosophy: "Something," Gilson says, "I took so much trouble to uncover in the facts, and whose name my colleague Émile Bréhier

30. Gilson, *Esprit de la philosophie médiévale*, 297–324. [Translator: this bibliography is not included in my edition of *The Spirit of Medieval Philosophy*, so references to it will cite the French edition.]

31. Gilson, *Christianisme et philosophie*, 129.

32. Gilson, *Esprit de la philosophie médiévale*, 316–17. It is not clear why the preface is not mentioned. When Gilson decides that a text is no longer suitable, he says so.

33. Gilson, *Esprit de la philosophie médiévale*, 32.

had brought back to my memory by denying that it existed," even though "it had imposed itself on me at the end of a long investigation."[34]

4. The Situation of Christian Philosophy

The first two Gifford Lectures have the privilege of also being the earliest authoritative exposition in which Gilson started by trying to finish off the problem of Christian philosophy (ch. 1) and then undertook to give a really clear notion of it. Obviously, Gilson had the feeling of placing a genuinely precise and quite new idea in a formulation that owes its apparent obviousness to absence of reflection. It was still difficult for him not to mix the investigation of a definition grounded in the understanding of its terms with the critique of philosophers or theologians who persist in not seeing the possibility of harmonizing adjective and noun in the expression "Christian philosophy." Let us try to retain from the polemic only what facilitates the comprehension of the phrase and to show, in this first great exposition of Christian philosophy taken in all its extension, some major themes that Gilson would persist in holding to be fundamentally true.

First, Christian philosophy is presented as rising out of history. There are historians who, without arguing *a priori* the question of finding out whether there can be or not a Christian philosophy, state as a fact that even in the Middle Ages, there never was one.[35] Indeed, in medieval doctrines, all philosophy comes from the Greeks. If this is granted, what it would prove is that up to this period there was no acknowledged Christian philosophy, not that there never will be one.[36] In the event, this historical question is assumed to be a question of logic.

"If the historians state the fact, the philosophers go on to add the reason—if no Christian philosophy has appeared on the stage of history, that is because the very concept of a Christian philosophy is contradictory and impossible." Indeed, "all agree in affirming that it [religion] does not belong to the order of reasoning, and that reason, on its side, is quite independent of religion. Now, the order of reason is precisely that of philosophy."[37] From there comes the famous comparison that Gilson

34. Gilson, *Christianisme et philosophie*, 30.
35. Gilson, *Spirit of Medieval Philosophy*, 2–3.
36. Gilson, *Spirit of Medieval Philosophy*, 10.
37. Gilson, *Spirit of Medieval Philosophy*, 3.

owes to Feuerbach: "Nobody today would dream of speaking of Christian mathematics, Christian biology or Christian medicine. But why? Because mathematics, biology, and medicine are sciences, and because science, in its conclusions no less than in its principles, is radically independent of religion."[38]

These last quotations express the thinking of philosophers or theologians who judge that the concept of Christian philosophy is condemned from within by the very logic of its definition. Indeed, in the 1925 preface that we read at the start of the third edition of *Thomisme*, Gilson recognizes the possibility of avoiding this logic so that the problem of Christian philosophy is shifted. The issue is no longer whether there is logical incompatibility[39] between noun and adjective but whether in particular, despite this incompatibility, a certain relation might not subsist that would be manifested in a collaboration between the data of Christian consciousness and the analyses of philosophy.

But how can cooperation be achieved between what is natural and what is supernatural? We have seen how Émile Bréhier insisted on "the total absence of theoretical views on the universe and on God" in the Gospel texts. Between the world of faith and the world of reason no communication is possible, at most mere juxtapositions. For example, in the Middle Ages, many Christians became philosophers, but everything philosophical in their doctrines is taken from Greeks, Platonists, Aristotelians, and Stoics.

As for the sacred books, they are certainly not books of philosophy, but as Gilson shows easily, their texts are impregnated with philosophy. "The Bible is full of concepts of God and divine government." "Are we," Gilson asks, "going to suppress the first Epistle of St. John or strip the Gospel of John of the doctrine of the Word contained in the prologue?" Jesus himself taught the doctrine, preached faith in a provident God, and announced eternal life to human beings. There will be still much more to say in this sense if we take the Old Testament, beginning with the idea of creation.

The situation is not as simple as it seemed when we only had two domains to consider, with clearly delimited boundaries. Gilson writes that there are "a kind of common ground of philosophy and theology,

38. Gilson, *Spirit of Medieval Philosophy*, 3.

39. Gilson, *Spirit of Medieval Philosophy*, 3; see 37. Passages from Feurbach in Gilson, *Esprit de la philosophie médiévale*, 306–7n13. These three examples, mathematics, biology, and medicine, come from Feuerbach.

and reason grounded in faith oversees everything."[40] There are truths of faith that can also become truths of reason, for example, the existence of God and the nature of the soul.

This common ground is what makes possible and even provokes the cooperation of faith and reason. Let us understand correctly: when I demonstrate God's existence, this existence is no longer considered by me as a truth of faith. When I say in prayer "I believe in God," this act of faith is no longer thought of by me as a rational truth.[41] There is, Gilson writes, "the meeting of two convergent rays."[42]

In the encounter, the supernatural as such does not enter "into the texture" of philosophy, which must remain "purely natural."[43] It is normal that faith should seek the understanding virtually present in it.[44] Let us also note a primacy of faith in the well-known expression *fides quaerens intellectum*, which, as another well-known phrase expresses, makes philosophy the servant, "the handmaid of theology."[45] But there are two ways of serving. For St. Peter Damian, who invented the phrase, *handmaid* invokes servitude. When Gilson writes, "Philosophy is 'subordinated to theology,'"[46] we must think, according to St. Thomas, of the intellect at the service of the highest demands of the mind.

If the cooperation of reason with faith in their common ground is so, that would seem to define this "sacred doctrine" meticulously studied by St. Thomas at the beginning of the *Summa*, question 1, "On Sacred Doctrine: what sort of thing it is and what it covers." Aristotle's *Metaphysics* is where St. Thomas finds the suitable term *theology*, which is to say, divine science, *theologia sive scientia divina*.[47] Accordingly, we can ask ourselves where the difference between this theology and Christian philosophy lies. In fact, this question is always present in the search for definitions that Gilson is going to propose.

40. Gilson, *Studies in Medieval Philosophy*, 103. [Gouhier seems to apply to Thomas what Gilson says here of the Christian predecessors of Albert and Thomas.]

41. Gilson, *Esprit de la philosophie médiévale*, vol. 2, n.p.

42. Gilson, *Spirit of Medieval Philosophy*, 41.

43. Gilson, *Spirit of Medieval Philosophy*, 37; see also 33 and 41.

44. Gilson, *Esprit de la philosophie médiévale*, 5, 35, 43.

45. "The Historical Significance of Thomism," in Gilson, *Studies in Medieval Philosophy*, 87. See also, "The Handmaiden of Theology," in same, 26–44.

46. Gilson, *Spirit of Medieval Philosophy*, 10.

47. Aquinas, *Summa theologiae*, I, q. 1, a. 1.

Let us begin this search with the earliest exposition in the first two lectures at Aberdeen. The definition of Christian philosophy is set out in the first pages of the second lecture,[48] but we find the point of view from which Gilson has chosen to examine the problem of the concept of Christian philosophy almost at the beginning of the first lecture. This point of view is that of history working upon facts and situating these facts in a world of intentions, decisions, actions, and reactions.

Accordingly, it is the historian of medieval philosophy who speaks. He asks what the Augustinians before St. Thomas, St. Anselm, and St. Bonaventure, for example, would have answered, if someone had spoken to them about philosophy as the work of reason alone. "They would certainly regard an exercise of pure reason as a possibility after Plato and Aristotle, who could do it—but . . ." This "but" is going to introduce a change of perspective: ". . . but they would view the matter not so much from the standpoint of the mere definition of reason as from that of actual conditions of fact under which it has to work."[49] In other words, these Augustinians are not interested in the possibilities of reason taken abstractly but in the accomplishments of a reason that takes circumstances, *circumstantiae*, into account. "It is a fact that between ourselves and the Greeks, the Christian revelation has intervened and has profoundly modified the conditions under which reason has to work." The sentence has all the greater interest in that it effectuates a change of level. We pass from the theoretical exercise of pure reason to the practical exercise of reason in its historical context. The immediate consequence of this change is a question. But it is a question that indicates its answer. "Once you are in possession of that revelation, how can you possibly philosophize as though you had never heard of it?"[50] It is not surprising to encounter this question at the beginning of each explanation that Gilson will propose for Christian philosophy.

For example, let us read the explanation of the second Gifford Lecture: "I call *Christian, every philosophy which, although keeping the two orders formally distinct, nevertheless considers the Christian revelation as an indispensable auxiliary to reason.*"[51] "Keeping the two orders formally distinct." There is no confusion between the order of faith and

48. Gilson, *Spirit of Medieval Philosophy*, 37.

49. Gilson, *Spirit of Medieval Philosophy*, 5.

50. Gilson, *Spirit of Medieval Philosophy*, 5.

51. Gilson, *Spirit of Medieval Philosophy*, 37 (emphasis in original).

the order of reason. Gilson insinuates the Thomist idea of philosophy and acknowledges in it the independence that is characteristic of all sciences. If there is a Christian philosophy, its truth, like that of physics, owes nothing to faith. In "*considers the Christian revelation as an indispensable auxiliary to reason*," the word *auxiliary* reminds us that the supernatural does not mix up any text with that of philosophy but intervenes in the inspiration and aspiration of this philosophy.

Gilson himself has emphasized these words and might have done so as well to the ones that follow. He continues, "The concept does not correspond to any essence susceptible of abstract definition but corresponds much rather to a concrete historical reality as something calling for description."

The change of viewpoint that Gilson wants to accomplish cannot be expressed better. Certainly, Christian philosophy can be considered as posing a logical problem, if what the noun says excludes what the adjective says, and what the adjective says excludes what the noun says. However, that is not the authentic problem of Christian philosophy; it is lived in the consciousness of Christians who want to be philosophers and wonder whether they can do philosophy as if they were not Christians. We are not dealing with a possibility but with an impossibility. This impossibility is experienced in an evidence that manifests an experience or, if we prefer, in an experience that an evidence imposes on us.

Here, we acknowledge that, for want of a better word, it is helpful to call upon Étienne Gilson's realism: his concern not to depart from the real, his search for facts upon which thought must base itself, his resolve not to be confused by words, and above all, his continuous sense of human presence in the heart as in thought.

We emphasize this last expression. It indicates the direction in which the facts that are to be situated under the definition of Christian philosophy will be found. Gilson states: "What I seek in the concept of Christian philosophy is a conceptual translation of what I believe to be a historically observable object: philosophy in its Christian state."[52]

Gilson speaks at length about this "historically observable object" in the first two lectures at Aberdeen and at the March 31, 1931, session of the Société française de philosophie. At the end of his reply to Maritain, the words "philosophy in its Christian state" not only refer to "Christianity's influence on medieval philosophy" but also apply to its influence on

52. *Bulletin* (1931), 72.

modern philosophy. Furthermore, "philosophy in its Christian state" is understood as limited to the situation of the Christian who wants to be a philosopher. Accordingly, there are two perspectives.

In the first, the question extends beyond what concerns Christian philosophy. The point cannot be to make Descartes into a Christian philosopher, Gilson said at Aberdeen. But no one would dare to maintain that modern philosophy would be what it was from Descartes to Kant if it had not received from Christianity "more than one of its directive principles."[53] Gilson shows this at length for the idea of creation in Descartes, both in his first lecture at Aberdeen and in his discussion with Bréhier at the Société française de philosophie.[54] In this way, we lead up to the question of the measure in which religious influence can be found in the origins of the most rigorously rational philosophies.

"Philosophy in its Christian state" creates the other perspective. We are no longer dealing with the influence of religion in the history of ideas but with the religious life of the Christian who also wants to be a philosopher. "The Christian philosopher," Gilson writes, "is one who effects a choice between philosophic problems."[55] He is concerned above all with those whose solution affects the truths of his faith: the existence of God, the nature of human beings, their relations with God.[56] If we want to see what the cooperation of faith and reason can be, we should think of the weakness of the human understanding in its present condition, left to its own powers alone.

> Without the aid of faith, what to many would seem to be clearly demonstrated would to others be exceedingly dubious, and the spectacle of the philosophic conflicts thus arising would contribute not a little to breed skepticism in the generality of mankind, who for the most part, would view the discussion from outside. To overcome the *debilitas rationis* man has, therefore, need of divine aid; and this is what faith offers him . . . faith taking him, so to speak by the hand, puts him on the right road.[57]

53. Gilson, *Spirit of Medieval Philosophy*, 13. Cf. ch. 2, 223n20 of the French version *Esprit de la philosophie médiévale*. The history of philosophy, therefore, should not be confused with the history of Christianity's influence upon philosophy. Auguste Comte underwent the influence of Christianity, and yet, positivism is not a Christian philosophy. [Translator: see *Spirit of Medieval Philosophy*, ch. 13, 469n10.]

54. *Bulletin* (1931), 57–58.

55. Gilson, *Spirit of Medieval Philosophy*, 37.

56. Gilson, *Spirit of Medieval Philosophy*, 38.

57. Gilson, *Spirit of Medieval Philosophy*, 40.

These lines remind us of others from St. Thomas:

> When Sacred Science utilizes other sciences, the reason is not its defect or insufficiency, but the problems of our mind (*propter defectum intellectus nostri*), which it is necessary to lead by the hand (*manu ductus*) as it were, starting from natural knowledge (*per naturalem rationem*) the object of other sciences, on to supernatural matters (*quae sunt supra rationem*), the object of the latter.[58]

St. Thomas talks about theology here, the name he gives to "sacred doctrine" a little further on.[59] Gilson talks about "Christian philosophy." What is the difference?

5. Philosophy and Theology

To understand Gilson's thinking, it is always necessary to begin by seeing, or seeing again, the particular situation in which the questions are posed. "Because they are concepts, philosophy and religion do not exist. Only religious and philosophical human beings exist." Consequently, "in no case will we be able to make the philosophy of a Christian other than purely rational; otherwise, it would no longer be philosophy. But from the moment that these philosophers are *also* Christians, the exercise of their reason will be that of a Christian's reason." Gilson specifies: "That is to say, not a reason for another kind than that of non-Christian philosophers, but a reason that works in different conditions." Continuing to explore the world where reason finds these "conditions for work," Gilson asks himself further whether we would find there this abstraction, "the pure philosopher," a particular realization of a concept in which reason would be placed next to something irrational." "And above all" (he emphasizes), "I wonder whether philosophical life is not precisely a constant effort to lead the irrational things that are in us to the state of rationality." Gilson acknowledges the difficulty: "What is hard for us is to make the distinction between the irrational and what is not yet rational." It seems that Gilson sets this difficulty aside, since he continues, "And once the choice is made . . ." But after all, it pertains to each one to proceed to the critical stocktaking of his beliefs. What is certain is that Christians, on the one hand, know that such a choice has nothing to do with their salvation;

58. Aquinas, *Summa theologiae*, I, q. 1, a. 5, ad. 1.
59. Aquinas, *Summa theologiae*, I, q. 1, a. 7.

but, on the other, they can know that not all the truths of their faith are necessarily destined to remain truths of faith.

"This is the true meaning of St. Augustine's *credo ut intelligam* and St. Anselm's *fides quaerens intellectum*: the Christians' effort to draw rational knowledge from their faith in revelation." The declaration is followed by a judicious "and that is why these two expressions are the true definition of Christian philosophy."[60]

Gilson often set out the concepts of this passage, but here they are found in a harmoniously composed presentation. It remains to clarify how such Christian philosophy differs from theology, at least from the *doctrina sacra* called *theologia* that St. Thomas defined in question 1 of the first part of the *Summa Theologiae*.[61]

This theology consists of truths that surpass reason, truths whose origin is revelation, and which consequently come under faith. A first, very natural, attitude is that of St. Peter Damian.[62] A Christian does not need philosophy, which would even rather be a source of errors. Peter shows "fundamental hostility toward any purely rational speculation."[63] The famous expression of philosophy as handmaiden of theology (*ancilla theologiae*) arises in this context. It must be understood that if we were speaking of services that philosophy could render to theology, it would be necessary to think of the service of a servant who might be a slave.[64] "In Peter Damian's famous phrase, the idea of slavery predominates over that of utilization, and by a great deal."[65]

However, when we read the famous expression in the *Summa Theologiae*, we think exactly the contrary. Of course, *Sacra Doctrina* is superior to the other sciences, which therefore can be only servants.[66] But Jacques Maritain does not misrepresent St. Thomas's point in saying "*ancilla* and not slave."[67] Theology uses philosophy as an instrument of truth, whether in the exposition of revealed truth or in the refutation

60. *Bulletin* (1931), 47–48.

61. The question is clearly posed in Gilson, *Spirit of Medieval Philosophy*, 5.

62. See "The Handmaiden of Theology," in Gilson, *Studies in Medieval Philosophy*, 26–44. For the same expression in St. Thomas, see "The Historical Significance of Thomism," in Gilson, *Studies in Medieval Philosophy*, 87ff.

63. Gilson, *Studies in Medieval Philosophy*, 27.

64. Gilson, *Studies in Medieval Philosophy*, 31.

65. Gilson, *Studies in Medieval Philosophy*, 31.

66. Aquinas, *Summa theologiae*, I, q. 1, a. 5.

67. See 116n14 above in this chapter.

of errors that contradict it.[68] One immediately sees the difference from Christian philosophy.

If philosophy is involved in this theology, it is involved in the service of theology; it is "subordinated to theology."[69] In the case of Christian philosophy, the very expression declares we were in theology, and we have now entered philosophy. At Mass, the Christian prays the creed: "I believe in God." Having become a philosopher, his reason demonstrates God's existence: where there is rational evidence, there is no longer belief. If philosophy is the work of reason alone, it cannot be accommodated to any subordination to dogma or to religious faith.[70]

It is, therefore, impossible to confuse Christian philosophy, which according to Gilson is an authentic philosophy and therefore a purely rational one, and theology, which according to St. Thomas employs philosophy as a servant. It remains to discover whether, in Christian philosophy, the relation of Christianity with philosophy may not be a matter of influence. For example, Cartesian metaphysics was certainly conceived in a cultural milieu of Judeo-Christian origin. Let us reflect upon this God "in whom the idea of creation extends even to eternal truths." The influence of Christianity upon philosophy seems indisputable.[71] Yet no one would dream of making Cartesianism into a Christian philosophy.

Gilson is not being opportunistic when he begins explaining, "First" (and this "first" is significant), "there will be philosophers who consider the Judeo-Christian revelation as a morally necessary assistance to reason. Thanks to this guide, they will be able to eliminate error, add new truths to old ones, complete these old truths, or simply conserve them." This passage is the beginning of a definition, or rather a description of Christian philosophy that Gilson gives at the beginning of his 1931 declaration to the Société française de philosophie.[72] This helps us understand the definition given in the second session of the Gifford Lectures, published as *The Spirit of Medieval Philosophy*: "I call Christian every philosophy which, although keeping the two orders formally distinct,

68. Aquinas, *Summa theologiae*, I, q. 1, a. 8, "Utrum haec doctrina sit argumentatio?"

69. Gilson, *Spirit of Medieval Philosophy*, 4, 6.

70. Gilson, *Spirit of Medieval Philosophy*, 5. For the discussions between Gilson and Bréhier, and Gilson and Brunschvicg, see sect. 1 of this essay.

71. On the idea of creation in Descartes, see Gilson, *Spirit of Medieval Philosophy*, 13.

72. Gilson, *Spirit of Medieval Philosophy*, 2–3.

nevertheless considers the Christian revelation as an indispensable aux-
iliary to reason."[73]

In *Christianisme et philosophie* in 1936, Gilson takes up this last
definition with explicit reference to *The Spirit of Medieval Philosophy*.[74]

Accordingly, this philosophy is Christian without ceasing to be
philosophical, because it includes a certain awareness of its nonphilo-
sophical sources. However real the influence of Judeo-Christian culture
may be in Descartes's thinking, at no time does he acknowledge in his
philosophy a certain rational ordering of the data of Christian conscious-
ness.[75] Malebranche's attitude in this regard is quite different; he knows
what every Christian ought to know: to cause is to create; to create is the
operation peculiar to God; accordingly, guided by faith, the philosopher
constructs the purely rational edifice that is occasionalism.[76] The Judeo-
Christian vision of the world is not a kind of stage set, in front of which
the interplay of ideas develops but which could disappear without major
change in this interplay. To the contrary, the permanence of the credo in
the consciousness of the Christian who wants to become a philosopher is
necessary, since the nonphilosophical source of the philosophy is there. It
is impossible to insist too much on this indispensable condition of Chris-
tian philosophy.

6. The Editions of *Le Thomisme*

In *Thomisme*'s fifth, revised edition in 1944,[77] Gilson must explain what
has to be understood by the phrase "philosophy of St. Thomas," given
that St. Thomas spoke of philosophy only in connection with his theol-
ogy. Gilson reproduces the 1927 text up to the moment when he believes

73. Gilson, *Spirit of Medieval Philosophy*, 37. An idea of the difficulty may be
obtained by reading Gilson's two philosophical letters to Maritain of Nov. 28 and
Dec. 18, 1963. [Translator: Gouhier's bibliography includes Gilson and Maritain,
Correspondance.]

74. Gilson, *Christianisme et philosophie*, 139, and the long note 2.

75. On Descartes and Christian philosophy, see Gilson, *Spirit of Medieval Philoso-
phy*, 13–14.

76. On Malebranche and Christian philosophy, see Gilson, *Spirit of Medieval Phi-
losophy*, 14–15.

77. Gilson, *Thomisme* (1944), 5th ed., had 552 pages. The 3rd ed. in 1927 had 322
pages. [Translator: This 3rd ed. was translated into English as *The Philosophy of St.
Thomas Aquinas*.]

he can attach the label "Christian philosophy" to the philosophy of St. Thomas.[78] But, far from going on to justify the use of this label, Gilson declares: "Since the expression is not that of St. Thomas himself, and moreover, since it has provoked interminable controversies, it is preferable not to introduce it in a purely historical exposition of Thomism."

A note recalls the use of the expression in Fr. Touron's biography of St. Thomas and in the title of the encyclical *Aeterni Patris* of August 4, 1879, without even mentioning the name of Leo XIII. Another note removes any misunderstanding. Gilson will avoid the expression "Christian philosophy" as a simple question of expediency, he says. "Its legitimacy, however, seems as great as during the period in which we used it, but history can do without it, provided that we retain intact the reality that this expression designates. We explained ourselves about the meaning of the expression in *Christianisme et philosophie*."[79] Gilson remits to this work, I suppose, because he has allowed himself to be dragged into "interminable controversies" by the different contributors to the collection *La philosophie chrétienne* that had appeared three years earlier [in 1933].

It is worth pointing out that the conclusion reached by Gilson in the fifth edition of *Le Thomisme* seems definitive, since the sixth "revised" edition that appeared in 1965 retained the passage announcing it.[80] In principle, he would no longer mix his views on Christian philosophy with his expositions as a historian of philosophy. That did not prevent him from speaking of it elsewhere. In this same sixth edition of *Le Thomisme*, the preface dated January 9, 1964, remits to two books written on Christian philosophy,[81] whose importance should be emphasized in the history of the concept: *Elements of Christian Philosophy* and *Christian Philosophy: An Introduction*.[82]

78. Gilson, *Thomisme* (1944), 14; (1927) 40; *Philosophy of St. Thomas Aquinas* (1929), 29.

79. Gilson, *Thomisme* (1927), 14n2, n3. Gilson could have indicated that in an appendix to the 5th ed., he publishes the prefaces to the different editions and, consequently, the preface of the 3rd ed., where the use of "Christian philosophy" is discussed at length. [Translator: Ch. 1, 30–31n2, n3 of *Philosophy of St. Thomas Aquinas* (1993) do not refer to Christian philosophy.]

80. *Thomisme* (1965), 14, and n19 and 20.

81. *Thomisme* (1965), 8. See below regarding these two works.

82. *Thomisme* (1965), 8.

In 1952, Étienne Gilson published his massive *John Duns Scotus: Introduction to His Fundamental Positions.*[83] He did not take advantage of passages on philosophy and theology to slip in a definition of Christian philosophy. He commented on the encyclical *Aeterni Patris* to point out that, while Leo XIII did not recommend the teaching of Duns Scotus, he did not exclude it.[84]

When Gilson published his *History of Christian Philosophy in the Middle Ages* in 1955,[85] he began by declaring, "We call 'Christian philosophy' the use made of philosophical notion by the Christian writers of those times." This refers to the period that goes from Justin to Nicholas of Cusa.[86] In short, we are dealing with the influence of Greek philosophies on Christian thought that, furthermore, is expressed most often in theologies. This interpretation of Christian philosophy and Christian philosophers is confirmed by the use of these expressions in the conclusion under the title Greek Philosophy and Christianity.[87] As he had decided in the fifth edition of *Le Thomisme*, Gilson acts like St. Thomas, who expressed his thought on theology and philosophy perfectly without speaking about Christian philosophy.[88]

Gilson, however, definitely reserves the possibility of returning to the expression "Christian philosophy" in its strictly Gilsonian sense. Quite significant in this regard is the edition of a selection of texts, *A Gilson Reader: Selections from the Writings of Étienne Gilson.* The book appeared in 1957 with an introduction by Anton Pegis.[89] A selection of this sort is evidently carried out in collaboration with the author. Section 3, some fifty pages, offers four texts under the heading "The Disciple of Christian Philosophy." The first one, "Greek Philosophy and Christianity," is the conclusion we have just quoted from *The History of Christian Philosophy in the Middle Ages.* The third, "God and Christian Philosophy," is taken from the work that bears almost the same title, *God and Philosophy.* The fourth, "Science, Philosophy, and Religious Wisdom" comes from a

83. *Jean Duns Scot* [John Duns Scotus], 700 pages; see 13ff; 642ff.

84. Gilson, *John Duns Scotus*, 517.

85. Gilson, *History of Christian Philosophy* (imprimatur Sept. 29, 1954; xvii and 830 pages).

86. Gilson, *History of Christian Philosophy*, v.

87. Gilson, *History of Christian Philosophy*, 540.

88. Gilson, *History of Christian Philosophy*, 366–68. See above.

89. Imprimatur May 1957; 358 pages. [Translator: "What Is Christian Philosophy?," is ch. 11, 175–91.]

lecture at the American Catholic Philosophical Association. And for the second, we find "What Is Christian Philosophy?," previously unpublished.

Accordingly, this 1957 publication reserves an important place for the concept of Christian philsophy as an essential theme in Gilson's work. That requires a definition answering the question "What is Christian philosophy?" But this question heads the second selection of the series, and its answer is not found in the first, despite its title, "Greek Philosophy and Christianity." In the selection drawn from *History of Christian Philosophy in the Middle Ages*, we are given the history of the influence of Greek philosophy upon Christian philosophy. But there is another, strictly Gilsonian sense of Christian philosophy, which we find in *The Spirit of Medieval Philosophy*. There, he means the philosophy of a philosopher whose thinking is as rigorously rational as a mathematician or physicist's thinking and who is aware of having been placed on the right road by his faith. Apparently, in 1957, Étienne Gilson did not find a passage in his published works that satisfied him as an answer to the question "What is Christian philosophy?"

If philosophy is love of wisdom, a Christian does not have to look very far for his answer: I have a philosophy; indeed, its name is Christianity. This might seem to be a manner of eliminating all philosophy, which is the work of reason alone. But it must be made clear. In Christian revelation, there are views on the world, on human beings and their destiny, that satisfy reason fully, so that the expression "Christian philosophy" is fully justified.[90] Both the extreme precision and the brevity of this exposition is striking: everything is stated in two and a half pages.

Christian philosophy, Gilson goes on to explain, is the philosophy worked out by St. Thomas Aquinas. It can still be taken as a model; that is, Thomism can still be a living philosophy today. The answer to "What is Christian philosophy?" has more than historical significance. It coincides with the search for the true philosophy.

The conclusion to Gilson's 1957 essay comes from "the encyclical letter *Aeterni Patris* published in August 4, 1879, by Pope Leo XIII, *On the Restoration of Christian Philosophy in Schools*.[91] . . . To the question *What is Christian philosophy*? the shortest answer now is, If you read

90. Gilson, *Gilson Reader*, 179.

91. [Translator: Gilson added the words "in Schools" to the title of the encyclical.]

the encyclical letter *Aeterni Patris,* you will find the most highly autho-
rized answer to your question. Reduced to its essentials, the answer is as
follows."[92]

Gilson recalls the doctrinal role of the pope in the Church, which
confers on him the authority required, first to recommend the study and
teaching of theology and philosophy according to St. Thomas and then to
acknowledge Christian philosophy properly so-called in Thomism.

That said, if Gilson invites us to read the encyclical *Aeterni Patris,*
are we really dealing with a conclusion? Isn't it rather the guiding notion
that directs the exposition of St. Thomas's philosophy taken as a privi-
leged example of Christian philosophy?

Let us return to what Gilson's *Christianisme et Philosophie* reports
about what his discovery of the encyclical *Aeterni Patris* meant for him.[93]
We may hypothesize that when Anton Pegis in agreement with Gilson
publishes these selections, Gilson does not find within the body of his
work a piece appropriate for the clarification of Christian philosophy. A
long explanation like that of the first two chapters of *The Spirit of Me-
dieval Philosophy* would be difficult to understand and would provoke
endless polemics, which might even raise the suspicion that Thomism
compromised its Christianity by its Aristotelianism. But if the answer is
given by the pope himself, it dispenses us from long controversies, and
above all, it must impose itself through the prestige of papal authority.
From there comes the idea of a definition of Christian philosophy whose
principal component would be Leo XIII's encyclical, an idea glimpsed in
Christianisme et philosophie and perfectly executed in *A Gilson Reader* in
1957. What happens next shows that this is not just a hypothesis.

7. The Encyclical *Aeterni Patris*

The preface to the sixth edition of *Le Thomisme,* dated January 9, 1964,
gives us a new, important element in the history of the concept of
Christian philosophy. Here, the professor addresses his students at the
Pontifical Institute of Mediaeval Studies in Toronto. His lectures on the
philosophy of Saint Thomas are certainly a course on the history of medi-
eval philosophy, but he allows himself to combine with the presentation
of historical truth the exposition of philosophical truth. "I think," Gilson
writes, "that Thomism is for them [his students] at least as much a living

92. Gilson, *Gilson Reader,* 186.
93. Gilson, *Christianisme et philosophie,* 129ff and above.

philosophy as a historical fact." From there comes an effort to set forth the "philosophical elements of Thomism," which in the writings of St. Thomas always appear within his theology.

Gilson publishes *Elements of Christian Philosophy* in 1960.[94] The first lines declare: "The words *Christian philosophy* do not belong to the language of St. Thomas Aquinas, but they are the name under which Pope Leo XIII designated the doctrine of the Common Doctor of the Church in 1979 in his encyclical letter *Aeterni Patris*." Thus, Étienne Gilson placed at the disposition of students and seekers a manual of Thomist philosophy whose title turned it into a manual of Christian philosophy.

In the same year of 1960, *Introduction à la philosophie chrétienne* was published at Paris by Vrin.[95] Gilson explains that this book is an "attempt to set before a potential French public the concepts belonging to Thomism that seem particularly valuable to me for their philosophical, theological, and even religious fertility."

Also in 1960, a third contribution must be added to those two: *The Philosopher and Theology*, very particularly chapter 9, "Christian Philosophy," and chapter 11, "The Future of Christian Philosophy."[96] It is completely natural not to group it with the other two, *The Elements of Christian Philosophy* and *Christian Philosophy: An Introduction*, which can be considered appendices to *Le Thomisme*. We have three complementary works there. *The Philosopher and Theology* is a sort of intellectual and spiritual autobiography, unique in Gilson's output.

When Gilson speaks about Christian philosophy, he knows perfectly well that the term must cease to be a trite expression that everyone thinks they understand, and that their comprehension must be found in a definition. A book like *Christian Philosophy: An Introduction*, whose title employs the expression "Christian philosophy" immediately sets us on the search for this definition. We find it in the work's first sentence: "By 'Christian philosophy' we shall mean the way of philosophizing described under this name by Pope Leo XIII in the encyclical *Aeterni Patris*. As its model he gave the doctrine of St. Thomas Aquinas."[97]

94. Its *nihil obstat* is dated Nov. 14, 1959; see p. 5. Published in paperback format in 1963.

95. Two hundred twenty-seven pages [Christian Philosophy: An Introduction (xxv and 139 pages)].

96. Gilson, *Philosophe et théologie* (261 pages) [Philosopher and Theology]. Its printing was completed on Mar. 14, 1960.

97. Gilson, *Christian Philosophy*, 3.

In the *Philosopher and Theology*, on the first page of the chapter on Christian philosophy, we read:

> Among the list of the acts that that Pope Leo XIII listed as the principal ones of his reign on the occasion of the twenty-fifth anniversary of his election, he placed first the encyclical *Aeterni Patris* given in Rome on the fourth of August, 1879. This document traditionally has the following heading: *On the Reestablishment in Catholic Schools of Christian Philosophy According to the Mind of the Angelic Doctor St. Thomas Aquinas*.[98]

When Gilson "discovered" the encyclical *Aeterni Patris*, as *Christianisme et philosophie* tell us, he was in the process of preparing the Gifford Lectures. This discovery amounts to something that will henceforth be evident: "I perceived that what I was in the process of demonstrating in two volumes with twenty lectures and I know not how many notes was *exactly* what this encyclical would have sufficed to teach me." We stress *exactly*, because Gilson continues: "I was, I confess, rather humiliated by this adventure."[99] In the meantime, Gilson adds two notes to the first part of the Gifford Lectures, which became *The Spirit of Medieval Philosophy*.

The first is only a reference. Gilson recalled that St. Paul "affirmed by implication the possibility of a purely rational knowledge of God in the Greeks." His note says simply, "The same idea is found in the book of Wisdom 13:1 and was cited by Leo XIII in the encyclical *Aeterni Patris*."[100]

The second note is much more important. It is not part of Gilson's text but of the *Notes bibligraphiques pour servir à l'histoire de la notion de philosophie chrétienne*. The note is almost a printed page in small font, on the teaching of philosophy and its relations to theology.[101]

After the publication of the volume containing this important note, Gilson does not seem to have had the opportunity to invoke the encyclical *Aeterni Patris* frequently, as becomes apparent from consulting his principal works up to 1960, the year of the passages on Christian philosophy. More precisely, the discovery of the encyclical coincides with Gilson's reflections about the definition of Christian philosophy, and it

98. Gilson, *Philosopher and Theology*, 175.

99. Gilson, *Christianisme et philosophie*, 129.

100. Gilson, *Spirit of Medieval Philosophy*, 26 (*Esprit de la philosophie médiévale*, 1:221n6). [Translator: Gilson reduced the number of notes for the published English version.]

101. Gilson, *Esprit de la philosophie médiévale*, 1:311–12.

was therefore quite naturally left aside from the historical exposition on Thomism.

Still, we have indicated a text to include in the dossier of the concept of Christian philosophy, composed in 1957 for *A Gilson Reader*. It attains its full significance when we know what happened three years later, in 1960.

Pegis had proposed to Gilson the publication of a selection of his writings. Gilson planned to give prominence to his concept of Christian philosophy. He intended, however, to keep it separate from his historical exposition of Thomism. He did not find an appropriate selection in his existing publications. Consequently, he wrote the answer to the question "What is Christian philosophy?" especially for the collection. He began by advising those who challenged him to read the encyclical *Aeterni Patris*.[102] We must juxtapose it with the 1960 trilogy's answers to the same questions.

Excluding a hypothetical discovery of other texts on Christian philosophy, that of *A Gilson Reader* would mark the moment when its concept finds in the encyclical *Aeterni Patris* both the operations that define it as *philosophical* and the exceptional authority that guarantees its *Christian* value.

Even though our compilation is surely incomplete, it seems to present no change or evolution of the concept of Christian philosophy. The same major themes are present more or less explicitly: there is a group of topics common to revelation and philosophy, there is a virtual rationality that reason can express, we can achieve a conscious understanding of what reason owes to the faith that guides it, the Christian philosophy that can and even must serve as model is Thomism; all that is also stated, and very well stated, in the encyclical *Aeterni Patris*. In different circumstances, different issues comes to the foreground. What seems new to us in *A Gilson Reader* and even more in the three 1960 books is both the encyclical's role and the tone of the speaker, personally engaged in a great opening of the mind.

Here again, a decisive passage comes to mind. In the 1960s, Étienne Gilson was the general editor of a *History of Philosophy* in four large volumes. He took the responsibility of writing some chapters himself, notably those that concern French and Italian philosophy in the fourth volume *Recent Philosophy: Hegel to the Present*. Something infrequently

102. Gilson, *Gilson Reader*, 186–88 and notes.

seen in histories of philosophy is that Gilson devotes nearly seven long pages and a column of notes to Pope Leo XIII.[103] The article begins: "Pope Leo XIII occupies a central position in the late nineteenth and early-twentieth-century history of Christian philosophy. In reading him on the subject, however, one must keep in mind that, speaking as a pope, he was not expressing any personal ideas. On the contrary, speaking as a pope, he could only intend to express the thought of the Catholic Church. And that is what confers upon his teaching a unique importance."[104]

Therefore, even for a non-Christian, even for an agnostic, the pope's encyclicals have historical interest. "It goes without saying that for Catholic philosophers, their importance is much more than a merely historical one." The papal encyclicals stem from a teaching function that belongs to the papacy. Gilson shows this immediately by taking the encyclical *Aeterni Patris* as an example.

In the 1957 essay of *A Gilson Reader* and the trio of 1960 books mentioned above, to which the chapter on Leo XIII will be added in 1966, Gilson considered Christian philosophy in the context of the encyclical *Aeterni Patris*. It becomes difficult for the Christian philosopher to separate the certainty imposed by reason working on its own and the certainty based on the authority of a divinely inspired expression. Hence, Gilson explains: "The competence of the Holy See in matters of philosophy is related to its apostolic mission." He quotes Matthew 28:19: "When saying to his apostles, 'Going therefore, teach ye all nations,' Jesus Christ left the Church he founded [as] the common and universal teacher of the nations." Always logical, Gilson writes: "Whichever way it be conceived, therefore, Christian philosophy will be linked with the teaching function of the Church. It will even be so as a matter of primary purpose, for philosophy has often been a source of error."[105]

On the next page, without concern for repetition, Gilson continues: "However one may feel about the notion of 'Christian philosophy,' this much is certain from the outset, that it should define an apostolic use of philosophy conceived as an auxiliary to the work of redemption."[106] In short, Christian philosophy is "a religious use of reason," in that it accepts

103. Gilson would write one day, "Pope Leo XIII was the greatest Christian philosopher of the nineteenth century and one of the greatest of all time" (Gilson, *Philosopher and Theology*, 218; see also 228, 213).

104. Gilson, in Gilson et al., *Recent Philosophy*, 38.

105. Gilson, *Philosopher and Theology*, 185.

106. Gilson, *Philosopher and Theology*, 186.

the guidance of theology, without audaciously attempting to withdraw itself from divine authority, because it is the authority that most surely protects it from error and enriches it with much knowledge.[107]

Can Gilson really prevent us from thinking about theology?

8. Étienne Gilson the Christian

In this dossier on Christian philosophy according to Gilson, there are differences in point of view. What does not change is Gilson, and Gilson continues to have a view about something real.

Nobody today would dream of talking about Christian physics or Christian biology. Physics and biology are sciences, and science is radically independent of religion in its conclusion, its methods, and its principles.[108] Why not say that the same goes for philosophy? Would there have been a difference in Aristotle's time? "It is a fact that between ourselves and the Greeks the Christian revelation has intervened." Reason is no longer the same after as before. "Once you are in possession of that revelation, how can you possibly philosophize as though you had never heard of it?"[109] Consider someone who has been baptized and raised as a Christian. If he is truly a Catholic, he cannot fail to hold that the pope expresses the mind of the Church in speaking about a subject like teaching philosophy.[110]

The Christian who wants to be a philosopher is named Étienne Gilson. He received the sacrament of baptism. "This fact makes it hard for me to understand how a Christian can ever philosophize as if he were not Christian."[111] Raised in a Christian family, he was taught the catechism, which, however elementary it may be, is to be respected.[112] "The Creed of the catechism of Paris has held all the key positions that have dominated, since early childhood, my interpretation of the world. What I then believed I still believe, and without in any way confusing it with my faith,

107. Gilson, *Philosopher and Theology*, 191; see 196–99. [Translator: I have removed quotation marks from two portions of the second part of this sentence, because I have been unable to find their equivalent in 196–99.]

108. Gilson, *Spirit of Medieval Philosophy*, 3. See above.

109. Gilson, *Spirit of Medieval Philosophy*, 5. See above 126n50.

110. Gilson, *Christianisme et philosophie*, 130–31. See Gilson's astonishment in the face of the attitude of Catholic theologians toward the encyclical.

111. Gilson, *Pilosopher and Theology*, 9.

112. Gilson, *Philosopher and Theology*, 10.

whose essence must be kept pure, I know that the philosophy I have to-day is wholly encompassed within the sphere of my religious belief."[113] In the last analysis, such remarks might be understood to postulate relative indifference to the choices that a Christian philosopher might make about this or that philosophy.

In Gilson's concern to remain in contact with reality, reality lived daily in his thought, *Christian Philosophy: An Introduction* makes a statement with vast implications. The proofs of God's existence are the issue and, quite particularly, the proofs established by a pagan philosopher like Aristotle. "It is true," Gilson says, "that if the God of revelation exists, he is the Prime Mover, the First Efficient cause, the First Necessary Being, and everything that reason can prove about the First Cause of the universe. But if Yahweh is the Prime Mover, the Prime Mover is not Yahweh." Let us emphasize these words. Reason guided by Aristotle demonstrates the Prime Mover, but Gilson continues: "The First Efficient Cause has never spoken to me by his Prophets, and I do not expect my salvation to come from him."[114]

In other words, we know that for Gilson, the Aristotelian proofs of God's existence are valid since Thomism has taken them up. But if some other philosopher criticizes them and prefers, for example, the proof labeled ontological since Kant, it is certainly his right. In Christian philosophy according to Gilson, what is essential is fidelity to Yahweh. Gilson goes so far as to write, in regard to the proofs of God's existence: "I have never been able to become passionate about this question. Why? It felt so certain that a reality that transcends the world and myself corresponds to the word *God*, that the prospect of searching for proof of what I am certain about seems to me devoid of interest."[115]

In the Christian philosophy lived by Étienne Gilson, fundamental certainty is a gift of faith prior to and above all demonstration. Evidently, since we are dealing with philosophy, reason plays an important role in the service of faith. But, at least in the last part of his life, Étienne Gilson does not care about entering personally into what André Gide called "the route of the proofs of God's existence."[116] Rather, he declares that he is

113. Gilson, *Philosopher and Theology*, 11.

114. Gilson, *Christian Philosophy*, 11.

115. Gilson, *Athéisme difficile*, 11/45. [Translator: The 2014 edition of *Athéisme difficile* includes a 31-page presentation by Fr. Therry-Dominique Humbrecht, OP, so that its pagination is different. Both paginations are included here.]

116. Gide, *Nourritures terrestres*, quoted by Gilson, *Athéisme difficile*, 80/110.

"curious" about the reasons invoked in favor of atheism. He tells us that for him, "The nonexistence of God is what is in doubt."[117]

Some will claim to have no need of philosophy since they are Christians. But this is really an attitude that Gilson dismisses when he opens his dossier on Christian philosophy.[118] Before speaking of contradiction, let us rather try once again to see what realities he has in mind when he comes across these questions, which precisely happens to him in the short work written in 1967 on the demonstration of God's existence, "Plaidoyer pour la servante."

This handmaid, as we know well, is the one St. Thomas encountered in Proverbs 9:3, where Wisdom is heard giving orders to her "handmaid,"[119] an image that is going to symbolize the relation of the sciences with theology, metaphysics being the "noblest of the handmaids."[120] Here, Gilson finds himself confronted by two facts.

Pope Paul VI published the encyclical *Ecclesiam Suam* on August 6, 1964, and expressed concern with scientificist and Marxist atheism. "Is there no one among us who could help him [the atheistic political scientist] to arrive at last at the realization of the objective reality of the cosmic universe which confronts the mind with the presence of God . . . ?"[121] Gilson turns toward the handmaid. "After nearly two thousand years," that is to say since the book of Proverbs, "it is pardonable for the handmaids to wonder what has gone wrong. Have they failed so much in finding a conclusive development of the existence of God?" Gilson continues relentlessly: "If such is the case, what hope remains for them to convince our contemporaries?"[122] It is useless to insist: no philosopher has won the universal agreement that would be the indisputable sign of its truth. "Descartes, Malebranche, and Leibniz . . . have tried to make God's existence into a mathematically demonstrable conclusion." But Gilson replies, "If we had a mathematical demonstration of God's existence, we would not look for another."[123]

117. Gilson, *Athéisme difficile*, 12/45.

118. Gilson, *Esprit de la philosophie médiévale*, 1:4–5. See above.

119. Aquinas, *Summa theologiae*, I, q. 1, a. 5.

120. "Plaidoyer pour la servante," in Gilson, *Athéisme difficile*, 95/124.

121. Paul VI, *Ecclesiasm Suam*, §104.

122. "Plaidoyer pour la servante," in Gilson, *Athéisme difficile*, 76/106.

123. "Plaidoyer pour la servante," in Gilson, *Athéisme difficile*, 85/114.

Before entering a plea of guilty, the handmaid's advocate has something else to offer. It is a fact that the history of philosophy is the history of an endeavor that must continually start anew. We would not be unfaithful to Gilson's thinking by evoking here a relay race, where there is always someone to take the torch and relight it.

Everything is explained if we look at reality carefully: "Obviously," Gilson writes, "the concept of God is prior to the proofs of his existence. It is always already there, while philosophers and theologians labor to proof his existence with the help of their demonstrations."[124] Again, "Certainty about God's existence in great measure is independent of the philosophical demonstrations that we give for it."[125] It will be asked how this concept and this certainty are present when the handmaid is not there. There are two possibilities. For the Christian, they are evidently present in faith, a situation described at length by Gilson when he writes the history of his thinking in *The Philosopher and Theology*. In the "Plaidoyer," he considers the case of the non-Christian: "The only path toward God," he writes, "outside of faith in a supernatural revelation, starts from the fact that humans are religious animals. Their reason naturally produces the concept of divinity."[126] Accordingly, there would be a kind of natural religion that allows the handmaid to communicate with non-Christians. Of course, it seems that if reason *naturally* produces the concept of divinity, such a possibility logically belongs to every being endowed with reason.

Logically, yes, but in reality? Here, reality is the handmaid who speaks to the deaf. "Is it right to want the handmaid to convince about the validity of certain metaphysical conclusions minds that are not endowed for this sort of speculation?"[127] "Is it right to ask the handmaid to demonstrate the existence of God to minds alien to metaphysical thinking?"[128] Are we going to make her waste her time with people "who suffer a kind of congenital metaphysical blindness, whose anti-metaphysicism is incurable?"[129] It is clear that Gilson is not thinking of an always virtual

124. "Plaidoyer pour la servante," in Gilson, *Athéisme difficile*, 80/109–10.

125. "Plaidoyer pour la servante," in Gilson, *Athéisme difficile*, 81/111. Here, Gilson speaks of a "hypothesis," but by that we must understand a working hypothesis that the facts confirm.

126. "Plaidoyer pour la servante," in Gilson, *Athéisme difficile*, 94/123.

127. "Plaidoyer pour la servante," in Gilson, *Athéisme difficile*, 88/117.

128. "Plaidoyer pour la servante," in Gilson, *Athéisme difficile*, 89/118.

129. "Plaidoyer pour la servante," in Gilson, *Athéisme difficile*, 91/126.

but never actual presence of the idea of God. He summons to his office a person of coarse, good sense with the wooden shoes of empiricism.

In Étienne Gilson's long life—ninety-four years—the history of the concepts of Christian philosophy seems to present nothing that resembles an evolution. Certainly, the existence of this great traveler plays out in a perpetual change of decor; his thinking on Christian philosophy is continually challenged. However, the point is always to reencounter the broad outline of a fundamental pattern. That said, we perceive a change of tone in the curious arrangement of texts in 1960.

Gilson unceasingly recalls what is essential, the one thing necessary: the God of faith who is the God of salvation. "The God whose existence the person of faith believes infinitely transcends the one whose existence the philosopher proves. *Often*, we emphasize the word, the former is a God of whom the philosopher has no idea." Again, "all philosophical demonstrations remain below this divine revelation that is supernatural."[130] Certainly, Gilson is going to demonstrate at length the role and limits of reason in theology and in the philosophy he calls Christian. Then he speaks as a philosopher who talks about philosophy. The tone changes when he speaks of the consequences of these views on his personal life.

Such for example is the warm admiration he feels for Leo XIII. Also, there is his relative indifference to demonstrations of the existence of God, which Gilson does not in the slightest attempt to hide at the beginning of *L'athéisme difficile*. Still more surprising is what we read in a long note almost at the end of the "Plaidoyer pour la servante."[131] Gilson has just read a work whose author declares he does not see why nominalism, Kantian and Hegelian idealism, or even positivism could not "contribute to a certain understanding of the faith." Gilson answers: "I would go so far as to say that the peace of mind of those who are satisfied with such doctrines should not be disturbed if that contributes to their faith, and if no other philosophy is intelligible to them. I have met a priest for whom philosophical truth was Octave Hamelin's system." In short, "my present point of view is the following: Let each one go toward God as he can," which demands reciprocally that others acknowledge the right to be a Thomist.

In his life as in his philosophy, logical rigor governed Gilson's thought—and his conduct. Thus he spontaneously had the respect for

130. [Translator: Quotations unreferenced.]

131. "Plaidoyer pour la servante," in Gilson, *Athéisme difficile*, 91n6/120n1. Gilson had just read Paupert, *Peut-on être chrétien ajourd'hui?*

freedom that he acknowledged in the other, as the other had the duty to acknowledge it in him. Still, beneath this hope, and doubtless more profound, there was a generosity of intellect. It is not necessary to drive those minds to despair who parade through the history of philosophy as in a cemetery. The priest who found his goodness in Hamelin, after all, found a path . . . and so? In a word, the handmaid arranges things as she can.

I no longer recall what the conversation was about, but one day as we finished, Gilson simply said to me, "Be good."

Third Essay

The Philosophy of Art according to Étienne Gilson

GILSON'S WORK IN PHILOSOPHY of art is far from being as well known as it should be. He is universally recognized as an authority in the history of medieval thought. It is natural that a historian of philosophy should become a philosopher himself and so that a historian of St. Thomas's philosophy could become the author of *Being and Some Philosophers*. But not many people connect philosophy of art with Gilson. Perhaps someday a scholar will chose as his subject "Étienne Gilson and Art." This is a huge subject, if we recall that Gilson took pleasure in writing articles on literary history and about his impressions of music and painting.

We will leave the trouble of publishing a complete bibliography, including work on the philosophy of the arts, to that possible doctoral candidate. We will limit our study to Gilson's reflections on the philosophy of the arts.

Étienne Gilson was mobilized in 1914. In 1916, he was at Verdun as a "second lieutenant in the machine gun company of the 164th Infantry Division." A reference in the regimental dispatches specifies: "February 23, [he was] buried by a shell and seriously bruised; he was taken prisoner the same day."[1] Some weeks earlier, he had sent the *Revue de métaphysique et de morale* an article titled "At the front, November-December, 1915, 'Art et Metaphysique'," which was immediately published.[2]

1. Titles and roles of Gilson "Vie, titres et fonction," 10. [Translator: See also McGrath, *Étienne Gilson.*]

2. Gilson, "Art et métaphysique." [Translator: Far better than the doctoral thesis Gouhier anticipates is Murphy, *Art and Intellect.*]

In this article, Gilson already uses the method he would follow later: first, observe a fact, then ask whether it is significant, and in that case, search for what it signifies.

"Philosophers have devoted much more effort to clarifying the relations of metaphysics and science than to determining the relations between art and metaphysics." "This difference in treatment has a basis," he affirms, and we, his readers, have a certain anticipation of what will be his thesis, that "art and metaphysics develop in different directions."[3] Metaphysics is knowledge; art belongs to a different order. Like science, metaphysics belongs to the order of learning, even when it tries to distinguish itself radically from science and seeks reality beyond concepts, when an intuition immediately grasps the real leaving to intelligence the task of knowing in order to act. In the 1915 article, Bergson's name is cited only once in passing—as a perfect example of a philosopher who is *also* an artist—but the article is impregnated with Bergsonism: the temptation to define art as a certain vision of the world is, in some philosophies, already structured by the dualism intuition-reason.[4]

From this effort to dispel possible confusion between art and learning, we emphasize three ideas: first, when we say art, we think work of art; second, the work of art is "a real object that has no other function than to be beautiful";[5] third, "the only word by which we can characterize the result of artistic activity is *creation*."[6]

The following is a brief introduction to his whole conception of art:

> The work of art is a new reality that the artist adds to the universe. César Franck finishes a symphonic composition. A mother and child emerge from the hands of Carrière. Something new has just been introduced into the world. This is not knowledge that existed but rather knowledge deepened, made more intimate, or especially original about what existed already. Through the scholar or metaphysician's thinking, the universe merely becomes aware of results to which it has already arrived. Through the artist's effort the universe is enriched by something it did not yet possess.[7]

3. Gilson, "Art et Metaphysique," 243.

4. This in no way indicates that Gilson refers to Bergson here; he considers impersonal forms of thinking.

5. Gilson, "Art et Metaphysique," 251.

6. Gilson, "Art et Metaphysique," 253.

7. Gilson, "Art et Metaphysique," 253.

And again,

> The artist is not only an artisan skilled in grasping the energy of the physical world with a view to our utility; nor is he a scholar or philosopher, who are mirrors where the universe is reflected. The artist is one of the creative forces of nature. He brings into existence beings that other humans can know but would not have been able to create and that, if he himself did not exist, would never have existed. When he dies, the series of these beings that all resemble each other like the children of the same father, finds itself forever closed, and the most ingenious piety of the most docile disciples will not succeed in increasing the series by a single unit. The disappearance of a Pierre Curie or Henri Poincaré can push into the distance the moment of discoveries they would have been had they lived, but it does not make these discoveries impossible. The disappearance of an André Chénier or an Albéric Magnard annihilates forever the hope of masterpieces to come that their genius promised. The artists death is a decrease of the world's value.[8]

The last words are the translation of the epigraph Gilson placed at the beginning of his article. It is D'Annunzio's goodbye to the funeral ship that leaves the port of Venice with Richard Wagner's coffin:

> Richard Wagner has died.
> The world seems to decrease in value.[9]

The work of art, we have said, "has no other function than to be beautiful." Consequently, the issue is "a relation between the work and the person who looks at or listens to it." To be clear, we are dealing with an action of the work upon someone who looks at or listens to it. This certainly indicates a spontaneous reaction: "What characterizes the genuine masterpiece or what we label as such, is its being that of which, according to the familiar expression, *we do not tire.*"[10]

On February 23, 1916, Second Lieutenant Étienne Gilson was taken prisoner at Verdun.[11] In its first issue of 1917, *La revue philosophique de la France et d l'étranger* published a long article—twenty-three pages—with

8. Gilson, "Art et Metaphysique," 253–54. [Translator: Cf. Gilson, *Painting and Reality* (2020), 159–60.]

9. D'Annunzio, *Feu*, 432, quoted in Gilson, "Art et Metaphysique," 243. [Translator: See Gilson, *Painting and Reality* (2020), 107n11.]

10. Gilson, "Art et Metaphysique," 258.

11. On Gilson and the war, see Shook, *Étienne Gilson*, ch. 5.

the title "Du Fondement des jugements ésthetiques," signed by Étienne Gilson, Officers' Prison Camp, Burg bei Magdeburg, Germany.

Years later, in 1957, *Painting and Reality*, the first book Gilson devotes to the philosophy of art, insists on recalling an article in *Revue de métaphysique et de morale* with the date of its composition, 1915, and not the date of its publication, 1916. In the work's preface, we read: "As to the philosophical positions in this book, their origin is to be found in an article in *Revue de Métaphysique et de Morale* published in 1915 with the title 'Art et Métaphysique.'"[12]

Gilson adds, perhaps with a wink to the reader, that there may have been continuity and discontinuity in the movement that connects *Painting and Reality* to the article in *Revue de métaphysique et de morale*, but we have not been able to find any published reference to the *Revue philosophique* essay. This is a question that a historian of ideas could examine easily, and Gilson seems to leave to his historians the task of studying the classic question of the unity of his thought. We might suppose that in reading his 1915 article, the author of *Painting and Reality* perceived a continuity that he did not experience reading the 1917 article. Nothing supports such a hypothesis. Rather, there is a difference of approach between the two.

The very title of the first article indicates a metaphysical investigation. Gilson discovers and posits the principles of a philosophy of art, that is to say the foundations of the values implicit in words like art, beauty, and aesthetics. Therefore, what is essential is already found in the first article dealing with the basis of aesthetic judgments. It would be stated differently in the second article.

After "Art et Métaphysique" (1916) and "Du fondement des jugements esthétiques" (1917), we have the good fortune to have a detailed bibliography of Étienne Gilson's writings up to 1958, which includes 648 entries.[13] However, only in 1957 do we find anything dealing with philosophy of art, properly speaking.

The return to these questions and their resolution forty years later was provoked by an invitation of the Bollingen Foundation to give six

12. Gilson, *Painting and Reality* (1957), x: "My first publication concerning the philosophy of art was written in November-December 1915, and published the next year in *Revue de Métaphysique et de Morale*, under the title 'Art et Métaphysique.'" [Translator: *Painting and Reality* (2020), ii; where possible, I refer to this edition in English. In this edition, reproductions of the paintings are on the publisher's website.]

13. Edie, "Writings of Étienne Gilson."

lectures at the National Gallery of Art in Washington, DC, on a subject involving the fine arts. According to the terms of the invitation, these lectures had to form the nucleus of a book. The lectures were given and the book published in English with the title of *Painting and Reality* in 1957, and included 117 illustrations.

This same year, participating in the ninth congress of French language philosophical associations, Gilson chose as the subject of his presentation "Peinture et imagerie," in the realm he had just explored for his Washington lectures. *Peinture et Réalité* appeared in 1958. It is not a translation but a new version of *Painting and Reality*. We have used the French text, but utilize the valuable "Historical and Philosophical Index" of the book in English.

It was still necessary to wait five years to see Gilson undertake a work of synthesis of a general philosophy of art and a philosophy pertaining to each particular art. The first lines of *The Arts of the Beautiful* narrate the occasion that caused this return to the philosophical path opened in 1915, a phrase of Lucien Febvre: "Assuredly, art is a manner of knowledge."[14] Gilson's reaction to this assuredness is immediate:

> The present book rests on the firm and considered conviction that art is not a kind of knowledge or, in other words, that it is not a manner of knowing. On the contrary, art belongs in an order other than that of knowledge, namely, in the order of making or, as they say, in that of factivity. From beginning to end, art is bent on making; this book says nothing else.[15]

This book led to another, *Forms and Substances in the Arts* (*Matières et formes*), whose French subtitle perfectly declares its subject: *Poiétique particulière des arts majeurs*. These major arts are architecture, statuary, painting, music, dance, poetry, and theater.

In the face of this splendid group of published works, it can be said that Gilson quite naturally achieved awareness of the strictly philosophical quality of his works on philosophy of art. The title of the first work, *Painting and Reality*, announces the concern for a particular art, painting, which he approaches from a particular point of view, that of its relations with reality. But a philosophical reflection on a particular art must consider art in general to situate that art. Hence, at the beginning of the second work, *Matières et formes*, we read: "After *Painting and Reality*,

14. Febvre, quoted in Gilson, *Arts of the Beautiful* (2000), 9.
15. Gilson, *Arts of the Beautiful* (2000), 9.

which goes from art to philosophy and even from one particular art to the most general philosophy, now we desire to go back down toward the most general concept of art as such." The three books *Painting and Reality*, *The Arts of the Beautiful*, and *Forms and Substances*, constitute a logically constructed whole that must be called a philosophy of art.

When the opportunity arose, Gilson would continue to consider problems more or less directly related to the philosophy of the arts. In 1964, the year *Matières et formes* was published, Gilson was invited to The International Course of High Culture for the Giorgio Cini Foundation on the San Giorgio Maggiore Island at Venice, September 7–9. He delivered three lectures, which are a kind of appendix to the three books. Revised and completed, the lectures became a small book, *La société de masse et sa culture*, but with a change of terminology. "Mass culture" replaces "industrialization" because "the industrialization of cultural products is only the means of creating a mass culture."[16]

In the wake of *Painting and Reality*, *The Arts of the Beautiful*, *Forms and Substances*, and now *La société de masse*, which set out what is essential for art in general and what is essential to each major art, it is appropriate to situate two complementary studies.

First there is "Plea for Boekmesser," published in *Revue internationale de philosophie* in 1964.[17] Gilson says, "The present essay completes chapter 5, 178, note 15, of our book *Forms and Substance in the Arts*, which is to say the chapter on music. To be exact, it deals with music related to theater in opera, especially in what Richard Wagner calls 'the musical drama.'"

The second study is the article published in *Diogène* in 1966, "Photographie et beauté,"[18] which seeks to discover whether it is possible to speak of a beautiful photograph and to ask oneself why photography would not also be an art of the beautiful. The end of science is to know; "to act" leads directly to an ethic. "To make" is the task of "arts and crafts." Gilson loves to repeat it: "The immense majority of the activities of manufacture propose as their goal to produce and to multiply useful objects in all orders of usefulness."[19] "The useful and the beautiful are not

16. Gilson, *Introduction aux arts du beau*, preface. [Translator: I cannot find this sentence in the introduction to the English versions of *Arts of the Beautiful*.]

17. Gilson, "Art et métaphysique," 263.

18. Gilson, *Introduction aux arts du beau*, beginning of preface. [Translator: again, this topic is not raised in the introduction to the English versions.]

19. "La peinture," in Gilson, *Matières et formes*, 122. [Translator: I have not located

opposed." One and the same object may be called useful and beautiful at the same time; but this "and" signifies a change of viewpoint. It belongs to another order. The beauty of an automobile or the beauty of an airplane certainly belongs to works made by competent human beings in certain arts and crafts, but these works have not been made with a view to their beauty, and in their construction there is a primacy of the product. If I say, "This automobile is beautiful," I leave its utilization and the services it can provide in parentheses. This kind of expression raises no difficulty, since we are dealing with qualities that do not belong to the object's essence. (Architecture will pose other problems.)

It remains to discover how Gilsonian philosophy escapes from the difficulties created by its own logic. Such is the case of the existence of a painting without images and that of architecture's particular finality. Let us consider nonfigurative painting. In writing his *Painting and Reality*, Gilson could not fail to encounter the apparent paradox of a painting without explicit reference to reality. He hardly uses the expression "nonimitative painting" and writes "nonrepresentational painting" in passing. But he regularly speaks of abstract painting. In *Forms and Substances*, "nonimitative," "nonrepresentational," and "abstract painting" are in fact synonyms. There is abstraction in certain figurative paintings, such as portraits painted by Picasso, but to avoid all ambiguity, we reserve "nonimitative" or "nonrepresentational" for works that present no apparent reference to the real. To answer the question "What is nonfigurative painting?," it is first necessary to discover what figurative painting is, something Gilson explains at length in the chapter "Pictures and Painting." He observes that, according to common usage, not all paintings are pictures: "Painting is inextricably enmeshed with another art for which there is no name. . . . Let us tentatively call this second art the art of picturing."[20] An odd sentence follows. "In this sense we can label as image every painting, seen or conceivable by the mind, even if it is composed only of lines or colors assembled in a certain image with no concern for imitation or representation."

The logical consequence of this broad sense is that imagery is not part of the essence of the painting and that a painting can be nonfigurative without ceasing to be a painting. Accordingly, with image in the

this work in *Forms and Substances*, but we find, in *Arts of the Beautiful* (2000), 21: "A large part of man's making activity aims at producing objects answering practical purposes."]

20. Gilson, *Painting and Reality*, 238.

broad sense, the nonfigurative painting would be no problem, and we could take literally Maurice Denis's famous definition of the picture: "Remember that before being a war horse, a nude woman, or telling any story whatever, painting essentially consists of a plane surface covered with colors assembled in a certain order."[21]

When Gilson begins his investigation into the essence of painting, he does not use this broad sense but the ordinary one. This is quite natural; he is writing a book about "painting and reality."[22] The reality is first a painting that is imagined in the diversity of its styles. As we know, Gilson never intends to abandon the world of facts. He will consequently speak about nonfigurative painting if it exists. The painting whose existence he seeks has a long history of being figurative. Gilson's analyses make imitation appear at the origin of the images and therefore, these images are representative. They signify something; we speak about models . . . To be sure, we cannot follow Gilson into the inner museum that is his memory, but let us simply note that a "remark by Delacroix," a passage of great importance, opens his eyes to new ways: "If art is invention, poetry . . . , realism is its very negation. Indeed in the measure that it is art, painting is invention. To be authentically art, that is to say the artist's peculiar invention and contribution, the painted work must get its source in the painter's mind, not in reality."[23] This is to grant the artist a liberty or, better, a liberation, in relation to reality, within which no one can foresee how far it will go.

Gilson comments on the effects of this liberation: Gauguin and Van Gogh, Cézanne and Matisse, Picasso and Juan Gris, many others, and finally Piet Mondrian, who can be considered symbolically as a point of arrival.[24]

Returning to the definition of painting according to Maurice Denis, once the battle horse, the naked woman, and any anecdote are erased, what remains? What is left will be the painting's essence, that without which there would be no painting. After having told us what is not essential, Maurice Denis could not fail to say what is essential: "Before

21. Denis, *Théories*, 1, quoted in Gilson, *Painting and Reality*, 95.

22. Gilson, *Peinture et réalité*, 241. [Translator: see, e.g., *Painting and Reality*, 221–22.] Cf. Delacroix, *Oeuvres littéraires*, 1:58.

23. Gilson, *Painting and Reality*, 118; quoting Delacroix: "Realism should be described as the antipodes of art."

24. Gilson, *Peinture et réalité*, 281–87. [Translator: see, e.g., Collectif, *Mondrian*; Michel, *Exposition Mondrian*.]

being a representation of anything whatever, a painting is a plane surface covered with colors assembled in certain order."[25] The definition does not propose any precise order; let us not reduce this to question words. It is certainly permitted to say that several juxtaposed colors make a figure. But what is a figure that does not represent anything and that signifies nothing? Better than any discussion, a painting by Mondrian makes the irreducible difference stand out between the figurative and nonfigurative. All the books on Mondrian reproduce the painting [*tableau*] *Still Life with Ginger Pot*. The painting's background is a rhythmical tangle of right-angle triangles, but at first glance, our eyes pick out the object that has given the painting its title. Mondrian's interpreters are quite in agreement in acknowledging a remainder of figurative painting just before the complete abstraction that will eliminate it.

One understands then the role of Piet Mondrian in Étienne Gilson's philosophy of painting. Inserted on a path where the essence of painting no longer implies imagery, Piet Mondrian devotes himself to an abstraction that rescues his mind from the spirit of imitation with its representations and its models, but he goes farther beyond realists and cubists.

What follows from these views on nonfigurative painting?

First, painting "must become fully aware of its peculiar essence." Henceforth, "it is no longer a question of finding out what nature is or to what degree or how it is suitable to imitate it. There is no longer a place for the concept of imitation: transferred to the art of imagery whose peculiar end is imitation, imitation fills it up in its entirety." "Where must we stop?" Mondrian tells us, "When it has led the art of painting to its end point on the path of abstraction."[26]

To think of this development as a progression would be contrary to Gilson's philosophy of painting according to Gilson. He observes that in the twentieth century, there exists nonfigurative painting, which has its own beauty but which subsists alongside, and not instead of, painting with imagery. "The existence of nonrepresentational painting does not prove that any other kind of painting has become impossible. It simply proves that nonrepresentational painting is also possible." Only the artist knows the form his work demands.

In *Peinture et réalité*, Étienne Gilson certainly seems to have thoroughly discussed the legitimacy of nonfigurative painting. In *Forms and*

25. "Définition du néo-traditionnisme," in Denis, *Théories*, 1; quoted in Gilson, *Painting and Reality*, 96n3.

26. [Translator: Quotations unreferenced.]

Substances in the Arts, the work in which he reviews the different arts of the beautiful, he has almost reached the end of the chapter on painting when he comes across the art without images: "The evolution of modern painting forcibly poses a final question."[27] Here again, the facts are what oblige Gilson to "speak of non-representational, non-imitative, or abstract painting."[28] In Gilson's writings, these three adjectives say the same thing, which causes an ambiguity in the whole chapter. Firstly, in the essence of painting: "The art of painting produces material objects situated in space like works of statuary," he says, but does so in two-dimensional space. To represent solids, three-dimensional objects upon a two-dimensional space, is something that must enter into the very definition of the art of painting. Gilson adds, "Painting is abstract by nature, for it abstracts from one of the dimensions of our space."[29] Still, it seems clear that abstraction by amputation of the third dimension and abstraction by amputation of imagery are radically different in nature.

Let us return to the moment when, seeing that he has come to the end of the chapter, Gilson announces the last question, that of nonfigurative painting and offers a solution. In *Peinture et réalité*, the answer ended in the encounter with Mondrian. Here, it begins with a reflection on what Mondrian contributes. We can formulate the question Gilson must have posed to himself: once the idea of nonfigurative painting is announced, is it possible to go beyond Mondrian, to go further than Mondrian, in abstraction that eliminates imagery?

Mondrian deliberately called his paintings a *Composition*.[30] The notion of order that Maurice Denis locates in the essence of the pictorial work quite often introduces the spirit of geometry in Mondrian's paintings. But the evolution of modern painting that leads to Mondrian does not stop with him.

"A later development has led our contemporaries to eliminate even form from the painting. We hesitate to describe works of this kind, which seem to reduce to colors assembled without apparent order on a plane surface."[31] Gilson does not mention any name; he simply indicates, "Some of the paintings look like wall panels covered with a layer of

27. Gilson, *Forms and Substances*, 135.

28. Gilson, *Forms and Substances*, 135.

29. Gilson, *Forms and Substances*, 114.

30. ["The series of paintings without any other titles than *Painting 1*, *Painting 2*, and so on" (Gilson, *Painting and Reality*, 234).]

31. Gilson, *Forms and Substances*, 136.

almost uniform paint without any diversity save that of brush strokes."[32] The question then becomes, is this still painting? Gilson's answer is a firm rejection. "It could be that this is still painting, but we can no longer be certain that it is art." Someone might retort: how can the painting [*tableau*] that would cease to be art not *ipso facto* cease to be painting [*peinture*]? What is at issue is truly the concept of a *work* of art. A bit of canvas on which we are invited to admire the splashes obtained by emptying pots of paint or turning a pot upside down is a gesture. But is it a work?

In other words, is there still an art when there is no longer an artist? We remain faithful to Gilson's thinking by recognizing that there is no painting beyond Mondrian. Let us recall his fundamental definition: "By aesthetic experience, I understand works of art, particularly works of the arts of the beautiful, which are the arts whose peculiar function is to produce objects desired for their very beauty."

It might seem strange, therefore, to find architecture at the head of the seven arts of the beautiful that Gilson proposes to examine. Gilson himself recognizes it: "Architecture presents a character that is wholly unexpected; of all the arts it is the one most obviously related to a practical need."[33] Indeed, "man builds habitation to shelter against cold, heat, winds, and rain." Of course, there are many ways of constructing buildings according to the services they must provide: "The most impressive temples, the magnificent palaces, the most complex modern structures, factories . . . the art of constructing such edifices is an authentic art, but this art is essentially utilitarian."[34] It is not necessary to underline here the scope of the adverb "essentially." Certainly, we can speak of a peculiar beauty characteristic of works of art, but this beauty includes utility: it springs from the perfect adaptation of means to end.

Thus, the logic of his thought obliges Gilson to inscribe utilitarian considerations in the very essence of architecture, which leads directly to this conclusion: "The master builder, or architect in the broader sense of the term, does not seek beauty for its own sake. If he chances upon it, even to the extent that he might have willed it into being, this beauty, even though very real, is of a kind properly suited to an architecture that is *essentially* functional."[35] Here again, the adverb is emphasized because it is

32. Gilson, *Forms and Substances*, 136.

33. Gilson, *Forms and Substances*, 40.

34. Gilson, *Forms and Substances*, 40.

35. Gilson, *Forms and Substances*, 41.

what obliges us to say: "The beauty proper to factivity does not belong to the order of the arts of the beautiful any more than does natural beauty; inasmuch as it aims to achieve the beauty proper to factivity, architecture cannot be considered as one of the fine arts."[36]

Let us insist on this point. Gilson knows that such a declaration will be surprising. Architects rightly lay claim to an artistic competence and authority. In their domain, "the pursuit of the beautiful always finds a place in this sphere, but is no longer the principal goal."[37]

Does such an observation forbid us to situate architecture among the arts of the beautiful? As a whole, Gilson's reflection about architecture does not amount to an incisive affirmation. But let us remain within the limitations of our subject.

In this chapter of *Forms and Substances in the Arts*, Étienne Gilson explicitly discusses architecture, but he is thinking about industrial beauty in general. It seems preferable not to consider together the beauty of a palace and the beauty of an automobile or airplane. This is what he calls "one of the paradoxes of architecture as an art."[38] The context shows what must be understood as art of the beautiful.

A few pages earlier, Gilson's fundamental definition of art had led to the conclusion that we must no longer situate architecture among the arts of the beautiful, and reality forced us to acknowledge "this paradoxical nature of architecture."[39]

Once again, Gilson obeys reality. What he sees when he considers architecture among the arts of the beautiful can be summed up briefly: "A painting answers no other purpose save that of being seen, music serves that of being heard, poetry serves that of being read, but the most beautiful of doors serves to let people go through it, any window serves to let in light, and even the breathtaking solid walls of the Doge's Palace at Venice, an unending delight to behold," which, he reminds us, "had the function of enclosing meeting rooms."[40] "The construction of a totally useless building is therefore a rare event."[41] The pyramids of Egypt and the triumphal arches were not built only for love of the beautiful. For

36. Gilson, *Forms and Substances*, 41.

37. Gilson, *Forms and Substances*, 41.

38. Gilson, *Forms and Substances*, 44.

39. Gilson, *Forms and Substances*, 45.

40. Gilson, *Forms and Substances*, 44.

41. Gilson, *Forms and Substances*, 45.

Gilson, the most indisputably useless instance is the case of "the architect who believes he embellishes a building by adding columns to it that have no use."[42]

The coexistence of utilitarian finality and strictly artistic finality is in the last analysis a question of proportion. The search for efficacy dominates when the architect constructs a train station. But when the architect builds a church, the demands of beauty call out to free creative imagination.

* * *

The absence of Kant from the essay may be surprising. Gilson himself defined his attitude toward Kant in *Introduction aux arts du beau* at the end of chapter 1. He recognized the *Critique of Judgement* as a "masterpiece in its type, but the type is philosophy of knowledge." He lamented "the extreme reticence of Kant on the subject of art itself." He remitted to paragraphs 43, 44, and 46 in the *Critique of Judgement*; but he found there "confusion between philosophy of art and philosophy of knowledge."[43]

42. Gilson, *Forms and Substances*, 44.

43. [Translator: See *Arts of the Beautiful* (2000), 151–53, for a fairly harsh judgment on Kant's philistinism about art. I find no reference to Kant in either ch. 1 or the introduction in the English versions.]

Appendix to the Third Essay

Merchants and Beauty[1]

ÉTIENNE GILSON HAD THE habit of saying what he thought in a straight-forward manner. That produces a strange contrast in the *Société de masse et sa culture*, between the sometimes provocative clarity of his expressions and the nuances of a thinker scrupulously attentive to the complexity of problems, a strange contrast indeed in an epoch when so often under the impressive obscurity of pedantically assembled words, rather simple ideas are disguised.

Gilson's thought was always a reflection upon reality. It was always an interpretation of facts, whether these facts were a document, a statis-tic, or a lived experience. Nevertheless, it is extremely difficult to parse a fact, above all when we are dealing with the human phenomenon, or to take all the facts into account, especially when we are dealing with immediately contemporary realities such as those with which the work's four chapters deal: mass sculpture, mass music, mass literature, liturgies of a mass society.

Our learned and cultured philosopher had ideas on all these sub-jects. In writing *Société de masse et sa culture*, Gilson's first intention was to invite the substitution of questions for certainties. Whether readers greet as evident progress the throng of visitors to a Picasso exhibit or de-plore popular music as a profanation, they are asked to put their pseudo-evidence in parentheses. In this critical attitude, we recognize the first condition of every philosophical investigation. "We are in a completely metaphysical territory," Gilson writes at the end of a note on copyright of philosophers or poets who cannot call themselves owners of their

1. This article appeared as "Les marchands et la beauté" in *Nouvelles Littéraires*, Aug. 3, 1967.

161

philosophy or poetry, although they still seem to have some ownership of a book produced for sale by their publisher. Thus, every chapter of this book, so clearly written in the language of educated persons, has as its goal to oblige them to see strictly philosophical questions where they saw only subjects of conversation.

These are the ideas that lead Gilson to a philosophical statement of these questions. The first is obviously that the industrialization of the arts of the beautiful implies the replacement of an aesthetic goal by a commercial goal, or at least it puts this commercial goal in the foreground. Simplistic comments are unhelpful. One surmises that Gilson knew well that the publishers of art books, recordings, and inexpensive books have a preference for masterpieces and that this preference can even combine a very strong artistic taste with commercial interest. It remains true that a collection of reproductions through a recording and a large printing can involve many activities whose goal is profit. Gilson does not feel the obligation to cover his face when he pronounces the word *money*. Alluding to his two editions of the *Discourse on Method*, the first with a commentary, the shorter for classroom use, he observes with "shame" but not without humor, that this work by Descartes "brought in" more for him than for Descartes. The industrialization of the arts of the beautiful requires capital. The money used for production naturally must be recuperated at the phase of consumption. The philosopher simply recognizes that the goals linked to the manufacture of an object and those linked to the creation of a work are not the same.

While Gilson does not make an issue of money at the service of the arts of the beautiful, neither does he accept contemporary models of putting the arts of the beautiful at the service of money. This is the book's second fundamental idea, which lets us glimpse, under the philosophical discussion, the reaction of the person who owes too much sheer enjoyment to great artistic works to fail to take offense at tricks of publicity, let alone enticing advertisement like: "She scandalizes her editor" in order to announce a collection of poems written by a woman.[2] Nor can Gilson read without righteous indignation a prospectus or an article like the one assuring that the *Pietà* is viewed better in the New York exposition than at St. Peter's in Rome or the announcement of a "more dramatic" setting

2. Gilson, *Société de masse*, 99.

for the statue of Michelangelo, an immense illuminated cross rising up behind it.[3]

After witnessing Gilson follow the consequences of publicity even in the psychology of artists, we go directly to a third idea, perhaps the most essential. Like *The Arts of the Beautiful* (1965) and *Forms and Substances of the Arts* (1966), *Société de masse et sa culture* is a reflection on aesthetic experience. If aesthetic experience implies a personal relation to the works of art, does multiplying the possibilities of entering into relation to the works of arts suffice to multiply aesthetic experiences? The *Venus de Milo* in Japan and the *Pietà* in the United States are presented as "attractions." Publicity converts them into "objects of curiosity." Many visitors look for and see nothing else in them. A still more difficult question is whether there is truly aesthetic experience when the work of art is replaced by its image.

Gilson does not condemn trade fairs.[4] If one of them brings about one vocation of a sculptor or painter, which is not impossible, it is justified. No one knows and appreciates better than Gilson the pedagogical and cultural advantages of photographic reproductions, recordings, and inexpensive books. So, it would be ridiculous to see under Gilson's words a kind of nostalgia for the "good old days" provoked by an anti-technological bias.

One might wish that he had added other analyses to those presented here, for example, on the peculiar nature of cinema as art, described here in passing as simple "industrialization of theater art," or on musical recordings. The pleasure that the latter give, we read, "is to music what the pleasure of seeing the photograph of a painting is to seeing the painting."[5] But the sentence that immediately follows seems to correct the comparison. "It is not simply a feeble image," specifies Gilson, "it is another object." We should remember that a few lines above, the author had mentioned that recording is a possible object of aesthetic experience.[6] Is the music that unfolds by emerging from the recording as if emerging from instruments a simple auditory photograph, or does it not enjoy another mode of existence?

3. McCarry, "*Pietà*," esp. 27, referred to in Gilson, *Société de masse*, 40–43.

4. Gilson, *Société de masse*, 75, 103–4n14.

5. Gilson, *Société de masse*, 52.

6. Gilson, *Société de masse*, 51.

The last chapter of this intriguing book poses a question that transcends art for the environment of questions concerning postconciliar sacred art. The vernacular liturgy involves the translation of certain Latin texts into the national language. In the French version of the creed, the Son is said to be "of the same nature as the Father."[7] Evoking the famous controversies of the first centuries of the Church, Gilson finds this mode of translating *consubtantialem Patri* strange. He expresses his surprise with an article in *La France catholique* of July 2, 1965, "Am I Schismatic?" (Suis-je schismatique?). Is not the consubstantiality of Son and Father the very mystery of the Trinity? After all, "of the same nature as the Father" is true of all sons? Two years after having posed his question, Etienne Gilson was to realize that it really belonged to another age, since he continued to await an explanation of the new formula. Does vernacular liturgy also require a vernacular theology?

7. Gilson, *Société de masse*, 122, 126, 128–29.

Bibliography

Aquinas, Thomas. "In Symbolorum Apostolorum Expositio." In *Opuscula Theologica*, 2:191–217. Rome: Marietti, 1954.

———. *Summa contra Gentiles*. Rome: Leonine Commission, 1934.

———. *Summa theologiae*. 5 vols. Ottawa: Collège Dominicain d'Ottawa, 1941–1945.

Arendt, Hannah. "Society and Culture." *Daedalus* 89 (1960) 278–87.

Augustine. *City of God*. Translated by Marcus Dods. Logos Library, n.d. https://www. logoslibrary.org/augustine/city/1924.html.

Barraud, Henri. "Musique, radiodiffusion et télévision." In *Histoire de la musique*, edited by Roland-Manuel, 2:1536–40. *Encyclopédie de la Pléiade* 60. Paris: Gallimard, 1963.

Baudelaire, Charles. *Les Fleurs du mal*. French with English translation by William Aggeler. N.p.: Digireads, 2015. First published 1857.

———. *Journaux intimes. Fusées. Mon coeur mis à nu*. Reprint, Paris: Hachette, 2020. Kindle.

Benrubi, Isaac. *Souvenirs sur H. Bergson*. Neuchâtel, Switzerland: Delachaux et Niestlé, 1942.

Bergson, Henri. "La conscience et la vie." In *L'énergie spirituelle: Essais et conférences*, 1–28. Paris: Alcan, 1919.

———. *Creative Evolution*. Translated by Arthur Mitchell. 1911. Reprint, New York: Cover, 1998.

———. *The Creative Mind* [La pensée et le mouvant]. Translated by Mabelle Anderson. New York: Holt, 1911.

———. *Essai sur les données immédiates de la conscience* [Time and free will: an essay on the immediate data of consciousness]. Paris: Alcan, 1889.

———. *Matter and Memory* [Mattière et mémoire]. Translated by N. M. Paul and W. S. Palmer. London: Swan Sonnenschein, 1911.

———. *Mattière et mémoire* [Matter and memory]. Paris: Alcan, 1896.

———. *Mélanges: L'idée de lieu chez Aristote, Durée et simultanéité, Correspondance, Pièces diverses, Documents [par] Henri Bergson*. Edited by André Robinet, with Marie-Rose Mossée-Bastide et al. Paris: Presses universitaries de France, 1972.

———. *La Pensée et le Mouvant* [The creative mind]. Paris: Alcan, 1934.

———. *Time and Free Will: An Essay on the Immediate Data of Consciousness* [Éssai sur les données immédiates de la conscience]. Translated by F. L. Pogson. London: Swan Sonnenschein, 1910.

———. *The Two Sources of Morality and Religion*. Translated by R. Ashley Audra and Cloudesley Brereton. New York: Holt, 1935.

Bréhier, Émile. "Héllenisme et christianisme aux premiers siècles de nôtre ère." *Revue philosophique de la France et de l'étranger* 103 (1927) 5–35. https://www.jstor.org/stable/41082416.

———.*Histoire de la philosophie.* 3 vols. Paris: Alcan, 1927.

———. "Y a-t-il une philosophie chrétienne?" [Is there Christian philosophy?]. *Revue de métaphysique et de morale* 38 (1931) 133–62.

Bulletin de la Société française de philosophie 54 (1959).

Bulletin de la Société française de philosophie 31 (1931).

Cazeneuve, Jean. *Sociologie de la radio-télévision.* Que sais-je? 1026. Paris: Presses universitaires de France, 1962.

Cerf, Bennett. *Publishers on Publishing.* Edited by Gerald Gross. New York: Grosset-Dunlap, 1961.

Couratier, Monique, ed. *Étienne Gilson et Nous.* Paris: Vrin, 1980.

Crossgrove, Roger. "Art for Publishing's Sake." In PBIP [Photography Books in Print?] 8 (1963) [page range unavailable].

D'Annunzio, Gabriele. *Le feu.* Translated by G. Hérelle. Paris: Lévy, [1901].

Dante, Alighieri. *The Convivio.* Translated by Richard Lansing. Digital Dante, n.d. https://digitaldante.columbia.edu/text/library/the-convivio/.

Delacroix, Eugène. *Oeuvres littéraires.* 2 vols. aris: Crés, 1922.

Denis, Maurice. *Théories, 1890–1910: Du symbolisme et de Gauguin vers un nouvel ordre classique.* 4th ed. Paris: Rouart, 1921.

Descartes, René. *Discourse on Method.* Translated by John Cottingham et al. Vol. 1 of *The Philosophical Writings of Descartes.* Cambridge: Cambridge University Press, 1985.

Dubuc, Eugénie. "Correspondance de Sir Joseph Dubuc." *Revue d'histoire de l'Amérique française* 20 (1966) 291–92.

Edie, Callistus, OSB. "The Writings of Étienne Gilson Chronologically Arranged." In *Mélanges offerts à Étienne Gilson,* 15–58. Toronto: Pontifical Institute of Mediaeval Studies, 1959.

Denzinger, Heinrich, ed. *Enchiridion Symbolorum, definitionum et declarationum de rebus fidei et morum.* Rome: Herder, 1960.

Fisher, Dorothy Canfield. "Book-Clubs." In *The Bowker Lectures on Book Publishing,* 202–30. New York: Bowker, 1957.

Fitch, James Marston. "The Forms of Plenty." *Columbia University Forum* 6 (1963) 4–9.

Gilotaux, Pierre. *L'industrie du disque.* Que sais-je? 16. Paris: Presses Universitaires de France, 1967.

Gilson, Étienne. "Art et métaphysique." *Revue de métaphysique et de morale* 23 (1915) 243–67.

———. *The Arts of the Beautiful* [Introduction aux arts du beau]. New York: Scribner, 1965.

———. *The Arts of the Beautiful* [Introduction aux arts du beau]. N.p.: Dalkey Archive, 2000.

———. *L'athéisme difficile.* Preface by Henri Gouhier. Paris: Vrin, 1979.

———. *L'athéisme difficile.* Intorduction by Thierry-Dominique Humbrecht, OP. 2nd ed. Paris: Vrin, 2014.

———. "Ce que nous devons à Henri Bergson." *Nouvelles littéraires* (Sept. 1, 1939) 1–3.

———. *The Christian Philosophy of Saint Augustine* [Introduction à l'étude de saint Augustine]. Translated by L. E. M. Lynch. New York: Random House, 1961.

———. *Christianisme et philosophie*. Paris: Vrin, 1936.

———. *Christian Philosophy: An Introduction* [Introduction à la philosophie chrétienne]. Translated by Armand Maurer, Toronto: PIMS, 1993.

———. *The Christian Philosophy of St. Thomas Aquinas* [Le Thomisme: introduction à la philosophie de saint Thomas d'Aquin]. Translated by Lawrence K. Shook. New York, Random House, 1956.

———. *D'Aristôte à Darwin et retour: Essai sur quelques constantes de la biophilosophie* [From Aristotle to Darwin and back again: a journey in final causality, species, and evolution]. Paris: Vrin, 1971.

———. *Doctrine cartésienne de la liberté et la théologie* [Theology and the Cartesian doctrine of freedom]. Paris: Alcan, 1913.

———. "Du fondement des jugements esthétiques." *Revue philosophique de la France et de l'étranger* 83 (1917) 524–46.

———. *Elements of Christian Philosophy*. New York: Doubleday, 1960.

———. *Esprit de la philosophie médiévale* [The spirit of mediaeval philosophy: the Gifford Lectures of 1931–2]. 2 vols. Vrin: Paris, 1932.

———. *Études de philosophie médiévale* [Studies in medieval philosophy]. Strasbourg: Commission des publications de la Faculté des Lettres, 1921.

———. *Forms and Substances in the Arts* [Matières et formes: poïétique particulière des arts majeurs]. New York: Charles Scribner's Sons, 1966.

———. *Forms and Substances in the Arts* [Matières et formes: poïétique particulière des arts majeurs]. N.p.: Dalkey Archive, 2001.

———. *From Aristotle to Darwin and Back Again: A Journey in Final Causality, Species, and Evolution* [D'Aristôte à Darwin et retour: essai sur quelques constantes de la biophilosophie]. Translated by John Lyon. San Francisco: Ignatius, 2009.

———. *A Gilson Reader: Selections from the Writings of Étienne Gilson*. Edited by Anton C. Pegis. Garden City, NY: Image, 1957.

———. *Heloise and Abelard* [Héloïse et Abelard: études sur le moyen âge et l'humanisme]. Washington, DC: Regnery, 1951.

———. *Héloïse et Abelard: Études sur le moyen âge et l'humanisme* [Heloise and Abelard]. Paris: Vrin, 1938.

———. *History of Christian Philosophy in the Middle Ages*. New York: Random House, 1955.

———. "L'industrialisation des arts du beau." *Quaderni di San Giorgio* 29 (1966) 77–140.

———. *Introduction à la philosophie chrétienne* [Christian Philosophy: An Introduction]. Paris: Vrin, 1960.

———. *Introduction à l'étude de saint Augustine* [The Christian philosophy of Saint Augustine]. Paris: Vrin, 1929.

———. *Introduction aux arts du beau* [The arts of the beautiful]. Paris: Vrin, 1963.

———. *Jean Duns Scot: Introduction à ses positions fondamentales* [John Duns Scotus: introduction to his fundamental positions]. Paris: Vrin, 1952.

———. *John Duns Scotus: Introduction to His Fundamental Positions* [Jean Duns Scot: introduction à ses positions fondamentales]. Translated by James G. Colbert. London: T. & T. Clark, 2018.

———. "La notion de philosophie chrétienne." *Bulletin de la Société française de philosophie* 31 (1931) 37–93.

————.*Matières et formes: Poiétique particulière des arts majeurs* [Forms and substances in the arts]. Paris: Vrin, 1964.

————.*Painting and Reality: The A. W. Mellon Lectures in the Fine Arts 1955, National Gallery of Art, Washington* [Peinture et realité]. Bollingen XXXV 4. New York: Pantheon Books, 1957.

————.*Painting and Reality* [Peinture et realité]. Providence, RI: Cluny, 2020.

————.*Peinture et Realité* [Painting and reality]. Paris: Vrin, 1958.

————. *Le philosophe et la théologie* [The philosopher and theology]. Paris: Fayard, 1960.

————. *The Philosopher and Theology* [Le philosophe et la théologie]. Translated by Cécile Gilson. New York: Random House, 1962.

————. *La philosophie au moyen âge*. Reprint, Paris: Payot, 1925.

————. *La philosophie chrétienne*. Juvisy: Cerf, 1933.

————.*La philosophie de Saint Bonaventure* [The philosophy of St. Bonaventure]. Paris: Vrin, 1924.

————. *The Philosophy of St. Bonaventure* [La philosophie de Saint Bonaventure]. Translated by Illtyd Trethowan and Frank J. Sheed. Paterson, NJ: St. Anthony Guild, 1965.

————.*The Philosophy of St. Thomas Aquinas* [Le Thomisme]. Edited by G. A. Elrington. Translated by Edward Bullough. Cambridge: Heffer & Sons, 1929.

————. *The Philosophy of St. Thomas Aquinas* [Le Thomisme]. 2nd ed. Edited by G. A. Elrington. Translated by Edward Bullough. New York: Barnes and Noble, 1993.

————. "Plaidoyer pour Boekmesser." *Revue internationale de philosophie* 18 (1964) 161–82.

————. *La société de masse et sa culture*. Paris: Vrin, 1967.

————. *The Spirit of Mediaeval Philosophy: The Gifford Lectures of 1931-2* [Esprit de la philosophie médiévale]. Translated by A. H. C. Downes. New York: Scribner, 1940.

————. *Studies in Medieval Philosophy* [Études de philosophie médiévale]. Translated by James G. Colbert. Eugene OR: Cascade Books, 2019.

————. "Suis-je schismatique?" *France catholique* (July 2, 1965) 1.

————. *Theology and the Cartesian Doctrine of Freedom* [Doctrine cartésienne de la liberté et la theologie]. Translated by James G. Colbert. South Bend, IN: St. Augustine's, 2019.

————. *Le Thomisme* [The philosophy of St. Thomas Aquinas]. 3rd rev. ed. Paris: Vrin, 1927.

————. *Le Thomisme: Introduction à la philosophie de saint Thomas d'Aquin* [The Christian philosophy of St. Thomas Aquinas]. 5th ed. Paris: Vrin, 1944.

————. *Le Thomisme: Introduction à la philosophie de saint Thomas d'Aquin* [The Christian philosophy of St. Thomas Aquinas]. 6th ed. Paris: Vrin, 1965.

————. "What Is Christian Philosophy?" In *A Gilson Reader*, edited by Anton Pegis, 75–191. Garden City, NY: Image, 1957.

Gilson, Étienne, and Henri Gouhier. Edited and translated by Richard J. Fafara. *The Malebranche Moment: Selections from the Letters of Étienne Gilson & Henri Gouhier (1920–1936)*. Marquette Studies in Philosophy 48. Milwaukee: Marquette University Press, 2007.

Gilson, Étienne, and Jacques Maritain. *Correspondance, 1923–1971*. Edited with commentary by Géry Prouvost. Bibliothèque des textes philosophiques. Paris: Vrin, 1991.

Gilson, Étienne, et al. *Recent Philosophy: Hegel to the Present*. Vol. 4 of *History of Philosophy*. New York: Random House: 1966.

Gouhier, Henri. *Bergson dans l'histoire de la pensée occidentale*. Paris: Vrin, 1989.

———. *Bergson et le Christ des évangiles*. Paris: Vrin, 1961.

———. "Les marchands et la beauté." *Nouvelles littéraires* (Aug. 3, 1967) 4.

Gréban, Arnoul. *Le Mystère de la Passion*. Edited by Omer Jodogne. Brussels: Palais des Académies, 1965.

Groueff, Stéphane. *The Manhattan Project*. New York: Little Brown, 1967.

Guichardan, R. "Editorial." *Pèlerin* 93, 3.

Guitton, Jean. *The Pope Speaks: Dialogues of Paul VI with Jean Guitton*. New York: Meredith, 1968.

Gurgand, J.-N. "Le phénomène Astérix." *L'Express* 796 (1966) 24–26.

Harris, Marvin. *The Nature of Cultural Things*. New York: Random House, 1964.

Hémon, Louis. *Maria Chapdelaine*. Paris: Grasset, 1921.

Hermant, André. *Formes utiles*. Paris: Salon des Arts Ménagers, 1959.

Huisman, Denis, and Georges Patrix. *L'esthétique industrielle*. Paris: Presses Universitaires de France, 1961.

Huysmans, Joris-Karl. *Les foules de Lourdes*. Edited by Pierre Lambert. Paris: Plon, 1958.

"Hymns: New Songs for Methodists." *Time* (July 22, 1966), 66.

Kant, Immanuel. *Critique of Judgement*. Translated by James Creed Meredith, revised and introduced by Nicholas Walker. Oxford World's Classics. Oxford: Oxford University Press, 2007.

Klein, David. "The Anomic Age in Publishing." *Columbia University Forum* (Spring 1963) 36–42.

Leo XIII, Pope. *Aeterni Patris* [On the restoration of Christian philosophy]. Encyclical letter. Vatican, Aug. 4, 1879. https://www.vatican.va/content/leo-xiii/en/encyclicals/documents/hf_l-xiii_enc_04081879_aeterni-patris.html.

Lewis, Freeman. "Paper-Bound Books in America." In *The Bowker Lectures on Book Publishing*, 306–35. New York: Bowker, 1957.

Livi, Antonio. *Étienne Gilson: filosofía cristiana e idea del limite crítico*. Pamplona: Universidad de Navarra, 1970.

Loewy, Raymond. *La laideur se vend mal*. Paris: Nouvelle revue française, 1963.

Longchambon, Louis. "Nécessité d'une esthétique industrielle." In *Encyclopédie française*, 13:338. Paris: Société de Gestion de l'Encyclopédie Française, 1937–1963.

Lotte, Joseph. "Entretien avec Henri Bergson." In *Mélanges: L'idée de lieu chez Aristote, Durée et simultanéité, Correspondance, Pièces diverses, Documents [par] Henri Bergson*, by Henri Bergson, edited by André Robinet, with Marie-Rose Mossé-Bastide et al., 880–82. Paris: Presses universitaries de France, 1972.

Magill, Frank A., ed. *Masterpieces of World Literature in Summary Form*. New York: Harper & Row, 1952–1969.

———. *Masterpieces of World Philosophy in Summary Form*. New York, Harper & Row, 1961.

Manchester, William. *The Death of a President*. New York: Harper & Row, 1963.

Manuel des Paroisses: Extrait du missel biblique et de cantique et psaumes. Paris: Tardy, 1958.

Mass Culture and Mass Media. Daedalus 89 (1960). https://www.jstor.org/stable/i20026567.

McCarry, Charles. "The *Pietà*: Masterpiece at the Fair." *Saturday Evening Post* (Mar. 28, 1964) 24–28.

McGrath, Margaret. *Étienne Gilson: A Bibliography/Une Bibliographie.* Toronto: Pontifical Institute of Mediaeval Studies, 1982.

Mélanges offerts à Étienne Gilson de l'Académie française. Études de philosophie médiévale. Toronto: Pontifical Institute of Mediaeval Studies, 1959.

Mondrian. Chefs d'oeuvres de l'art: Grands peintres 47. Paris: Hachette, 1967.

Murphy, Francesca Aran. *Art and Intellect in the Philosophy of Étienne Gilson.* Columbia: University of Missiouri Press, 2004.

"Museums without Walls." *New York Times Literary Supplement,* Mar. 22, 1964.

Paperback Books in Print 7/3. New York: Bowker, 1962.

Paperback Books in Print 8/1. New York: Bowker, 1963.

Paul VI, Pope. *Ecclesiam Suam.* Encyclical letter. Vatican, Aug. 6, 1964. https://www.vatican.va/content/paul-vi/en/encyclicals/documents/hf_p-vi_enc_06081964_ecclesiam.html.

———. "Omilia de Paolo VI" [Homily of Paul VI]. Vatican, Mar. 7, 1965. https://www.vatican.va/content/paul-vi/it/homilies/1965/documents/hf_p-vi_hom_19650307.html.

Paupert, Jean-Marie. *Peut-on être chrétien ajourd'hui?* Paris: Grasset, 1986.

Polin, Raymond. "Bergson, philosophe de la creation." In *Bergson et l'histoire de la philosophie,* by Martial Guerolt et al., 193–213. Études bergsoniennes 5. Paris: Presses universitaires de France, 1959.

"Profiles: Quiet, Beneficent Things." *New Yorker* (Oct. 31, 1964) 63, 126.

Proust, Marcel. *In the Shadow of Young Girls in Flower.* Translated by James Grieve. New York: Penguin Classics, 2005.

"Records: Age of the Patchwork." *Time,* Sept. 24, 1965. https://content.time.com/time/subscriber/article/0,33009,834382,00.html.

Régis, Louis-Marie, OP. "L'opinion publique et l'exercice de l'autorité dans l'Église." *Communauté chrétienne* 25 (1966) 41.

Roland-Manuel, ed. *Histoire de la musique.* Vol. 60 of *Encyclopédie de la Pléiade.* Paris: Gallimard, 1982.

Russoli, Franco. *Renaissance Painting.* New York: Viking Compass, 1962.

Sainte-Beuve, Charles-Augustine. *Portraits contemporains.* 5 vols. Paris: Didier, 1846, 1869–1871.

Schramm, Wilbur. *Communications in Modern Society: Fifteen Studies of the Mass Media* Urbana: University of Illinois Press, 1948.

Second Vatican Council. *La liturgie: Constitution conciliaire et directives d'application de la réforme liturgique.* Vol. 5 of *Documents conciliaires.* Edited and translated by Emile Gabel. Paris: Centurion, 1966.

———. *Les moyens de communication sociale.* In *Documents conciliaires,* 3:301–408. Edited and translated by Emile Gabel. Paris: Centurion, 1966.

———. *Les seize documents conciliaires.* Edited and translated by Emile Gabel. Paris: Fides, 1966.

Seldes, Gilbert. "Reply to James Marston Fitch." *Columbia University Forum* 6 (1963) 43–44.

Seuphor, Michel. *Exposition Mondrian, Orangerie des Tuileries, Janvier 1969.* Exhibition catalogue. Paris: Réunion Des Musées Nationaux, 1969.

Shils, Edward. "Mass Society and Its Culture." *Daedalus* 89 (1960) 288–314.

Shook, Lawrence K. *Étienne Gilson.* Étienne Gilson Series. Toronto: Pontifical Institute of Mediaeval Studies, 1984.

Simmons, Francis. "The Catholic Church and the New Morality." *CrossCurrents* 16 (1966) 429–45. https://www.jstor.org/stable/24457213.

Souriau, Paul. *La beauté rationnelle.* Paris: Alcan, 1904.

Sweeney, James Johnson. "The Artist and the Museum in a Mass Society." *Daedalus* 89 (1960) 354–58.

Stanton, Frank. *Mass Media and Mass Culture: Great Issues Lecture at the Hopkins Center, Dartmouth College November 26, 1962.* New York: Columbia Broadcasting System, 1963.

Touron, Antoine, OP. *La vie de S. Thomas d'Aquin de l'ordre de frères prêcheurs, doctor de l'église: avec un exposé de sa doctrine et de ses ouvrages.* Paris: Gissey et Bourdelet, 1737.

"Vie, titres et fonctions d'Étienne Gilson." In *Mélanges offerts à Étienne Gilson de l'Academie française,* 9–14. Études de philosophie médiévale. Toronto: Pontifical Institute of Mediaeval Studies, 1959.

Index of Names

General Index

176

Made in the USA
Middletown, DE
24 August 2023